**Learning Centre, Canolfan Dysgu**
Coleg Y Cymoedd, Campus Nantgarw Campus
Heol Y Coleg, Parc Nantgarw
CF15 7QY
01443 653655 / 663168

D0323074

CHIMNEYS AND TOWERS

# CHIMNEYS AND TOWERS

# Charles Demuth's Late Paintings of Lancaster

Betsy Fahlman

With an essay by Claire Barry

AMON CARTER MUSEUM
FORT WORTH

DISTRIBUTED BY
THE UNIVERSITY OF PENNSYLVANIA PRESS
PHILADELPHIA

# Contents

9    **FOREWORD**

12    **ACKNOWLEDGMENTS**

17    **PLATES**

33    **CHIMNEYS AND TOWERS**
      *Charles Demuth's Late Paintings of Lancaster*

      Betsy Fahlman

139    **ACROSS THE FINAL SURFACE**
      *Observations on Charles Demuth's
      Painting Materials and Working Methods
      in His Late Industrial Oil Paintings*

      Claire Barry

184    **SELECTED BIBLIOGRAPHY**

194    **LIST OF ILLUSTRATIONS**

202    **EXHIBITION CHECKLIST**

## Foreword

Charles Demuth's masterpiece, *Chimney and Water Tower*, has resided in the Amon Carter Museum's collection since 1995. Formerly owned by Georgia O'Keeffe, to whom Demuth bequeathed all his oil paintings, and on loan to the National Gallery of Art in Washington from 1949 until 1989, the painting was acquired by the Carter during the tenure of former director Rick Stewart. It was his determination that ensured the painting would be displayed alongside other icons of American modernist painting that the museum has acquired since it opened in 1961.

*Chimneys and Towers: Charles Demuth's Late Paintings of Lancaster* is the fourth exhibition in a series organized by the museum. The three previous exhibitions each took as its centerpiece a masterwork of the nineteenth century from the Carter's collection: Martin Johnson Heade's *Thunder Storm on Narragansett Bay* (1868), Thomas Cole's *Garden of Eden* (1828), and Thomas Eakins' *Swimming* (1885). The exhibitions were tightly focused projects that significantly enriched the study and appreciation of these works by investigating their creation from the vantage points of history, aesthetics, and biography. Two of the exhibitions traveled to other institutions around the country. *Ominous Hush: The Thunderstorm Paintings of Martin Johnson Heade* (1994) traveled to the Shelburne Museum and the Metropolitan Museum of Art. *Thomas Eakins and the Swimming Picture* (1996) traveled to the Corcoran Gallery of Art; Brandywine River Museum; and the Museum of Art, Rhode Island School of Design. All three exhibitions received the generous support of the National Endowment for the Arts, the National Endowment for the Humanities, and The Henry Luce Foundation, Inc. With *Chimneys and Towers*, we once again extend our deepest appreciation to The Henry Luce Foundation, Inc., and the National Endowment for the Arts, both of whom helped make the exhibition and publication possible.

Demuth's *Chimney and Water Tower* had long been recognized by the Amon Carter Museum as a complex work that called for further study. In the exhibition, the painting is united with the artist's other strikingly powerful works depicting commercial sites in his hometown of Lancaster, Pennsylvania. The display provides an opportunity not afforded Demuth's contemporaries, for the paintings were never shown

together during the artist's lifetime. Executed over a six-year period and distinctive within the artist's career for their subject, scale, and technique, the series of paintings begins in 1927 with Demuth's brilliant *My Egypt* and ends not long before his death in 1933 with *After All*. Together, the works represent the sustained and thoughtful effort of an artist who was becoming increasingly disabled by the diabetes that would take his life just short of age 52.

In this enterprise the museum was fortunate to collaborate with Demuth scholar Betsy Fahlman, whose previous works on the artist include the publication *Pennsylvania Modern: Charles Demuth of Lancaster* (1983). Dr. Fahlman has built upon her previous scholarship in this publication, providing deep connections between Demuth and the ostensibly commonplace enterprises of agriculture and linoleum production. Her essay also brings to light many illustrations never before published.

As with the earlier examinations of paintings by Heade, Cole, and Eakins, key to this study of Demuth's late work is the technical essay provided by Claire Barry, chief conservator in the museum's paintings conservation program jointly sponsored with the Kimbell Art Museum. Her essay greatly enriches the project through fascinating and heretofore unknown information about Demuth's materials and technique, including a discussion of the artist's related sketches, which are also featured in the exhibition.

Many individuals, institutions, and organizations helped bring this project to fruition, and it is our hope that we have recognized all of them in these pages. The generous support of museum colleagues enabled the Carter to borrow for the exhibition five of the artist's seven late architectural paintings. For allowing these major works to be seen together, we gratefully recognize here the Norton Museum of Art, Whitney Museum of American Art (both venues for the exhibition), Dallas Museum of Art, and the Art Institute of Chicago. (*Buildings Abstraction, Lancaster* [1931], in the collection of the Detroit Institute of Arts, was unavailable for loan.) We also extend our thanks to Wanda Corn and Judy Walsh, both of whom provided excellent critical feedback on the essays. Finally, we extend our thanks to several other magnanimous institutional and private lenders who enabled us to create

such a meaningful context for these seven remarkable paintings: the Tacoma Art Museum, Yale University Art Gallery, Jay E. Cantor, Judith and Arthur Marks, and Joseph Masheck.

Our appreciation goes to many on the Amon Carter Museum staff, including Will Gillham, director of publications, who produced the catalogue; Timothy Gambell, graphic design/production manager, who created a book design commensurate with the artworks' spare elegance; and Wendy Haynes, director of exhibitions and collection services, who marshaled the project over a period of some years.

The Amon Carter Museum has long been committed to sharing its research in American art through its publications and exhibitions. We thank the Board of Trustees and the Amon G. Carter Foundation for their continuing support of this worthy endeavor.

Jane Myers
*Senior Curator of Prints and Drawings*

Ron Tyler
*Director*

## Acknowledgments

As geography shaped Charles Demuth's career, so it has mine. My first academic position was in Lancaster, and the genesis of my 1983 exhibition at the Philadelphia Museum of Art, *Pennsylvania Modern: Charles Demuth of Lancaster*, had its roots there as well. I am grateful for the opportunity to work on him once again.

I am happy to acknowledge the many individuals and institutions who have aided me in my research on this project. It has been both a personal and scholarly pleasure to work with conservator Claire Barry. What began as a work on two different essays turned out to be a fascinating collaboration and one that has illuminated both sides — front and back — of Demuth's paintings.

It has been a pleasure as well to work with the knowledgeable and congenial staff of the Amon Carter Museum. I would like to thank in particular Sam Duncan, Will Gillham, Wendy Haynes, Jane Myers, John Rohrbach, and Allen Townsend. I owe a special debt to former librarian Milan Hughston, who always made me feel welcome among the stacks. I also thank Miriam Hermann for her tireless work on permissions, Steve Watson for his photographic services, and Timothy Gambell for his handsome design of this publication. My deepest thanks are due to Rick Stewart, former director of the Carter, not only for more than thirty years of friendship but also for his groundbreaking scholarship on Charles Sheeler, which has, as ever, shown me the way.

In Lancaster, Pennsylvania, I am grateful for the assistance of past and present staff of the Demuth Foundation, especially Anne Lampe, Corinne Woodcock, Teri Traner, and Mara Sultan. Members of the Demuth Foundation Board have also been unfailingly helpful. I would also like to thank other Lancastrians: Marilyn and Bill Ebel, Rose Fronczak, Bruce Kellner, Gerald and Margaret Lestz, John Ward Willson Loose, C. Eugene Moore, Ginger Shelley, Lisa J. Stone, and Chris Welch.

I would like particularly to thank several individuals for their assistance. Ruth L. Bohan graciously permitted me to read her book manuscript on Walt Whitman and American visual culture. Kimberly Camp, executive director, and Katy Rawdon-Faucett, archivist, of the Barnes Foundation have been very helpful. Grete Meilman aided me in locating several key Demuth drawings. A generous scholar, Steven Watson shared with me his research on Muriel Draper, and I thank him for the trust he placed in me with his unpublished material. For assistance during my research trip to New Haven, I am especially grateful to Jonathan Weinberg, Nick Boshnack, and Ray Smith. Robin

Jaffe Frank of the Yale University Art Gallery kindly alerted me to several key Demuth drawings.

I am also grateful for the assistance of the following individuals: Judith A. Barter, Stacy Bomento, Jil Borin, Lillian Brenwasser, Doris Bry, Priscilla Vail Caldwell, Leslie Calmes, Jeanne Chevosta, Michelle Clisham, Wanda Corn, Elissa Curcio, Anita Duquette, Christian Dupont, Joellen ElBashir, Erica Fisher, Milton Fisk, Jane Glover, Denise Gosé, Sarah Greenough, Karen E. Haas, Barbara Hall, Allie Hendricks, Betsy Hurley, Carol A. Irish, Jane Joe, Philip Johnson, Vance Jordan, Katherine Kaplan, Joanne Kares, Carol Lee, Mary Leonard, Michele McDonald, Arthur Marks, Professor Joseph Masheck, Barbara Mathes, Chryssa Moyer, M. P. Naud, Frances M. Naumann, Dianne Nilsen, Lynne Oliver, Arnold Rönnebeck, Lois Rudnick, Rachael Sadinsky, Daniel Schulman, Pam Scott, Kevin Sharp, Ginger Shelley, Earle G. Shettleworth Jr., Eric Schruers, Nancy M. Shader, Marc Simpson, Pamela Simpson, Andrew J. Thomas, Valerie Westcott, Debbie Westmoreland, Ursula Rönnebeck Moore Works, and Richard York.

Staff members at the following institutions were critical to my success: the Art Institute of Chicago, Beinecke Rare Book and Manuscript Library (Yale University), Detroit Institute of Arts, Hagley Museum and Library, Joint Free Public Library of Morristown and Morris Township, Lancaster County Historical Society, Library of Congress, Morris County Library, Morristown Historical Society, National Archives, Susan Teller Gallery, Winterthur Museum and Library, and the Yale University Art Gallery.

In Arizona, I am grateful for the close friendships that have sustained me through many projects, including this one. I would particularly like to thank Anthony and Anne Gully and Emily Umberger. Finally, I celebrate the love and good humor with which my husband, Daniel Ball, has supported my research.

Betsy Fahlman
*Tempe, Arizona*

## Acknowledgments

Several people generously assisted in the examination of Demuth's paintings at their institutions as well as in the paintings conservation studio of the Kimbell Art Museum. At the Amon Carter Museum: Jane Myers, Rebecca Lawton, Melissa Thompson, and Sylvie Pénichon; at the Art Institute of Chicago: Frank Zuccari and Alison Langley; at the Columbus Museum of Art: Nanette V. Maciejunes and Melissa Wolf; at the Dallas Museum of Art: William Rudolph, John Dennis, Dorothy Kosinski, Gabriela Truly, and Susan Squires; at the Detroit Institute of Arts: Barbara Heller and Alfred Ackerman; at the Norton Museum of Art: Jonathan Stuhlman; at the Whitney Museum of American Art: Carol Mancusi-Ungaro, Pia Gotshaller, and Heather Cox; at the Metropolitan Museum of Art: Rachel Mustalish, Marjorie Shelley, and Margaret Lawson; at the Philadelphia Museum of Art: Nancy Ash, the late Faith Zieske, and Scott Homolka; and at the Yale University Art Gallery: Patricia Garland, Suzanne Boorsch, and Robin Jaffee Frank.

Special thanks are also owed to Isabelle Tokumaru, Elise Effmann, and Na'Cole Trujillo for their assistance with the examination and photography of Demuth works in the conservation studio of the Kimbell Art Museum. Rick Stewart, Jane Myers, Patricia Junker, Rebecca Lawton, John Rohrbach, Scott Barker, Gerald S. Lestz, C. Eugene Moore, Wanda Corn, Jonathan Weinberg, Barbara Buhler Lynes, Judith Walsh, Dale Kronkright, Stephen Kornhauser, and Ulrich Birkmaier provided valuable insights. The publications staff at the Amon Carter Museum, particularly Will Gillham and Miriam Hermann, diligently edited the manuscript and secured photographs, and Timothy Gambell produced a beautiful design that elucidates both images and text. I also extend my thanks to Steve Watson for his help with all aspects of photography.

My research on Demuth's painting materials and technique would not have been possible without the generous help of the Demuth Foundation, especially Anne Lampe, Robert Fenninger, Bruce Kellner, and Ellen Barley. The resources and staffs of several outstanding research libraries and archives also provided essential support. At the Amon Carter Museum library: Allen Townsend, Sam Duncan, and Jonathan Frembling patiently assisted with countless requests; the Beinecke Rare Book and Manuscript Library (Yale University) provided access to both significant archival material as well as Demuth's poster portraits; at the Barnes Foundation, Barbara Buckley provided invaluable help with archival research; the Hagley Museum and Library made available industrial manuals and brochures on the Armstrong

Company and Beaver Board; and at the Museum of Modern Art library and archives, Milan R. Hughston allowed the study of relevant conservation records from the 1947 Stieglitz Memorial exhibition.

Finally, I am deeply grateful to Betsy Fahlman for sharing so freely of her time and extensive knowledge of Demuth throughout this study and for making this a truly enjoyable project. My sincere thanks also go to Ron Tyler, director at the Carter; the Amon G. Carter Foundation; and the museum's Board of Trustees for the continued support of the paintings conservation program and for advancing publications, such as this one, that unite an art historical perspective with a focused study of the object and the artist's creative process.

Claire Barry
*Fort Worth, Texas*

# CHARLES DEMUTH'S
# LATE PAINTINGS OF LANCASTER

*Plates*

Plate 2
*Buildings, Lancaster*, 1930

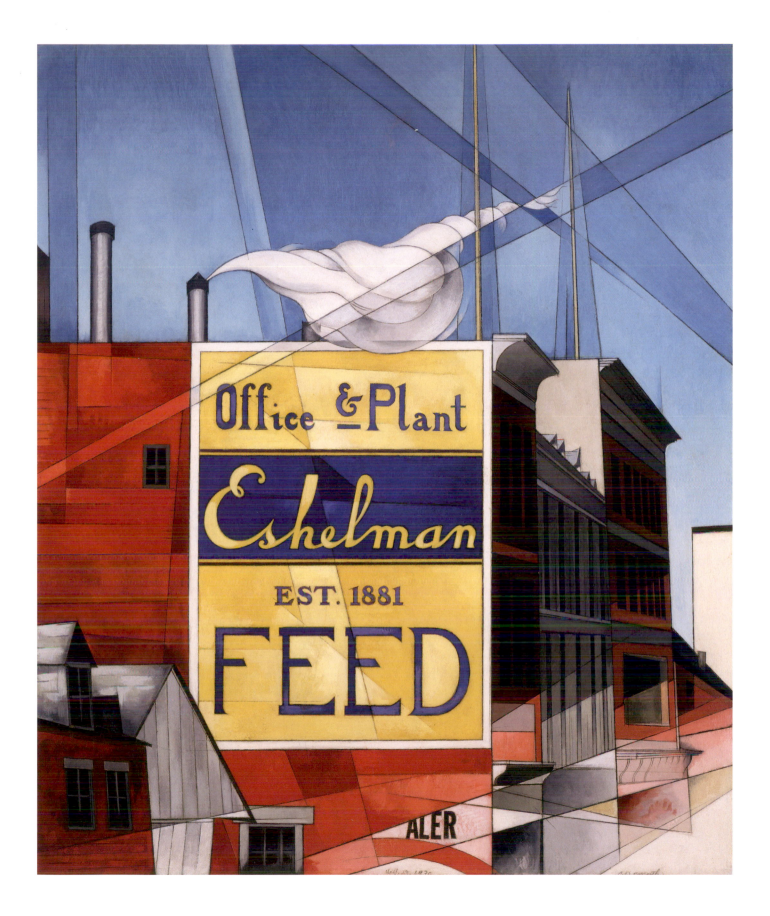

Plate 3
*Chimney and Water Tower*, 1931

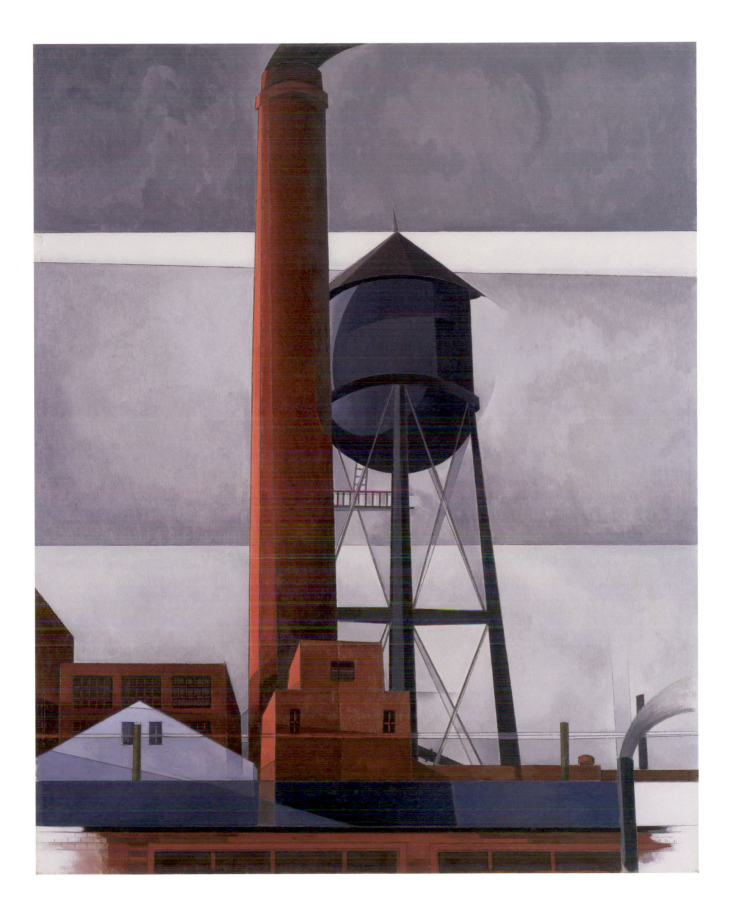

Plate 4
*Buildings*, ca. 1930–31

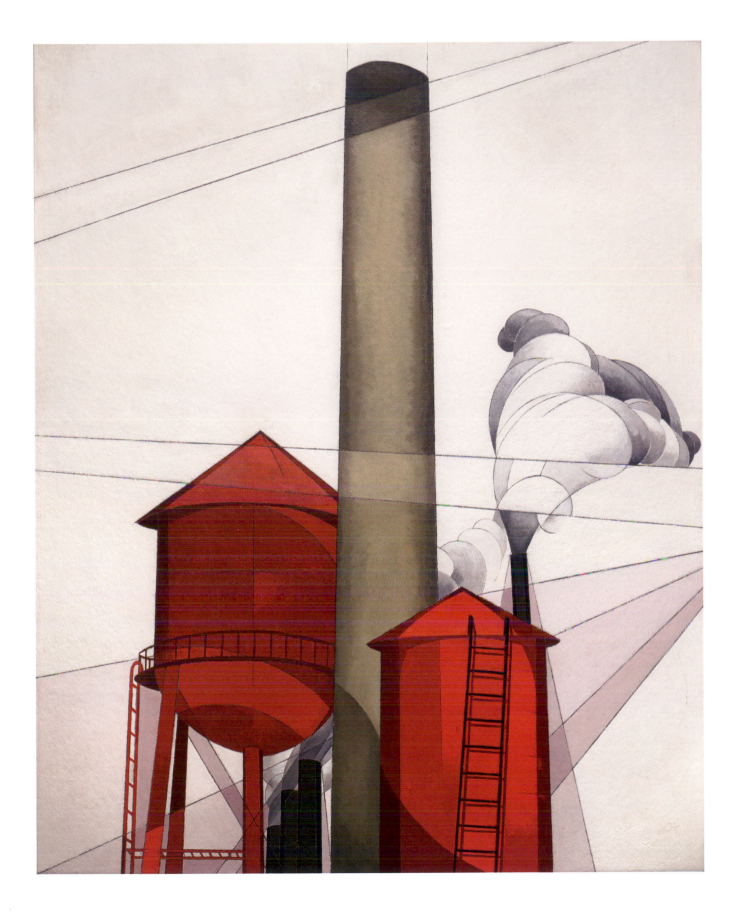

Plate 5
*Buildings Abstraction, Lancaster*, 1931

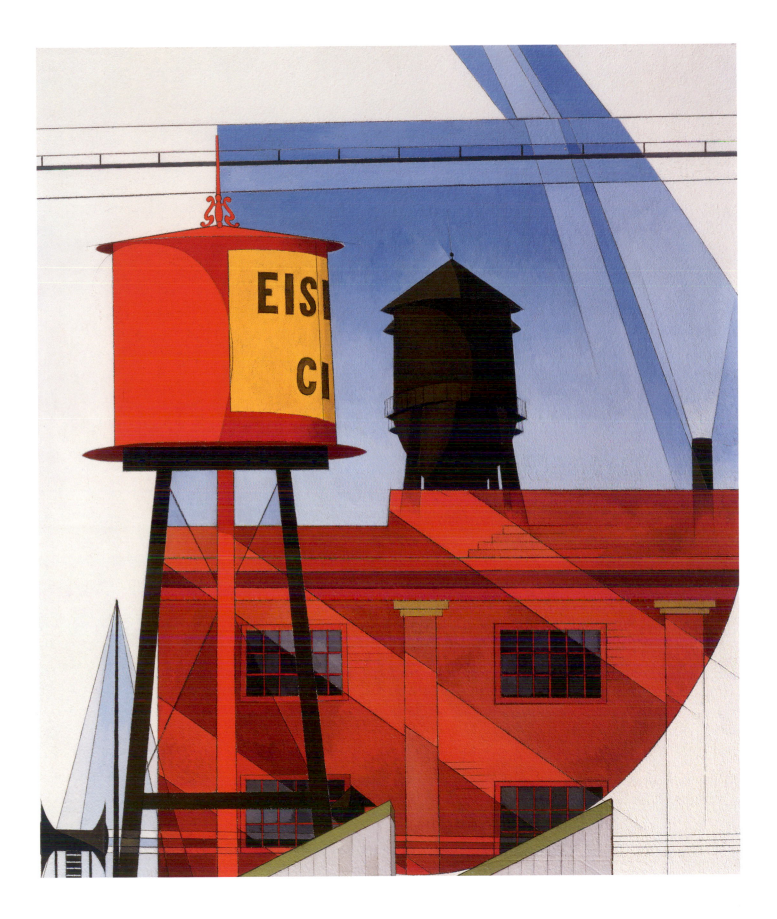

Plate 6
*And the Home of the Brave*, 1931

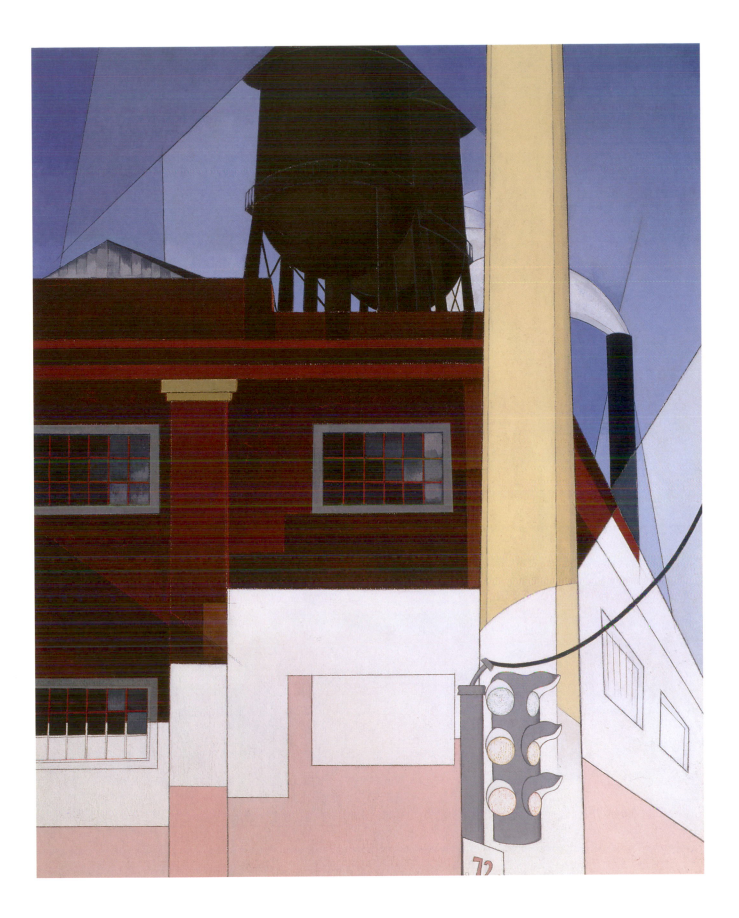

Plate 7
*After All*, 1933

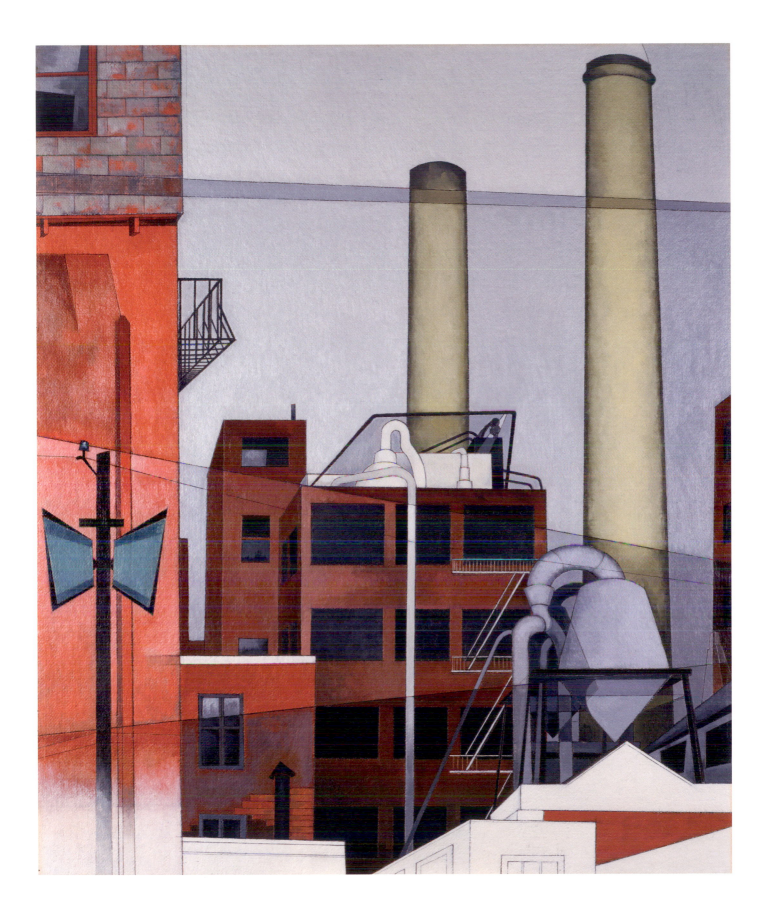

# CHIMNEYS AND TOWERS

*Charles Demuth's Late Paintings of Lancaster*

Betsy Fahlman

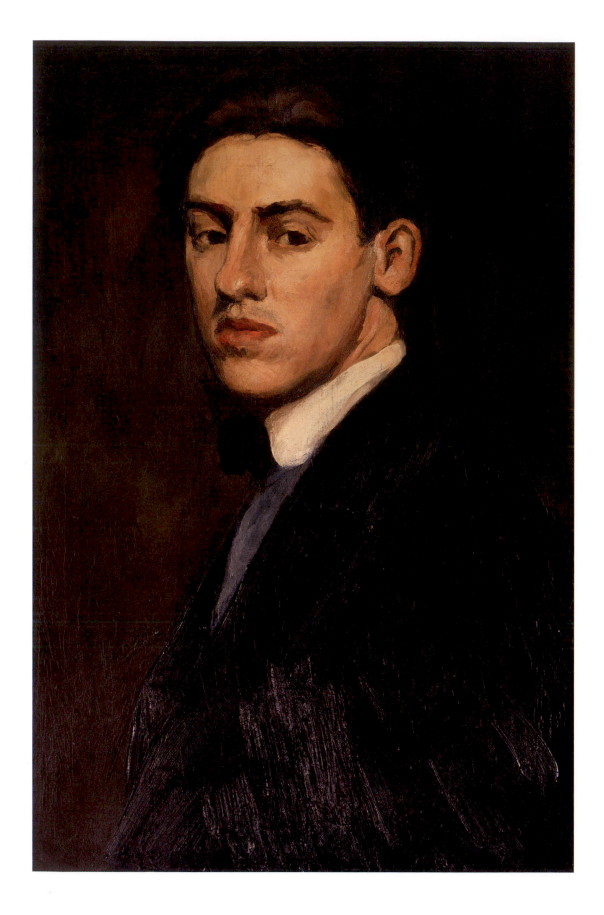

# Charles Has Only Just Gone:
# A View from the Province

Charles Demuth (1883–1935) commenced his series of seven late architectural paintings in 1927 with his iconic *My Egypt* (pl. 1), and their importance has long been recognized by scholars. But new material relating to the artist's chronic illness; the paintings' critical reception when they were first exhibited; and their relationship to his native Lancaster, Pennsylvania, now permit a richer explication of their landmark art historical significance.

This essay weaves together several thematic strands. The first chapter charts the artist's grounding within Lancaster, using the local as a revealing interpretive lens. Place and biography are interwoven within the rich chronicle of friendship he maintained amongst the international avant-garde, all set against the backdrop of the most significant fact of the last decade and a half of his life: his struggle to create art while he became increasingly debilitated by the diabetes that led to his early death. The photographic portraits Alfred Stieglitz made of Demuth, which are reproduced in these pages, document the devastating course of his illness and are balanced by previously unpublished correspondence that reveals the central role Pennsylvania collector Albert C. Barnes played in extending the artist's life.

It is a profound fact that without the temporary restorative effects of the recently discovered insulin with which he was treated, Demuth would never have lived to create the late architectural masterpieces that are the focus of the second section. These remarkable industrial portrayals are considered within the context of Precisionism and Regionalism. While their exhibition history is known, their period critical reception has never been thoroughly explored. The role of drawing in Demuth's artistic practice is discussed as well, as are the businesses whose structures he painted. The artist balanced competing personal and aesthetic agendas to realize a stunning body of work whose powerful visual impact belied the diminishing physical strength of the talented painter who created them.

Fig. 11
Charles Demuth
*Self-Portrait*, 1907

Powerful in composition and scale, despite their relatively modest size, Demuth's late architectural paintings were executed within an intense period between 1927 and 1933. They represent the last creative surge of the increasingly ill artist, who after completing a group of watercolors in Provincetown, Massachusetts, during the summer of 1934, would never paint again. Diabetes, first diagnosed in 1921, was a central fact of the artist's life, and the status of his health governed his ability to work and travel.

His letters from the 1920s and 1930s document the discouraging downward spiral of his physical condition and the diminishment of his artistic energy, if not aesthetic power. It is amazing that he was able to produce some of the most significant paintings of his career during this period. The chronicle of his poor health makes clear that work was a struggle for the artist, who might go months without making a single piece. The late architectural paintings are remarkable for the sheer force of the will to work they represent for an artist who marshaled all his physical and mental resources to produce them.

The first of the series is *My Egypt* (pl. 1), the artist's most famous painting and the only one of this series to be purchased in his lifetime. The grain elevators depicted in this work stood adjacent to the structures portrayed in *Buildings, Lancaster* (pl. 2), which delineates part of the complex occupied by the John W. Eshelman Feed Company in the city's downtown.[1] Three of the paintings — *Chimney and Water Tower* (pl. 3), *Buildings* (pl. 4), and *After All* (pl. 7) — feature structures within the Armstrong manufacturing complex in Lancaster, then the nation's leading producer of linoleum. Two others show tobacco-related industrial sites not far from the Armstrong plant. *Buildings Abstraction, Lancaster* (pl. 5) was inspired by the Otto Eisenlohr and Brothers Leaf Tobacco Resweating Plant; *And the Home of the Brave* (pl. 6) depicts the offices and warehouses of the Bayuk Brother's Cigar Company.

Together these powerful paintings summarize the polarities of Lancaster industry — manufacturing and agriculture. Linoleum and tobacco, in particular, were among the city's most significant commercial enterprises. Like Demuth's own work and life, these businesses permit a historical and contemporary vantage dually grounded in the specifics of time and place, within whose parameters the artist negotiated a distinctive matrix of artistic and personal identity. The enterprises Demuth recorded were thoroughly embedded in the economic fabric of Lancaster, and with one, tobacco, Demuth's family was directly involved.

The vegetable farming that provided him with so many subjects further reveals how intricately connected Demuth was with the visual texture of his native city.

As were the majority of his works, the late architectural paintings were executed in Lancaster. Plagued as he was by unpredictable health, Demuth's isolation was imposed upon him. Even when he kept distractions to a minimum, the diabetes that afflicted him frequently rendered him unable to work or venture out, let alone travel. His artistic output was reasonably steady through 1929, but his first biographer, Emily Farnham, lists only four paintings from 1930 in her 1959 catalogue of his work: *Buildings Lancaster*; *Waiting* (or *Ventilators*); and two watercolors of tulips. Thereafter, Demuth's production remains erratic. The year 1931 was a slow one for the artist. Farnham only lists four paintings from this year as well, though three of them are major: *And the Home of the Brave* (pl. 6), *Buildings Abstraction, Lancaster* (pl. 5), and *Chimney and Water Tower* (pl. 3).[2] The fourth, *Landscape, Peach Bottom*, is a small oil on canvas Demuth gave to his Lancaster friend Elsie Everts. For 1932, Farnham only knew of two works, though in 1933 there are eleven, including *After All* (pl. 7). The other ten are watercolors of flowers and fruit. In 1934 there are twelve, all figural studies from a Provincetown sketchbook. None are recorded from 1935, the year of his death. While other works have been located since Farnham compiled her catalogue, her listing graphically charts the general ups and downs of Demuth's health and the effect this had on his artistic production.

## HOME REMAINED LANCASTER

Lancaster is necessarily the starting point for any discussion of Demuth's work and begins with his birth there on November 8, 1883. The son of Ferdinand Andrew Demuth and Augusta Wills Buckius Demuth, the artist spent most of his life in the historic southeastern Pennsylvania city where his family had operated a tobacco shop since the eighteenth century. The city was a lifelong source of inspiration and personal stability for the artist, making his regional orientation as significant a source for his art as were his connections to the American and European avant-garde. He resided for relatively short periods in New York and Paris and, when health permitted, visited New York. He eagerly anticipated and savored these sojourns, gaining much

from the lively intellectual milieu of these cultural capitals. But home remained Lancaster.[3]

Demuth has long been recognized as a central figure in the chronicle of the first generation of the American avant-garde, but much of his work was inspired by the buildings and agricultural production of Lancaster. The local, therefore, is the lens through which much of his life and work must necessarily be viewed. As A. E. Gallatin observed, his works "are full of the locality of the scene."[4] The paintings exemplify the central role of place in his work and provide a historical thread linking his oeuvre.

Deeply attached to Lancaster (he was the only major American modernist to remain in the place of his birth), Demuth was inspired by local imagery, and he regularly juxtaposed the old and the new in his cityscapes. His church spires are recognizable historic markers of a city strongly identified with the Colonial and Federal eras. But his warehouses and factories dated from the mid-nineteenth century, and, although their subject matter referenced modern activities, they too were historic structures whose functional exteriors had changed little from when they were built. The exception was Armstrong, whose site was actively developed and expanded during Demuth's lifetime.

Not only did history amplify his sensibility of the present, for him the past and the present constituted a dynamic continuum whose historical tension invigorated his canvases. Demuth's paintings comprise a visual anthropology of Lancaster through a highly personal perspective. The past confirmed a present that he, like his contemporaries, did not so much discover as invent. Matthew Baigell has observed: "For artists such as Charles Sheeler and Charles Demuth the future had to grow from the past and the past would have to be embedded in the future in complex ways."[5] That Demuth could blend historical buildings and the industrial structures of modern capitalist business in his paintings energizes the vigorous connections between the broad stylistic and thematic categories of modernism, Regionalism, and the American Scene.

Demuth was able to remain in Lancaster in large part because of his mother, Augusta, who was his primary caregiver (fig. 1). His father, who died in 1911 at the age of fifty-four, does not appear to have been a notable presence for him. Augusta is often represented as a formidable individual ("Augusta the Iron-Clad"), and certainly early widowhood and the work of caring for a chronically ill son necessarily set for her a role of strength. William Carlos Williams

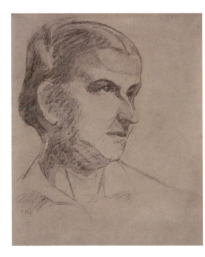

Fig. 1
Charles Demuth (1883–1935)
*Portrait of Augusta B. Demuth (the artist's mother)*, 1906

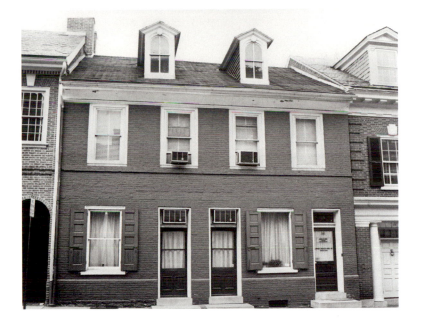

Fig. 2
Demuth House, 118 East King Street,
Lancaster, Pennsylvania

characterized her: "She was a horse of a woman, a strange mother for such a wisp of a man."[6] But others who met her knew a different side. Author Bradford Fuller Swan characterized her as a "gentle old lady, who had been a great beauty in her day," an individual who possessed "perceptiveness and inherent graciousness."[7] Editor and arts patron Emily Clark Balch described her in a 1928 letter to Carl Van Vechten: "His mother is an adorable old lady, tall, dignified, and impressive beyond words. She is quite regally gracious and refers to Charlie always as 'the boy.'"[8]

The anchor for the artist's activity was his family's home (fig. 2), which was, as Marsden Hartley observed, "the solid background of his rich simplicity."[9] Demuth and his mother occupied the plain brick house at 118 East King Street, into which his parents had moved in 1889.[10] Located next to his family's tobacco shop, the house was a comfortably old-fashioned abode; his dealer, Charles Daniel, characterized the residence as "a quaint, charming old house, in a lovely 'American' city."[11] Demuth's friend, critic Henry McBride, recognized that the house and garden served as "a secure retreat" for the artist. McBride had paid several visits to the Demuth home: "Inside, the whole house had been controlled by the sure taste of the artist. The ancient pieces of family furniture consorted amiably with the entirely modern innovations and the whole effect was that of quiet and unforced elegance."[12] He described it in more detail in a 1927 letter: "The Demuth house…in the heart of town, with a narrow entrance (decorated chastely by [Demuth's close

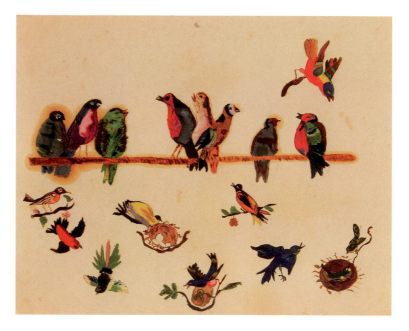

Fig. 3
Watercolor of birds from Demuth's
childhood sketchbook

friend] Bobbie Locher) that opens out into bigger rooms at the back,
which in turn look out on delightful gardens, in which there is a long
brick terrace and many brick walks. The flowers are plentiful and many
of them are family relics that have nothing to do with the fashions of
the day. The house is full of quaint furniture and some amusing works
of art."[13] Hartley's description of the interior was more florid: "It belongs
to the era of shell flowers, wax fruit, painted velvet, bead-encrusted
antimacassars, and the usual complement of horsehair, bell pulls,
opaque glass, silver lustre, and all the lavish profusion of accessory of
such periods."[14]

McBride also noted the "Cubistic patterns"[15] Demuth had
designed for a Queen Anne wingchair. As a child, he was attracted
to the prevailing forms of the decorative arts. He learned the china
decorating techniques popular with Victorian women and painted
flowers on teacups. He also made ornithological studies in his childhood
sketchbooks (fig. 3). His grandmother Caroline and aunt Louisa were
among the many amateur watercolor painters in the region.[16] That
Demuth was adept at this medium in part derives from a strong local
tradition, but one whose discipline he applied to the modernist still life,
a subject that also fascinated other modernists who utilized simplified
and streamlined forms, including Louis Lozowick, Georgia O'Keeffe, and
Charles Sheeler. It was in this environment that the artist worked for
much of his life. The situation permitted a quiet, gently urban country
life, but one with amenities not available had the house been more

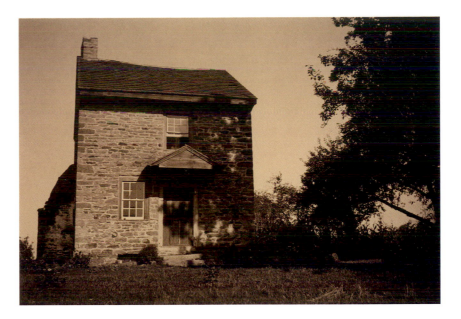

Fig. 4
Charles Sheeler (1883–1965)
*Doylestown House, Exterior View*, ca. 1917

rurally located. Rita Wellman, a fellow student at the Pennsylvania
Academy of the Fine Arts, noted that the house was "not far — but far
enough — from Philadelphia."[17]

Home was a central concern for leading members of the avant-
garde. Demuth was one of several American modernists who gained
strength for their work by creating domestic environments that were
both creative retreats and a means of self-presentation. Demuth's
living circumstances, however, contrasted noticeably with those artists
whose visual language was sympathetic to his, such as his fellow
Pennsylvanian Charles Sheeler. Steeped in both the historical and
present Lancaster, Demuth did not make any special effort to collect
artifacts and antiques as did Sheeler, who rented an eighteenth-
century house in Doylestown from about 1910 to 1926 (fig. 4). Demuth
had no need to construct such an environment as he already resided
in the house that had been in his family since the eighteenth century.
Sheeler's weekend retreat in Bucks County represented "a refuge from
the hectic commercialism of contemporary urban society,"[18] whereas the
Demuth house, located in the busy center of town, was part of the larger
architectural fabric of Lancaster.

Not having to create his environment enabled Demuth to conserve
his energy for his work. It suited him that his domestic setting was
largely maintained by his mother, and he was content to live there with
few changes. For him "a usable present," to invert Van Wyck Brooks'
oft-quoted phrase, was intricately connected to a usable past, which in

Demuth's case was familial. Much of the source of his inspiration derived from nearby sites, most within easy walking distance for a person who did not drive, and several were visible from his own backyard. As Emily Clark Balch observed: "I used to be sorry for him because his health requires him to remain in Lancaster, but I'm not anymore. His house, his garden, and his mother are divine, completely perfect. The garden is a story book place, full of all the flowers he loves to paint, and the steeple of the Moravian church, with statues of four apostles, towers over it. It is like something out of Holland or certain parts of Germany."[19]

## INTERIORS

Demuth's small studio was located on the second story in the back of his family's home (fig. 5). While it is not known exactly how he arranged it, there was little room for furniture, and one assumes it was tidy. Augusta apparently kept his rooms as they were when he occupied them, and her 1943 will indicates what works of art he had in his personal spaces. Hung in his studio were lithographs by Henri de Toulouse-Lautrec (*Mary Hamilton*) and Henri Matisse (*Nude*), a watercolor by Louis Bouché (*The Lovers*), and *Dancing Nudes*, a wash drawing by Matisse. In his bedroom were *Alligator Pears* by Georgia O'Keeffe, a drawing by Pascin, and two etchings by Matisse: *Head of a Woman* and *Head of Young Girl*. He owned four watercolors by John Marin: *Landscape*, *Sunset*, *Boat Number Four*, and *Boat and Sea*. Also in his bedroom was his tempera *Lancaster*. Hartley's *Abstraction* was in the attic when Augusta's inventory was made. McBride recollected having seen photographs by Man Ray of Robert Locher and his wife, Beatrice. The inventory for Augusta's estate does not list furnishings for these two rooms.[20]

There are few extant interior photographs of the house taken during Demuth's lifetime. One includes the artist when he was quite young, slouched in a wicker chair beside an open door (fig. 6). Two framed items are visible in the image, as well as a piece of china, all hung against floral wallpaper above dark wainscoting. The "rich simplicity" described by Hartley can be seen in another view of an unidentified room (fig. 7), and a view of the family parlor presents a more formal presentation of Demuth as a young man seated in a wooden chair (fig. 8). His arms are balanced on either side, and the pages of his book are kept open by two fingers, suggesting a self-consciousness that might also be inferred in

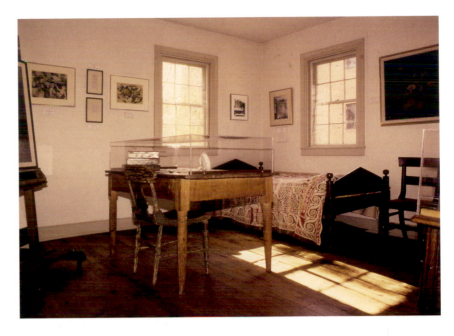

Fig. 5
Demuth Studio, ca. 1994

Fig. 6
Demuth as a young boy in the house on
East King Street

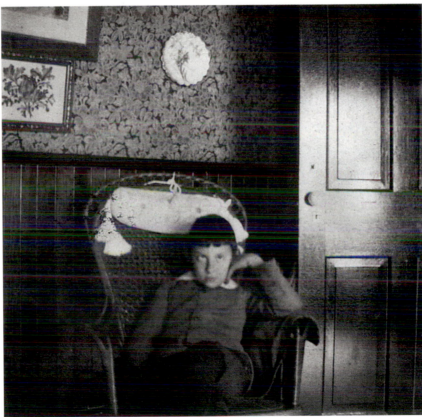

the careful parting of his dark hair. Again, only fragments of frames are visible in the background, all hung on wallpaper of alternating elaborate crests and fleurs-de-lis.

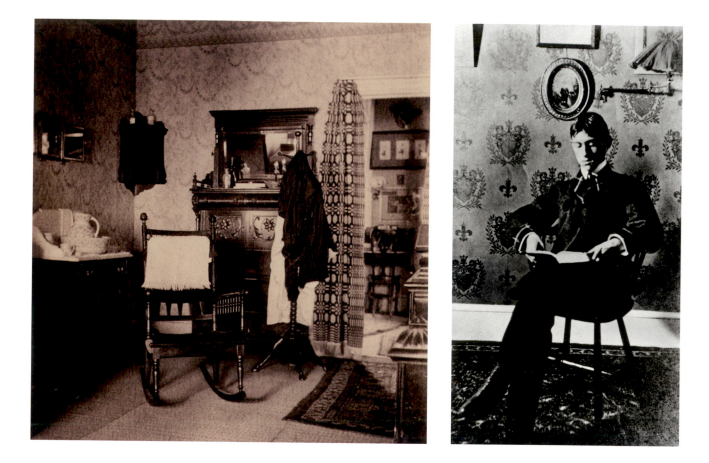

Fig. 7
Interior of Demuth house, before 1917

Fig. 8
Charles Demuth, ca. 1898

A photograph of the dining room, taken at the end of Demuth's life, presents a space that looks rarely used for entertaining (fig. 9). There are no chairs arranged invitingly for guests, suggesting that little convivial social life took place here. The home is certainly no Federal showplace, and the rather random arrangement of objects and furnishings suggests that no particular value was placed on any individual item.

But Demuth occasionally transcended the historicity of his surroundings. As Emily Clark Balch wrote after a summer visit in 1928: "The house is enchantingly Victorian—Demuth has developed that very cleverly, but we had mint juleps in the garden, instead of coffee, and caraway seed cakes."[21] On one July 4, Henry McBride enjoyed a luncheon of turtle soup and champagne, though he commented in a letter: "They drink a good deal in Lancaster but I refrained. I contented myself with the amber colored wine Mrs. Demuth makes."[22] In the end, however, McBride evidently did not restrain himself: "The visit to Charles Demuth was a success, I think, though I am hardly yet (three days after) recovered from it."[23]

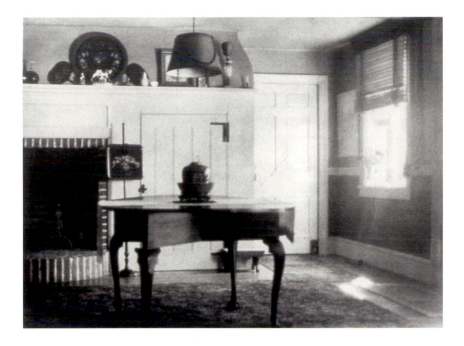

Fig. 9
Dining room, Demuth house, ca. 1934

After Demuth's death, the house remained occupied by his mother until she died eight years later in 1943. "In accordance with the wishes of my deceased son,"[24] Augusta bequeathed the house to his long-time friend, Robert Evans Locher, a talented Art Deco interior decorator and stage set designer. Also a native of Lancaster, Locher was the son of a prosperous banker who had died while the boy was in his teens. Locher and Demuth shared not only the experience of the early deaths of their respective fathers but artistic interests as well. The two had met in 1909 and by 1912 had established the durable relationship that would last until the artist's death; it is not clear if they were ever lovers. Locher would occupy the Demuth house until his own death in 1956.

### EDUCATION AND ARTISTIC EVOLUTION

Learning Centre, Canolfan Dysgu
Coleg Y Cymoedd. Campus Nantgarw Campus
Heol Y Coleg, Parc Nantgarw
CF15 7QY
01443 653655 / 663168

Demuth's earliest education took place in Lancaster, where he graduated from Franklin and Marshall Academy in 1901. He took his first art lessons from local teachers, but for serious art study he went to Philadelphia, first enrolling at the Drexel Institute of Art, Science, and Industry (1903–05) and then at the Pennsylvania Academy of the Fine Arts (1905–10). Both institutions emphasized drawing as a fundamental aspect of their pedagogy; thus, the care Demuth took thereafter with this medium was instilled early. His teachers at the academy, most of whom were progressive, included Thomas Anshutz, Hugh Breckenridge,

William Merritt Chase, and Henry McCarter. It was at the academy that he made his exhibition debut in 1907. A photograph taken of him about 1905 shows his characteristic careful manner of dress and serious expression (fig. 10).

Demuth's first childhood watercolors were made about 1896, but his earliest mature works date from a decade later. Typical is his *Self-Portrait*, which reflects the strong impact of Chase in its realistic treatment, dark coloration, and visible brushwork (fig. 11). Demuth's palette gradually lightened, though, and visits to nearby summer locales popular with the Pennsylvania Impressionists — New Hope, Pennsylvania, and Lambertville, New Jersey — brought Impressionism to bear on his emerging style.

Around 1915 Demuth began a series of watercolors inspired by vaudeville themes, entertainments he could view both in New York and in Lancaster. He took considerable anatomical liberties with his figures; in their bright colors, deft lines, luminous washes, and fluid movement, these works recall the spirit of Edgar Degas, Henri Matisse, Auguste Rodin, and Henri de Toulouse-Lautrec. Typical is *Three Acrobats*, whose trio of figures float effortlessly between their trapezes (fig. 12). Chronologically and stylistically related to his vaudeville works is a series of watercolor illustrations. Produced between 1915 and 1919, they were inspired by the works of Henry James, Edgar Allan Poe, Franz Wedekind, and Émile Zola.

The years 1915 to 1919 were a period of great thematic and stylistic change for the artist, and it was during this time that he began to paint the still lifes of flowers, fruits, and vegetables that would remain favorite

Fig. 10
Charles Demuth, ca. 1905

Fig. 11
Charles Demuth
*Self-Portrait*, 1907

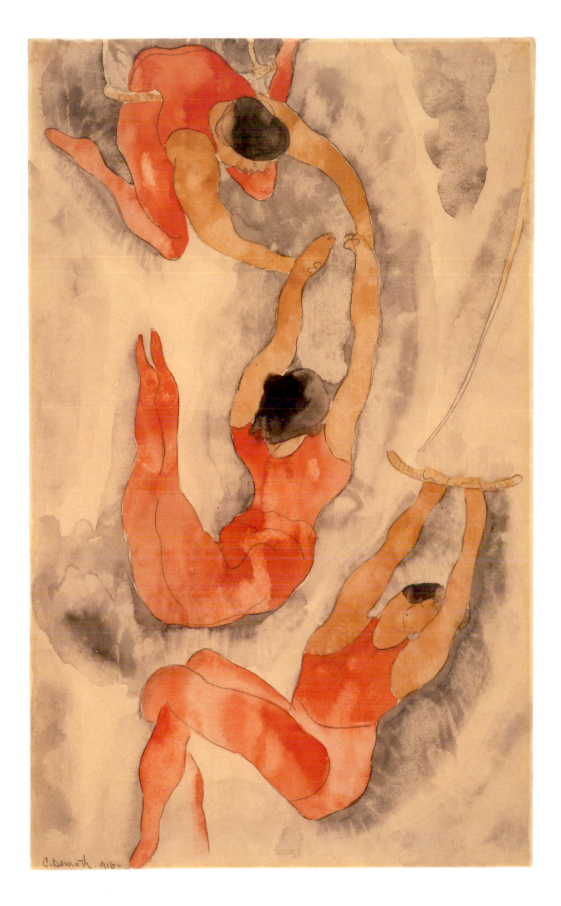

Fig. 12
Charles Demuth
*Three Acrobats*, 1916

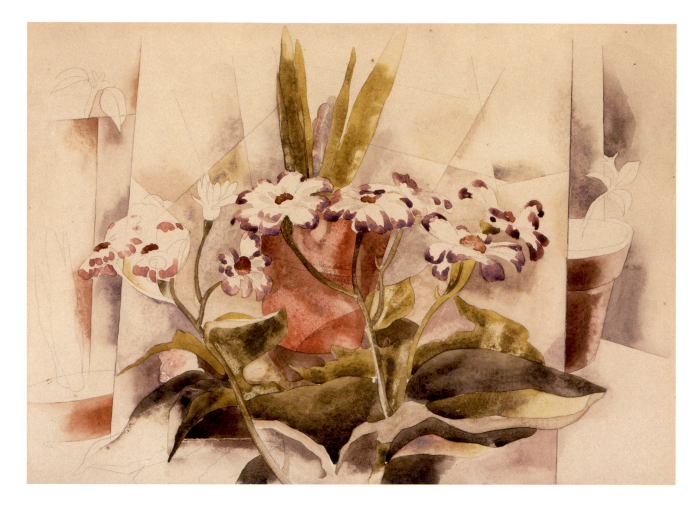

Fig. 13
Charles Demuth
*Cineraria*, 1923

subjects for the rest of his career (and popular with collectors and critics). Like his architectural works, these represented distinctly local subject matter. The gorgeous flowers that were the subject of so many still-life paintings were picked from the garden he and his mother maintained together. Augusta recalled: "I used to come in from the garden in the morning, with my arms full of flowers. And Charles would meet me at the door and say: 'Give them to me.' And he would rush upstairs to his room and paint them."[25] Some of Demuth's floral studies, like *Cineraria* (fig. 13), show several plants contained in pots, whereas in others he depicted cut flowers arranged in elaborate bouquets. Both Demuth and his mother enjoyed gardening, and the plain brick facade of their home belied the beds of lush plantings in the back, which the artist could view from his studio window. Common perennials and annuals flourished in the garden, though more exotic plants could also be grown. In one photograph, young Charles is dwarfed by lotus leaves and blossoms (fig. 14). In another view Demuth, having paused from reading

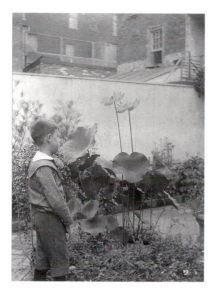

Fig. 14
Charles Demuth as a boy in the family garden, ca. 1891

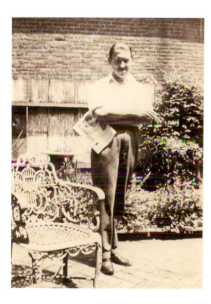

Fig. 15
Demuth in the family garden, 1928

his newspaper, stands before a flourishing backdrop of blossoms (fig. 15). Areas not planted were bricked, the lushly growing plants contrasting with the formality of the rest of the backyard. As critic Henry McBride observed: "The proper place for a Demuth flower, I sometimes think, is in the hands of an educated gardener — one who knows what a flower is and what an artist is."[26]

From his Lancaster base, Demuth gradually established a broad spectrum of relationships that sustained his spirit during a period when modernist styles were contentious issues. His circle of close friends and acquaintances comprised a disparate social landscape of overlapping groups and individuals, and his interactions with them were governed by an inner compass set to cardinal points of personal and geographical mandates. Hartley valued these qualities, observing that "Charles had a good time being himself."[27] These friendships encompassed the places he lived and visited, the personal choices he made, the patrons who purchased his work, the imagery he chose to portray, and even the state of his health; indeed, without the support of Albert C. Barnes, Demuth would not have lived to make the paintings that are the focus of this essay.

As his physical condition steadily worsened throughout the 1920s and early 1930s, Demuth's connections to several individuals, maintained primarily through letters as he was often too sick to travel, gave him the physical stamina and mental fortitude to go on as an artist, a strength that culminates in the late architectural paintings. The production of these works was an intense effort for him and reinforces the idea of place that is central to understanding the works. Unlike most artists, money was never Demuth's primary worry; rather, it was the serious disease for which treatment during his time was experimental and results unpredictable. Despite his illness, however, Demuth was a key player in the lively intellectual and artistic milieu of the first quarter of the twentieth century.

Portraits made of the artist reference the breadth of his professional and social connections over the course of his career, and they serve as a visual counterpoint to the many conversations he shared with his friends and associates. Along with his correspondence, these works provide an interesting analogue to the events of his life. The core of his friendship network was with the members of the American avant-garde, a group that defined itself in a period of vigorous discovery as American artists embraced modernist styles in the heady cultural environments

of New York, Paris, and Berlin. Their enthusiasms were nourished and sustained by a series of fluid personal attachments, connections that resonated long after their initial intensity had waned.

Articulate and perceptive critics, including Henry McBride, Paul Rosenfeld, and Carl Van Vechten, were early admirers of Demuth's work. His paintings were purchased by adventurous collectors, notably Louise and Walter Conrad Arensberg, Albert C. Barnes, Arthur Jerome Eddy, Albert E. Gallatin, Ferdinand Howald, Duncan Phillips, Carroll Tyson, Samuel S. and Vera White, and Gertrude Vanderbilt Whitney. Other paintings were presented as gifts to his friends. Artists Arthur B. Davies, Muriel Draper, Robert Laurent, George L. K. Morris, Sarah Choate Sears, and Florine Stettheimer owned his work, as did several connected with literature — George Cram Cook, Susan Glaspell, Agnes Boulton O'Neill, Carl Van Vechten, and William Carlos Williams.

As part of the first generation of American modernists, Demuth was part of a group that has tended to be heroized in scholarly literature, especially in terms of formalistic development and aesthetic adventurousness. But definitions of modernism then and now were fluid, and its practitioners participated in multiple and overlapping modernisms. As Allan Antliff has persuasively argued, to define them only stylistically creates artificial and limiting polarities of abstraction and realism.[28] Further, such an intellectual compartmentalization fails to address the richness of experimental ferment that was characteristic of the period.

The boundaries of the circles in which Demuth moved were highly porous and the codes of discourse permeable within and between them. A combination of personal reticence, residence, and health meant the artist maintained a certain distance and personal reserve. That he was gay imposed upon him an adversarial stance even within the liberalities of his own circle. His naturally private nature was further reinforced by societal attitudes toward homosexuality. Most who eschewed intellectual restriction and who embraced the most modern modes of aesthetic production were heterosexual and, as a result, were less comfortable with those who transgressed traditional sexual roles. Modernism was easier to accept in the concrete form of a work of art, but some of its social tenets were more discomfiting when they became personal.

If Lancaster was the anchor of Demuth's inner world, connections
to the avant-garde moored his outer one. He was one of the first
American artists to be receptive to European modernism, to which he
was exposed in New York and, in a more intensive manner, through
three sojourns abroad. In 1907, Demuth made his first trip to France,
spending about six months in Paris, returning home in March 1908.
Most transformative for his development as an artist was his second
visit to the French capital, where he remained from December 1912
until the spring of 1914, pursuing classes at the Moderne, Colarossi, and
Julian Académies, progressive ateliers popular with an international
array of art students. This period marks his most extended contact with
European modernism, including the adventurous coloration of the Post-
Impressionists, as well as work by the Fauves and Cubists. While abroad
he painted little, but was stimulated by the many interesting individuals
he encountered, including sculptor Jo Davidson, American artist
Marsden Hartley, poet Ezra Pound, German sculptor and printmaker
Arnold Rönnebeck, and Gertrude Stein (whose famous salon he visited).

The impact of his second Parisian trip would not be felt for several
years. His first serious exploration of Cubism is a series of landscapes
and architectural views painted in Bermuda in February and March
1917. His companions there were Hartley and the French painter Albert
Gleizes. The late work of Paul Cézanne also emerged as a significant
influence during this period, seen particularly in a series of architectural
watercolors inspired by the buildings Demuth saw there. One, purchased
by Albert Barnes in 1922, *Bermuda: Stairway* (fig. 16), conveys the
visual character that intrigued him in the Caribbean. Unlike his later
Lancaster views, these works abstracted the visual essence of the
shapes and colors of the houses, chimneys, and trees he saw in Bermuda,
presenting geometrically architectonic forms overlaid with fluid washes
rather than recording recognizable buildings. Important predecessors to
his Precisionist works, the structures he saw there—whose plain, clean
lines resonated with visual memories of the orderly brick buildings of
home—clearly engaged him.

It was Hartley who introduced Demuth to Rönnebeck at Gertrude
Stein's apartment at 27 Rue de Fleurus, and it was in Paris during the
winter of 1913–14 that Rönnebeck executed a bust (now lost) of his new
friend. A remarkable series of photographs documents Demuth's visit to

Fig. 16
Charles Demuth
*Bermuda: Stairway*, 1917

his studio. In one, he gestures animatedly, eyes upward (fig. 17). Dapper, wearing a suit and vest with a jaunty bow tie, his shiny hair carefully combed back and moustache neatly trimmed, Demuth was meticulous about his dress and appearance. The typical accoutrements of a young artist's studio are everywhere apparent—inexpensive cotton hangings, patterned rugs, assorted sculptures—all designed to make a temporary space more personal and comfortable, but that also could be efficiently dismantled. Another photograph records him with his head in full profile (fig. 18).

What is remarkable about these photographs is the vividness with which they capture Demuth's physical features and characteristic gestures, conveying an image of health and energy. His self-presentation is to a good friend with whom he feels comfortably at ease. These are simply snapshots, with their subject very much aware of the camera. But they convey the sartorial dandiness and insouciant liveliness that Demuth's friends found so engaging. These were the qualities William Carlos Williams recollected in his autobiography: "He had an evasive way of looking aslant at the ground or up at the ceiling when addressing you, followed by short, intense looks of inquiry."[29]

The photographs likely aided Rönnebeck as he completed his white plaster bust of Demuth. The plaster, later published in *The Dial* in September 1925, captures the serious intensity of his American friend (fig. 19). The Cubist planes of Demuth's angular face provided an

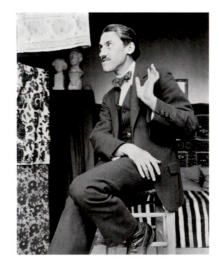

Fig. 17
Arnold Rönnebeck (1885–1947)
*Charles Demuth*, Paris, 1913

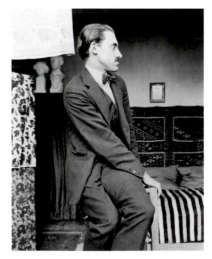

Fig. 18
Arnold Rönnebeck
*Charles Demuth*, Paris, 1913

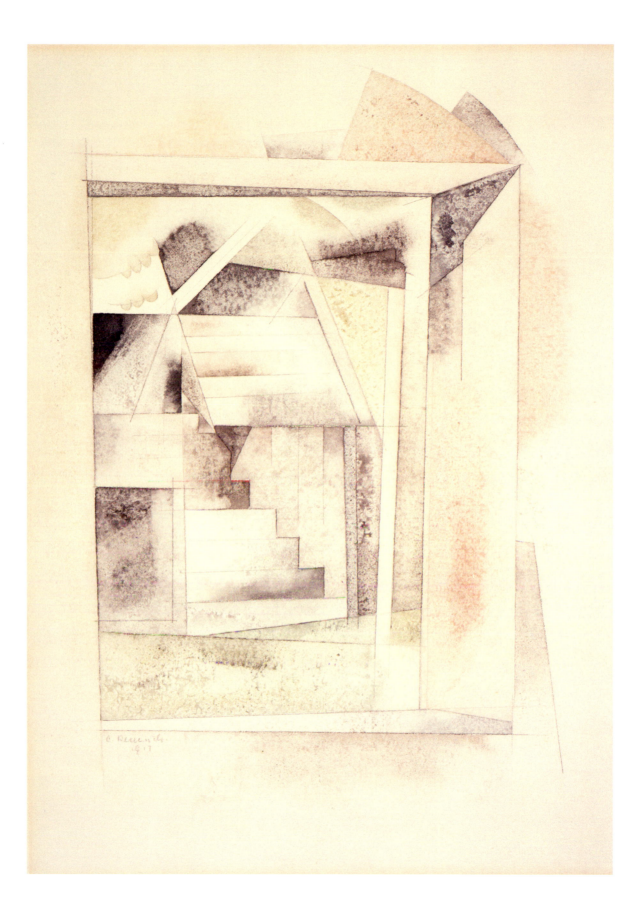

Fig. 19
Arnold Rönnebeck
*Charles Demuth*, 1913

Fig. 20
Arnold Rönnebeck
*Georgia O'Keeffe*, ca. 1924

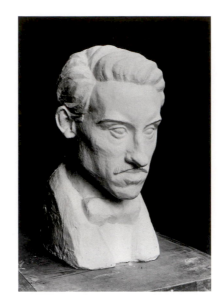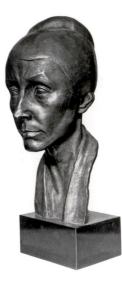

excellent subject for a modernist sculptor. The effect is starkly formal, and in the sculpture his hair is fuller than in the photographs, the bags under his eyes more pronounced. Demuth was thirty-one, on his second trip abroad, and on the verge of his mature work. It would be only another six or seven years before the effects of his illness would begin eroding his body and sapping his energy.

Demuth and Rönnebeck shared both a sense of youthful possibility and a deep interest in modernism. In part because of his contact with Demuth and Hartley, Rönnebeck eventually decided to leave Germany for America in 1923, and he moved to New York in the fall of 1924. Stieglitz had already shown his work at his gallery 291 (1914) and soon drew him into his circle. Rönnebeck, who later became director of the Denver Art Museum, executed a number of busts of members of the Stieglitz group, including several of Hartley. He created one of Georgia O'Keeffe as well, after he had visited her at Lake George during the summer of 1924 (fig. 20).

Demuth's friends were broadly eclectic and represented the overlapping modernist groups in New York. Conveniently accessible by train from Lancaster, the city was the center of the American avant-garde. During Demuth's regular visits, he associated with the most advanced artistic and literary circles, participating in a lively bohemian life and gay subculture based in Greenwich Village. Sometimes he would stay at one of two popular neighborhood hotels, either the Brevoort or the Lafayette, and during the winter of 1915–16 he rented a studio apartment on Washington Square. His closest alliances were with the coterie who first gathered around photographer Alfred Stieglitz at his gallery 291, the renowned center of American modernism.

It was in the fall of 1914, after his return from Europe, that Demuth first became friends with Stieglitz, though he had visited the gallery by 1909. Demuth's first surviving letter to Stieglitz was written in April 1916, and the two thereafter maintained a regular correspondence. The warmth of their exchanges is evident.[30] Demuth exhibited at the Anderson Galleries in 1925, as part of *Alfred Stieglitz Presents Seven Americans*, and later at Stieglitz's The Intimate Gallery, where he had a series of solo shows. When Stieglitz opened his gallery An American Place in 1929, Demuth was included in group shows and had a solo exhibition there in 1931.

Despite his admiration for Stieglitz, Demuth was one of several figures who remained clustered at the edges of the group, falling just shy of the photographer's full support. He established intense lifelong friendships with Hartley and O'Keeffe, but his active social life extended well beyond the confines of Stieglitz's orbit. Perhaps the photographer-dealer desired a more single-minded loyalty, but Demuth nonetheless was devoted to him, valuing his opinion as much as that of any other colleague.

Demuth also met French artist Marcel Duchamp, along with many other Dadaists who gathered at the apartment of Walter and Louise Arensberg. Less domineering than Stieglitz, the Arensbergs were collectors of art and artists and provided a significant point of contact between American and European modernists. Demuth was also part of painter Florine Stettheimer's salon, and he appears in a number of her works. He was one of the many artists, poets, dancers, musicians, writers, and intellectuals who attended her evening soirées, formal

dinners, and summer picnics. In her 1928 *Portrait of Alfred Stieglitz*, the photographer, clad in his trademark black cape, stands in the middle of his gallery (fig. 21). Two visitors enter, one from the right, the other from the left, but all that is visible of each is one hand, a single shoe, a bit of sock, and the very bottom of their pants legs. Both are clearly fashion conscious individuals. The one with a cane and wearing gloves is Demuth. The man entering at the right with the ermine-cuffed hand is photographer Baron de Meyer, for whose firm Robert Locher worked for a time. That both are shown fragmentarily reflects, as Jonathan Weinberg has astutely observed, "that neither artist was a permanent member of Stieglitz's stable."[31] Arthur Dove is present, and the names of other artists are inscribed throughout the scene, including Marsden Hartley, John Marin, Georgia O'Keeffe, and Paul Strand. Together, by name or actual presence, these comprise Stieglitz's "Seven Americans."

In one of Stettheimer's most decoratively diva paintings, *Love Flight of a Pink Candy Heart*, Demuth, holding his sketch pad, lounges

Fig. 21
Florine Stettheimer (1871–1944)
*Portrait of Alfred Stieglitz*, 1928

Fig. 22
Florine Stettheimer
*Love Flight of a Pink Candy Heart*, 1930

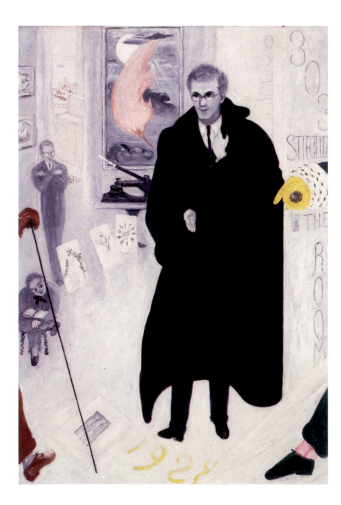

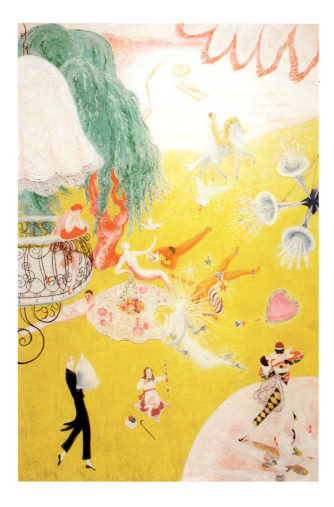

with other revelers in the center, participating in an elaborate picnic (fig. 22). Described as "looking uncharacteristically virile and fit,"[32] Demuth is stretched out on a bright yellow ground; the atmosphere is festive, and the artist herself surveys the scene from her canopied balcony. Stettheimer enjoyed Demuth's company, and at his death she sadly noted in her diary: "Demuth I shall miss. He was somebody to look forward to seeing."[33]

Stettheimer was a friend of Muriel Draper (art and literary hostess and the owner of Demuth's *Buildings*; pl. 4), whom she invited to the parties she and her sisters hosted at Alwyn Court, and there was considerable overlap in their respective salons (fig. 23). The painter included Draper as part of the multitude pictured in *Cathedrals of Fifth Avenue* (fig. 24). Dressed in bright red, she stands near Demuth, with her elbow resting on the shoulder of her friend Max Ewing, who would portray her in his 1933 novel *Going Somewhere*.

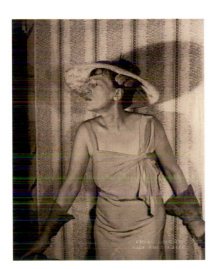

Fig. 23
Carl Van Vechten (1880–1964)
*Muriel Draper*, 1934

Fig. 24
Florine Stettheimer
*Cathedrals of Fifth Avenue*, 1931

Draper's friends represented an international cross section of artists, writers, and musicians whom she encountered on both sides of the Atlantic. A strong personality and gifted conversationalist, she provided a vital link between some of the leading cultural figures of her era. Included were several Demuth knew as well — Robert Edmond Jones, Lincoln Kirstein, Robert Locher, Mina Loy, Mabel Dodge Luhan, Henry McBride, and Carl Van Vechten.

To Demuth and others, Draper exemplified the liveliness of New York. She was the center of a musical salon in London (1911–15) and one in New York during the late 1920s and 1930s. Her experiences at Mabel Dodge's Villa Curonia were recorded in a word portrait by another visitor, Gertrude Stein. Establishing herself in New York, Draper filled the void left by Dodge's departure for the Southwest in 1917. Her gatherings were lively, and her guests cared little for social conventions. Draper's closest friends were gay men, and she relished bringing together smart, talented, and imaginative people. Draper also pursued a career as an interior decorator for a number of years after her return from Europe. She and Locher worked with decorator Paul Chalfin on James Deering's grand villa, "Vizcaya," overlooking Biscayne Bay in Miami. Chalfin appears in Florine Stettheimer's *Sunday Afternoon in the Country* (1917).

Although Draper only wrote occasionally on the visual arts in her publications, she admired an eclectic range of artists. While she did not respond well to O'Keeffe's work, observing sharply that she "pursues her sensuous surgery with passionless penetration,"[34] for Demuth she had only high praise, finding him "in a class by himself. Breathless white calla lilies, jaunty dancing sailors, portrait posters of fellow artists, puffing Paris river boats and serene still lifes are all painting to his brush. Uncanny flexibility of technique, penetrating emotional insight and sudden poignant flashes of things unknown are qualities that do not strain the delicate medium he works in, but are perfectly suited to it."[35]

Draper admired Robert Locher, too (fig. 25), whom she characterized as "that rare thing, a painter who conceives his work as primarily decorative and to be incorporated as such in the building or a room."[36] It may have been her 1931 article on Locher in *Creative Art* that led to her acquisition of Demuth's *Buildings* (pl. 4), which she owned by 1932. It was likely a gift as she certainly could not have afforded to buy it. She was close enough to Demuth during this period that in 1929 he wrote to Stieglitz about a fine watercolor he had just finished: "I'd like to give it

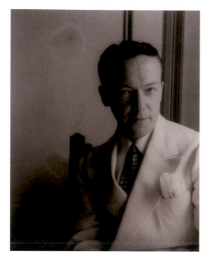

Fig. 25
Carl Van Vechten
*Robert Locher*, 1937

away—if I were really rich—to Georgia, or Robert, or Muriel, all having seemed enthusiastic about it."[37]

The neighborhood bars and restaurants Demuth frequented in the city were those popular among the adventurous artists and writers of the period and included the Purple Pup, Romany Marie's, and the Golden Swan at the corner of Fourth Street and Sixth Avenue (whose back room was colorfully known as "the Hell Hole"). Other favorite destinations were located in the black bohemia of midtown Manhattan; Demuth enjoyed the African-American cabaret in the basement of the Marshall Hotel on West Fifty-third Street at Sixth Avenue. Barron Wilkins' Little Savoy was located on West Thirty-fifth Street (it moved to Harlem about 1920). Jazz culture in Harlem also fascinated him, as it did so many of his contemporaries. The watercolors inspired by his visits to such establishments document him in the company of Marcel Duchamp, painter Edward Fisk, Carl Van Vechten, and William Carlos Williams.

The spirit of Demuth's Greenwich Village social life is captured in a 1917 watercolor by Beatrice Wood (fig. 26). The work records the aftermath of the Blindman's Ball, held at Webster Hall in late May to celebrate the now-famous Society of Independent Artists' exhibition, the show in which Duchamp's absent *Fountain* created such a scandal. Demuth's poem, inspired by the legendary readymade sculpture, had appeared in the 1917 issue of *Blind Man*, published in honor of the work by the pseudonymous R. Mutt. Wood recalled that the costume party, featuring all-night dancing, was "a riotous affair" and was attended by the "whole art world."[38] The occupants of the bed are identified in the drawing she made the next day as poet Mina Loy, Demuth, actress Arleen Dresser, Duchamp, and Wood. After partaking of a 3:00 a.m. breakfast consisting of scrambled eggs and wine at the Arensbergs, Duchamp returned to his apartment after 6:00 a.m., accompanied by his four tired friends so they could get some sleep; the five arranged themselves on his bed "like a collection of worn-out dolls."[39] Loy was at the bottom, with Dresser against her and Duchamp pressed into the wall. Wood squeezed in next to him. Demuth, she recalled, "lost no time

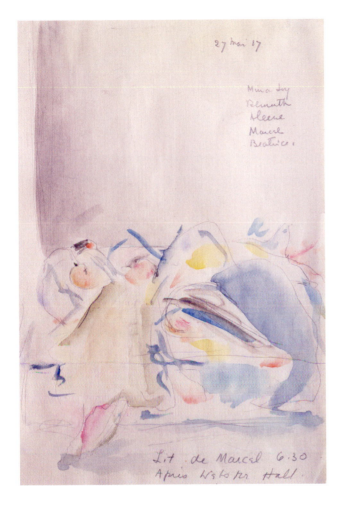

Fig. 26
Beatrice Wood (1893–1998)
*Lit de Marcel*, 1917

in draping himself horizontally at right angles to the women, with one leg dangling to the floor, a trouser tugged up revealing a garter."[40]

A lively gay culture flourished in Greenwich Village, and Demuth found its social freedom liberating. The Lafayette Baths, a favored destination for gay men, was located south of Cooper Square not far from the Brevoort, where Demuth sometimes stayed. His participation in the many pleasures offered by a social life at once surprisingly open, yet necessarily coded and masked, may be seen in a series of works featuring openly homosexual themes, including *Dancing Sailors* (1918) and a remarkable nude self-portrait, *Turkish Bath* (1918).

MacDougal Street was the dynamic center of Greenwich Village intellectual life. Demuth was involved in the Liberal Club, whose motto declared it "A Meeting Place for Those Interested in New Ideas."[41] Its activities reflected the broad interests of its membership, ranging from purely social events to more intellectual offerings like poetry readings and lectures (the Washington Square Bookstore was in the same building). Paintings by Demuth and Hartley were exhibited there, and Polly Holladay and her anarchist friend Hippolyte Havel operated a restaurant in the basement. Another eatery, run by Christine Ell with her brother Louis, was located next door. These venues attracted writers and artists, as well as political activists, anarchists, and socialists. The theater was a strong interest of many club members, and a good proportion became involved with the Provincetown Players, as well as with the Washington Square Players, for whom Robert Locher designed sets.

The social and artistic relationships Demuth established in the city often continued during vacations. During the hot summer months, New Yorkers who could afford to do so left the city for the country, seeking inexpensive vacations in cooler locales. Coastal areas were popular, and the fluid spirit characteristic of their urban relations extended to lengthy summer sojourns that were relaxed and informal. Visits to Provincetown and Gloucester on the Atlantic Coast of Massachusetts throughout the teens reinforced connections previously made in New York.

Following his return from his second trip to Europe, Demuth began spending parts of his summers in Provincetown, a destination favored by the more adventurous artists. Those in residence in the Massachusetts village included Louise Bryant, Hutchins Hapgood, Hippolyte Havel,

Robert Edmond Jones, John Reed, Carl Sprinchorn, Mary Heaton Vorse, and William and Marguerite Zorach. During the summers of 1914 to 1916, Demuth shared a beach cottage with painter Edward Fisk, whom he had met in Paris.[42] One snapshot from the Fisk family papers shows Demuth in the company of Helene Iungerich and Stuart Davis (fig. 27). Gazing intently at the camera in a second photograph are Demuth on the beach with Marsden Hartley, Louise Bryant, and Eugene O'Neill (fig. 28). Together, the group acted in plays and painted sets for the Provincetown Players, the legendary theater group founded by George Cram Cook and Susan Glaspell in 1915. It was a time characterized by Hartley as "that remarkable and never repeated summer."[43]

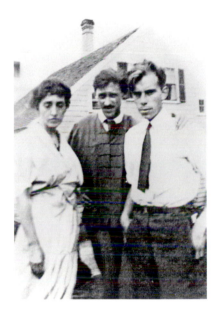

Fig. 27
Edward Fisk (1886–1944)
*Helene Iungerich, Charles Demuth,*
*and Stuart Davis in Provincetown,*
*Massachusetts,* 1914

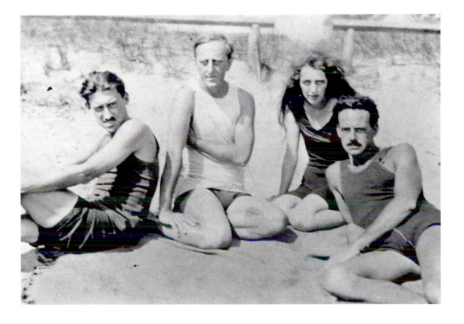

Fig. 28
Edward Fisk
*Charles Demuth, Marsden Hartley, Louise Bryant, and Eugene O'Neill on the beach in*
*Provincetown, Massachusetts,* 1916

The New York cultural milieu naturally contrasted with the quiet of Demuth's residence in Pennsylvania, though not necessarily negatively. Demuth regularly referred to Lancaster as "the province," his affectionate and ironic term for his hometown. The word did not simply signify "provincial" to the artist, but it was one way Demuth could position his vantage on the world both when he was at home and when he traveled. *In the Province* is the title he gave to three works dating from 1920, about the time he commenced his first series of architectural paintings of Lancaster. [44] Two picture actual sites — one is a view of a church steeple (fig. 29); the other (which is also called *Lancaster*), depicts the Lorillard factory located several blocks from his house (fig. 30). A third (also called *Roofs*), is a more generic rendition of the upper stories of typical Lancaster residential structures (fig. 31). Another view of Lancaster, *From the Garden of the Château*, conveys the irony of a putative aristocratic country seat in this rural red brick city surrounded by well-kept farms (fig. 32).

Demuth made reference to "the province" with some regularity in his correspondence. For instance, to Agnes and Eugene O'Neill, he wrote:

*You see, dearies, I'm back in the province in the garden of my own chateau, — where I'll be for the remaining days of the season. The quiet and yellow velvet old age which I always predicted for myself has started: oh, yes my health is much more advanced than any of my contemporaries! I hope, dear Agie, you are still thin. You are about the only one I could at the moment appear with....* [45]

He had written to John Reed probably during the fall of 1916 regarding the Provincetown Players, a group in which he was a participant:

*You might tell said meeting that I will be in my province until November 10th or 15th. After all there is no place like one's own home for a slow season; the only possible place for a complete 'get away' from the 'drama' (in America) and artists of all kinds!* [46]

He found quiet and sanctuary in Lancaster, a useful thing for a private artist who needed to carefully shepherd his physical resources.

But the fastness of Lancaster — his "home" or "native" province — could be oppressive as well. [47] As he observed in 1919: "I must have a drink on some street corner of the world soon, — or bust." [48] When he

chafed at the restrictions his health imposed on him in preventing him from visiting Europe or New York, he complained: "The provinces are overpowering."[49] The province could be both a source of strength and frustration, though he was as rooted in Lancaster as Johannes Vermeer had been in seventeenth-century Delft, as Paul Rosenfeld observed in 1931:

*Indeed, many of the freshest, most original perceptions of the chance beauties of wharves, grain-elevators, chimneys, office-building rears and fronts, are to be found in the aristocratic company of his paintings, with their Vermeer-like surfaces.*[50]

Both worked in neat, orderly environments of red-brick buildings. Their painting methods were also precise and deliberate, and the views they produced are readily identifiable with the specific place of their creation.

Demuth deepened his perspective on his hometown whenever he was away. As was the case with many travelers, being abroad made him thoughtful about national identity, especially the contrasts he noted between Europe and America. His statements often reveal an anxiousness about where to situate himself personally and aesthetically, as he observed in a letter he wrote to Stieglitz from London in August 1921 during what turned out to be his final trip abroad:

*I wonder if it will ever happen in the land of the free? — or is it happening? I never knew Europe was so wonderful, and never knew really — not so surely — that New York, if not the country, has something not found here. It makes me feel almost like running back and doing something about it, — but what does that come to? So few understand love and work; I think if a few do we may not have lived entirely without point. …It is more difficult in America to work, — perhaps that will add a quality.*[51]

These comments are echoed in another letter he wrote about the same time to collector Albert C. Barnes a few days before he left for Paris: "More than ever do I feel how hard it is to work in the U.S. I'm sure it is easier here. Perhaps just this lack of, or, the desire for, a, call it, background will in the end produce an American Art."[52] The lively art atmosphere of Paris exhilarated him, as he declared to Barnes: "Will probably stay on as you suggest. I would love to, — have never loved it so before. And our dear country is cold to ideas. I feel, however, that I will always come back to it, — maybe only because it is too late to stay

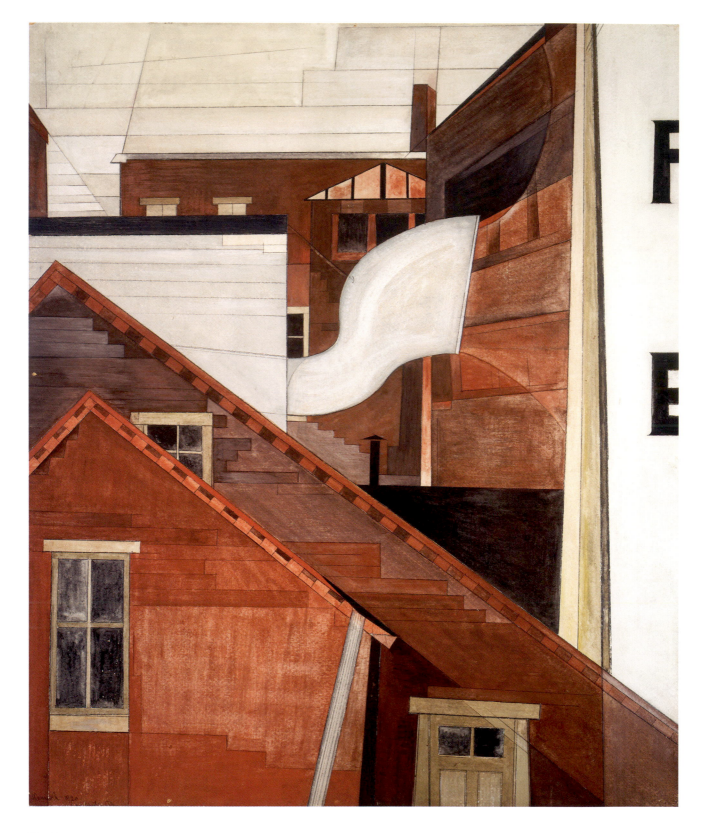

Fig. 31
Charles Demuth
*In the Province (Roofs)*, 1920

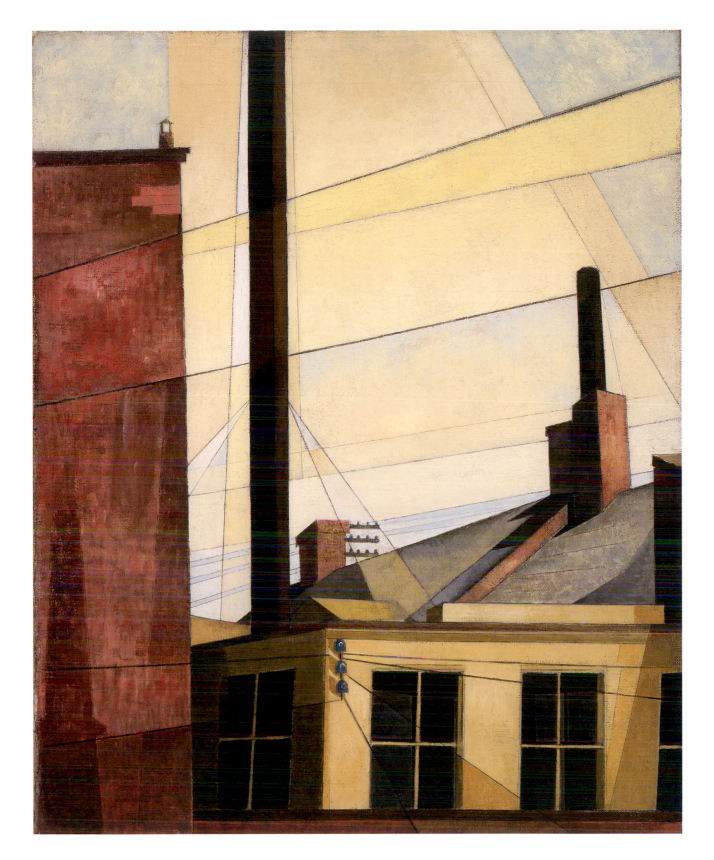

Fig. 32
Charles Demuth
*From the Garden of the Château*, 1921 (reworked 1925)

Fig. 33
Alfred Stieglitz (1864–1946)
*Charles Demuth*, 1915

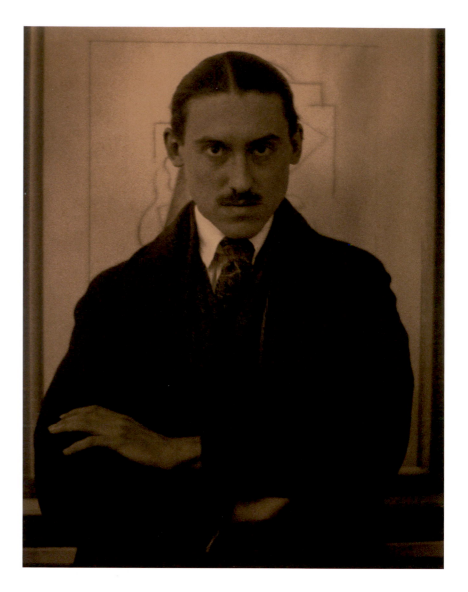

away."[53] To William Carlos Williams he confided regretfully: "Paris is more wonderful than ever, — but I must hurry back to Lancaster and work. I'm too old to stay."[54]

For reasons of both health and personal inclination, expatriation was not something Demuth ever seriously considered, even had his funds permitted it.[55] Certainly he could become frustrated back in the United States, and not just in Lancaster, as he complained sharply to Henry McBride: "In New York, so few get it."[56] To Stieglitz he confessed after his return from Paris to Lancaster: "It was all very wonderful, — but I must work, here."[57] Continuing in this vein, he vowed: "What work I will do will be done here terrible as it is to work in this 'our land of the free.' …Together we will add to the American scene."[58] It is interesting

how common, even patriotic, fragments or phrases appear as emblematic signifiers in the letters he wrote to his friends. From Europe, he reported his ambivalence to Barnes as well: "I think really I could stay on forever, —maybe not. I suppose if I do anything it must be done in America. But certainly one can understand what kept James from being able to live in Boston after some years here. [It] all seems too difficult, hard, unsympathetic. Still, —there does at times seem to be something doing at home."[59]

Where there was always "something doing" was New York City. On a trip there in 1915, he visited Stieglitz at 291 and posed for his portrait (fig. 33). The composition is a strong one, and Demuth stares directly at the viewer, standing in front of a large drawing by Picasso.[60] The intensity of his expression is startling, and one can only imagine what the two had been talking about. The artist appears vital and engaged. He had returned from his second trip to Europe the previous spring and had recently concluded his first solo show at the Daniel Gallery in the late fall. Eight years hence, Stieglitz's photographs of Demuth would convey a man much changed.

### DR. ALBERT COOMBS BARNES

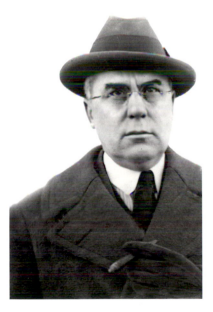

Fig. 34
Dr. Albert Coombs Barnes

Demuth's most significant patron was Dr. Albert Coombs Barnes (1872–1951), who lived on the Philadelphia Main Line in Merion (fig. 34). Beginning with his purchase of a Corot in the first decade of the twentieth century, his extensive collection of modern art by 1928 numbered over 1,000 paintings. Justly famous for his purchases of European Impressionist, Post-Impressionist, and modernist paintings, Barnes also collected American artists, favoring William Glackens, Ernest Lawson, Alfred Maurer, Maurice Prendergast, and Demuth.

Barnes once owned fifty works by Demuth, and his holdings comprised the largest single collection of the artist's paintings. "You ought to be about as well represented in the new gallery as anybody," he observed to the artist in 1922. "In fact I have so many of yours I think I will have to give you a special room."[61] Others who had a significant number of his works possessed far fewer than Barnes. Of Ferdinand Howald's 200 modernist works, twenty-eight were by Demuth, and Samuel and Vera White owned nine watercolors. Although little seen by the public, Barnes' collection of Demuth's work included some of the

artist's best, and the collector encouraged others to buy his paintings as well.

Barnes' prickly relations with the Philadelphia and New York art establishments were extensively reported in contemporary newspapers at the time, though not always accurately. Barnes enjoyed living with his collection and regarded it as essential to the teaching mission of his foundation, but he did occasionally lend pieces for exhibition during his lifetime, as he did when he sent seventy-five paintings to be shown at the Pennsylvania Academy of the Fine Arts in 1923. Unfortunately, the display received negative press, an experience that contributed to his deep resentment of Philadelphia's museums and cultural arbiters.

But there was another, more private, side of Barnes that few outsiders knew. Next to William Glackens, whom Barnes had known since they were fellow students at Central High School in Philadelphia, one of his most sustained art friendships was with Demuth.[62] The artist was certainly aware of the character traits of his friend, a contentious man of strongly held opinions, often forcefully expressed. Demuth kept abreast of his skirmishes with the press, for instance approving of Barnes' defense of an exhibition of modernist painting at the Metropolitan Museum in New York. He wrote Barnes from Paris: "We all think that the rumpus must have been grand, and that you came out on top."[63] He reported to Stieglitz in March 1931: "Barnes has been going wild in Philadelphia, I hear — will tell you all those pretty details when I see you."[64] But the artist's tact and admiration for his friend apparently kept them from ever quarreling. As Demuth reported to his mother in October 1921: "I write to Barnes quite often. I'll be nice to him, — I like him and he has been nice to me."[65]

It was Glackens who introduced Barnes to Demuth, and Demuth deeply appreciated his connection with the collector, who regularly invited him to visit his home in Merion. From time to time Barnes and his wife, Laura, also drove to visit Demuth and his mother in Lancaster, where they enjoyed exploring the area's many antique shops. Demuth sometimes advised them on the purchase of objects he had spotted during his travels throughout the county. They shared other intellectual interests as well, sending books back and forth. During the spring of 1921, Barnes proposed that Demuth and his mother come live in the Merion house while he and Laura were abroad for six weeks. But Augusta thought it "too much of a responsibility."[66] Demuth, clearly disappointed, reluctantly declined on their behalf: "I would like to

live with the pictures for six weeks, almost as much as I would like going abroad."[67]

Barnes valued Demuth's expertise, and when the artist was in Paris in 1921, he investigated a Matisse painting Barnes was considering. Demuth shared his other artistic enthusiasms with the collector but could never convince his friend to purchase the work of John Marin, one of the contemporary artists he most admired. Through Demuth's introduction, poet William Carlos Williams was permitted to visit the collection in the early 1920s. Their friendship was also sustained through correspondence, and Demuth and Barnes wrote regularly to each other during the late teens and early 1920s, the period when they were closest.

## HARDSHIP AND LIMITATION: DEMUTH'S DIAGNOSIS

Throughout the 1920s Demuth's health steadily deteriorated, and despite insulin treatment, he suffered periodic debilitating attacks from the disease that increasingly drained his artistic energies. Indeed, the last fifteen years of his life are played out against the backdrop of the diagnosis and treatment of his diabetes and the broader history of medicine. His ability to travel was constricted, largely because of his dietary regimen; he endured increasing restriction with a blend of frustration and wry humor. To Scofield Thayer, editor of *The Dial*, he wrote in June 1921: "Enforced residence in the old home town has made me a bit weak minded perhaps."[68]

The nature and scope of Demuth's illness, which had an enormous impact on his work, has never been thoroughly examined. It is now possible to gain a thorough picture of his struggle with diabetes, a tale that is intertwined both with the history of medicine and his friendship with Barnes, for it was at the collector's urging that the artist first sought the treatment at a Morristown, New Jersey, sanatorium that certainly extended his life. For a decade and a half, Demuth lived with serious chronic illness, forced to come to terms with a disease for which, when he was first diagnosed, there was neither a cure nor a reliable long-term treatment. His medical experiences bracket his early and late architectural paintings of Lancaster, and illness is the palimpsest on which his art is necessarily inscribed.

Barnes and Demuth corresponded extensively between 1919 and 1923 (quotations from their letters are published here for the first

Learning Centre, Canolfan Dysgu
Coleg Y Cymoedd Campus Nantgarw Campus
Heol Y Coleg, Parc Nantgarw
CF15 7QY
01443 653655 / 663168

time). This period marked the initial onset of the artist's diabetes and treatment. Barnes' own medical training made him both a sympathetic and knowledgeable friend, and his purchases of Demuth's work are also concentrated in this period. Demuth saw few people when he was sick, but he felt comfortable enough with Barnes to visit him even when in ill health, as he reported in October 1930 to Stieglitz after a visit to Merion: "I went to see Barnes at my worst this summer. He was in Europe. But Mme. Barnes received me as of old. He probably gave instructions. Will try to pay him a visit soon as I hear he is back."[69]

In Demuth's case, the disease had likely developed gradually over a period of years. The first noticeable symptoms of diabetes came during a summer visit to Provincetown in 1920 when he became so ill that he cut short his sojourn in Cape Cod and returned home to Lancaster. Some months later, in January 1921, he wrote to Stieglitz: "I'm not up to doing very much about anything."[70] A sketch by Philadelphia artist Julius Bloch, done around 1921, shows Demuth about the time of his diagnosis (fig. 35). The askew eyes and expression seem anxious, and the deep hollows of his cheeks reveal his weight loss.

Demuth's diagnosis came on the brink of a major medical milestone: the discovery of insulin, which would earn researchers a Nobel Prize in 1923. The breakthrough was made at the University of Toronto in January 1922, when the first person in the world was treated with insulin. The effects were dramatic. Demuth was extremely fortunate that the leading American specialist in the disease had established a clinic in New Jersey, within reasonable traveling distance from Lancaster.

The central American figure in the history of diabetes was Dr. Frederick Madison Allen, who in 1920 purchased an imposing mansion in Morristown, the former house of Otto Hermann Kahn, a wealthy banker and arts patron. "Cedar Court," built in 1896, comprised two identical two-story villas designed by the notable firm of Carrère and Hastings in an elaborate Renaissance Italianate style and set on extensive grounds of 176 acres. Demuth felt it "looks like Versailles in terre cuite [terra cotta]!"[71] At the turn of the twentieth century, Morristown was a favored country place for the wealthy elite of New York. A decade and a half after Kahn's Morristown villas were constructed, Long Island supplanted Morristown as a fashionable place of residence. Kahn then built a much grander estate, "Oheka" (1915–17),

Fig. 35
Julius T. Bloch (1888–1966)
*Charles Demuth*, ca. 1921

in Cold Spring Harbor near Oyster Bay and another mansion in New York City (1918); he then sold his Morristown property to Allen.

Allen had carefully selected the site for his sanatorium, regarding the Morristown property as "ideal in its beauty and its fitness for the purpose, in an excellent year-round climate, and in convenient proximity to New York, Philadelphia and other centers of population."[72] Located in northern New Jersey about thirty miles west of New York City and Newark, Morristown was at the edge of the metropolitan area and easily accessible by train and automobile. Founded in July 1920, the Physiatric Institute opened in late April 1921. Deriving its name from the Greek words for nature and healing, Allen's clinic was the first in America for the treatment of diabetes. It was in Morristown on August 10, 1922, that Allen first administered insulin.[73]

Allen organized his new institution into three separate corporations. Primary was the Physiatric Institute, described as "a first-class sanatorium for the more prosperous class of patients."[74] For those of more modest means, the Physiatric Hospital Association was "incorporated as a charitable association for the purpose of giving treatment to poor patients either free or at such reduced rates as they are able to pay."[75] Allen's hospital patients received "the same treatment as is offered to the rich, though on a less luxurious basis."[76] A third division, the Physiatric Foundation, was established for research.

Wealthy patients flocked to Allen's clinic, making it an instant success. Rates were established at between $50 and $250 per week, depending on whether patients had a private room or were lodged in a ward. Through the purchase of paintings and by loans and gifts, Barnes made possible Demuth's extended treatment there, and his assistance meant that the artist could be lodged in the more agreeable accommodations occupied by wealthy patients.[77]

Demuth had first consulted a physician in Morristown in February or March 1921, and it was at that time the diagnosis was made.[78] He would return regularly over the next several years. Barnes kept track of his friend's health and urged him to take advantage of what the Morristown facility had to offer:

*Dear Deem …I think you ought to stir Riesman up about the room in the hospital because if you don't it is liable to go indefinitely without you getting there—and the sooner you get there and he obtains the data*

*he wants the better off you will be. …I hope you make out all right in the hospital…*[79]

In developing diabetes as an adult (known as Type 2), the artist, who was then thirty-eight years old, had a much better chance of survival than if he had developed it as a child, for a diagnosis at an early age was tantamount to a death sentence. Easier to diagnose than to treat successfully, the disease's most obvious symptoms were rapid weight loss, frequent urination, constant thirst, excessive hunger, fatigue, and an overall weakening of a patient's general physical condition.

Allen's methods of treatment were arduous, spartan, and severe, characterized by a rigorous privation for wealthy and poor patients alike. First a patient fasted, and once their condition had stabilized, their diet was carefully monitored. Before the discovery of insulin, individual dietotherapy was the primary focus of treatment. But severely ill patients might still waste away. Unable to tolerate or process any form of nutrition, their key organs severely damaged, they would die of "inanition," or exhaustion from a lack of food or an inability to assimilate it — essentially starvation. For these deaths Allen had been sharply criticized by some of his colleagues in the medical community. He was sensitive regarding this characterization, which some described as a "starvation treatment,"[80] preferring the more euphemistic term "undernutrition."[81] William Carlos Williams, who visited Demuth several times in Morristown, recalled the effects of the disease and the initial treatment on his friend:

*The result was frightening. Charley faded to mere bones, but he was able to live. They occasionally permitted him to be taken home to us for a short visit but I had to return him the same evening. He brought with him a pair of scales and weighed his food carefully. I never saw a thinner active person (this, as I say, was before the discovery of insulin), who could stand on his feet and move about.*[82]

But in truth viable treatment alternatives were few, as a later historian of medicine observed: "All of Allen's experimental and clinical evidence showed that total dietary regulation was the *only* way of prolonging the lives of diabetics. Nobody had a better way."[83] Allen, a controlling and stern individual, insisted that his patients follow his regimen with near religious fervor. Those who failed to do so he deemed "unfaithful," observing that "…diabetic patients who will co-operate faithfully in

diet…"[84] could remain symptom-free for long periods. Treatment was necessarily rigorous, for he recognized that diabetes, in "its severe forms, is a hopelessly progressive disease"[85] that can be arrested for a time, but whose "course is irresistibly downward and the end inevitably fatal."[86]

Many of his patients were grateful for the strict regimen Allen imposed on them, believing that it saved their lives. But initial treatment was just the beginning of a life-long program to which they would have to adhere. Individuals needed to conscientiously control their diet if they were to survive. As Allen observed: "The life of the severely diabetic patient is one of hardship and limitation."[87] Diet remained an important part of any program of long-term treatment for diabetics, even after the discovery of insulin.

Following his first success, Allen administered insulin in August 1922 to a small group of critically ill patients with dramatic results. But because the treatment was still experimental, its effects were unpredictable, and monitoring dosages was complicated by the lack of uniform manufacturing standards. Allen was not the only physician testing insulin during the first year of clinical trials, but he administered it to more patients than any other single doctor. Until the end of 1922, quantities remained limited, and not until the spring of 1923 were supplies plentiful.

Back in Morristown in late November 1922, Allen must have proposed Demuth be given insulin, a course of action Barnes encouraged: "If Allen thinks that serum is a good thing for you, I think you ought to take that procedure."[88] But Demuth remained reluctant to do it and declined, observing to Barnes:

*Allen comes high, — but is worth it. The new serum seems to be working, — I've had none so far. Allen thinks it almost a cure, — I don't want to try it quite yet, — the manufacture of it at present is not very level, as to quality, — some lots are good and others bad.*[89]

The artist became friends with a number of people he met in Morristown, including physician James Winn Sherrill, who treated Demuth over a period of two years. The artist gave him a small watercolor of a purple iris while under his care. The doctor recalled of his interesting patient: "I have never met a more delightful, entertaining and unsolvable person as Charles Demuth."[90] One wonders what the unsolvable part was — whether disease or personality — but the physician nonetheless made a wonderfully Duchampian observation.

Alexander Lieberman, a realtor from Philadelphia, was also a patient in Morristown in the spring of 1922 and later recollected:

*Mine was a corner room with a large round balcony overlooking a magnificent valley with a rather profuse growth of spring flowers. Mr. Demuth and I picked these blooms and he asked my permission to use my balcony which had a northern exposure and it was there that he actually painted the first three watercolors above mentioned.*[91]

Lieberman saw Demuth frequently after his release, visiting him in Lancaster. He purchased two vaudeville sketches and owned three watercolors of gladiolas, white tulips, and one of field flowers that featured daffodils and bluebells. The floral still lifes had been executed on his Morristown balcony in 1922.

### FINAL TRIP TO PARIS

Determined to continue making art and to enjoy life, Demuth made a third trip — his last — to Paris between August and November 1921. He wrote Stieglitz from London, where he had stopped on his way to France: "I wanted to do something to stop the 'Wheels' going around backwards, — so, chanced this. I wanted so to feel it once more, — so here I am, and will go to Paris next week."[92] He was glad to be able to see old friends, including Hartley, Duchamp, and Gertrude Stein, the latter of whom was, he reported, "very fat and has a very little Ford."[93] Demuth enjoyed the opportunity to see her collection again: "Her pictures are really very fine, few, but really good ones."[94]

Man Ray photographed the artist while he was in Paris (fig. 36). Demuth wears a dark suit, with a striped shirt and checked tie. The smoke from his cigarette swirls upward, and his elegant hands gesture during conversation. Hartley admired Demuth's hands and long slender fingers as "unusual," "very sensitive," "patrician," and "Chinese in character," describing them as "living a life of their own."[95] His adjectives also suggest femininity. But Charles Daniel also noted them: "His hands were the most extraordinary hands that I have ever seen. They were alive. Yet he was never affected; was without any pose."[96]

Demuth's enthusiasm while in France had the freshness of someone who has had a brush with death and so approaches life with renewed pleasure: "It has never seemed so beautiful, — it is different in some ways than before the war, — but I don't remember it as fine as it is now."[97]

Fig. 36
Man Ray (1890–1976)
*Hands of Charles Demuth*, 1921

He observed excitedly to Barnes that he found Paris "one marvelous place."[98] He entertained hopes of having a showing at the Galerie de l'Effort Moderne, whose owner, Léonce Rosenberg, apparently liked his work and purchased two watercolor views of the city: "So, I may return with a European reputation. Maybe, — which, of course, would be nice."[99]

The exhilarating visit soon took a hard turn, though. Within a month of his arrival, Demuth experienced symptoms severe enough for him to be hospitalized for several weeks in mid-September at the American Hospital in Neuilly. He wrote to Barnes on institutional stationery:

*I'm giving myself a treat of this for a few weeks. I was told it was the best thing that I could do, and that it would have been better had I done what I*

*am doing now, on landing. I think that the boat did me up, a bit, — I was not very careful, and vegetables were scarce. I haven't lost any weight, in fact, have gained a bit, and am told I am not in bad shape, at all, — only that I had better rest and get some sane food for a few weeks; I feel quite well.*[100]

Not wanting his mother to worry, he asked Barnes to be discreet if he saw her: "If you get to Lancaster don't say anything about the hospital, as I haven't written to mother about it."[101]

Once he was discharged, he took an upper room at the Hotel Lutetia on the rue Raspail: "I have quite a large room with a wonderful view of Paris, — it's not very cheap but the view is worth almost anything asked. I could work from the material seen from the window for years."[102] Hartley visited him there and reported that his dormer window "afforded one of the most amazing views of Paris to be had anywhere on the Left Bank."[103] As Hartley recollected: "It was a visual operatic Paris that one beheld, and I can never fathom just how this angle was obtained, but you had to a striking degree, all that Paris had to offer, or most all."[104] As they stood on either side of the window, Demuth revealed to Hartley the news about his health: "I recall it so well — O well, I've seen it all — I've done it all, and the throat thickened with the sense of sudden revealment — Charles learns that he is really ill, and that he must go home."[105]

Despite the seriousness of his illness, Demuth wrote to Barnes of being very glad to be back at work:

*Paris, on the whole, is the great place of the world at the moment. My God, it is wonderful. I don't think I would like to stay on forever, — but wouldn't mind a year or two, — I don't believe, now, that I could really ever get really into the French scene. I would always, — anyway, for years, feel on the out side. I wish that I could have stayed on when I first came over, — I would feel now that my work, here, would have a superficial quality for years, — owing to the lack of not really being in the main stream. However, — it is grand to be here, — and I love it, and it is easy to work, — so much more so than at home.*[106]

This American in Paris also observed that "all the French seem to think that there is no place like New York."[107] He executed one work abroad, *Rue de Singe qui Pêche*, and in its jazzy tilt of buildings and cacophony of fragmented signage conveys the visual energy of Paris

Fig. 37
Charles Demuth
*Rue de Singe qui Pêche*, 1921

(fig. 37). The colors are more restrained than some of his American architectural paintings, perhaps reflecting the state of his health. Initially he considered spending the winter painting in the city, but he returned home in November and would not go abroad again. He confided to Stieglitz: "But all that is left of my energy, I suspect, had better go into painting!"[108]

## ILLNESS AND INSULIN

The following spring, Demuth was cheered by a short piece Carl Van Vechten had written about him in the February 1922 issue of *The Reviewer*, and his account is livelier than the artist felt. The critic celebrated the work of "this perverse genius, a genius which would be recognized at once at full-value in Germany or France."[109] Recently returned from Paris, where his hopes of a showing did not materialize, these words must have seemed bittersweet. Van Vechten especially admired the watercolors: "I wonder how many collectors are buying the water-colours of Charles Demuth? In a few years they will surely bring big prices."[110] He continued in this vein of overheated hothouse prose: "How beautiful and how terrible the flowers: daisies with cabalistic secrets, cyclamens rosy with vice, orchids wet with the mystery of the Rosicrucians!"[111] However infused with cryptic Symbolist reference, the Baudelairean *fleur du mal* tone of the critic's description lifted the artist's spirits, as he wrote Van Vechten from the Hotel Brevoort: "Your frisky and urbane lines about me made me wish that I could really be as naughty as you imagine; perhaps I can be after the 'cure,' dear Carl."[112]

But Demuth's health worsened, and he once again checked into the Physiatric Institute for further treatment early in April 1922, reporting to Barnes from Morristown: "Well, here I am finally put away, by my own hand. It seems very thorough!—well, rather,—but what, no doubt, I need. Very tiring,—although a wonderful place as to surrounding country." He reported on his treatment: "In time, I will get everything, —that seems the idea,—even sugar. Of course, so far I've been starved, that is egg and meat in little quantities." He hoped Barnes could visit: "I am bored stiff."[113] He painted several watercolors of flowers, two of flowers his mother sent. He reported to Barnes in late April 1922:

*To-day my food goes up,—then we will see,—will let you know. I think that I'll be here, of course, for some weeks,—however, I'll go through with*

*it now, — what else is there to do, — and I do think Allen is the real thing, — very unemotional and cold, — drives me almost mad at times, — best in the long run, I tell myself, in my sane moments.*[114]

He was eager to hear from friends, as he wrote: "Letters are my only connection with the world."[115] At the end of the month he asked Barnes for a loan of $500: "I will be here for some time, — I don't want to give it up now, — and there is little loose money at my command."[116] Barnes lent him the money and assured him that he did not need to worry about repayment:

*I got your note and am very glad to loan you the five hundred ($500.00) dollars you ask for. At this time you don't want to worry about such matters as arranging to see that I get the money back — so we won't say anything about that now, just content yourself and stay there as long as your doctor wants you to.*[117]

After he purchased five Bermuda watercolors for $300 the following March, Barnes cancelled the loan.[118] One, *Bermuda: Houses Seen Through Trees*, is a handsome composition (fig. 38). Early in May, Demuth reported:

*The treatment has made me very weak, — I do very little. Dr. Allen tells me I am getting along remarkably well, — and that as far as they can see none of the organs which are affected in this trouble are seriously impaired, — only from not knowing just what to eat and how to eat it, — I was seriously and constantly over taxing them. Of course, I think this is hopeful, don't you. Allen said that I responded well and quickly (for my overtaxed condition).*[119]

He had no choice but to be patient and wait out the course of his treatment. Later that month he wrote:

*Have been through quite some hell, — but some of it is, I hope, now over. It was some weak that I got when I got hit by the treatment, — really felt it[s] effects. I suppose that I am now coming to, — how long I will stay here, — that is be required to stay is — something I don't, as yet, know. I suppose still some weeks. And then go to Lancaster.*[120]

By July 1922, he could observe: "Very little left after I do my daily (sometimes, now weekly) painting."[121] The artist was able to visit the Daniel Gallery later that year, and the dealer was shocked at his appearance: "Demuth was always slim, but he looked like a skeleton."[122]

It was during this sojourn that, discouraged, he wrote Stieglitz: "My old age has started."[123] The uncertainty was clearly wearing. In late January 1923, he noted: "I'm still hanging onto this world."[124] Demuth hoped he could soon manage a visit to the city: "Perhaps you can do my hands then. That will be wonderful if you would. It, if you wish to do them, would, I feel, be well to do them soon, for in the language of the moment: Every day they grow thinner and thinner."[125]

## INSULIN: A DOSE

In mid-March 1923, he returned to Morristown, writing A. E. Gallatin that he would probably be there several weeks "taking a kind of 'rest-cure.'"[126] After experiencing problems with his vision, a frightening prospect for an artist, Demuth eventually consented to insulin treatment and was given his first dose in mid-April 1923. The improvement in his condition was noticeable, as it was for so many patients (medical historians refer to this transformation as "The Resurrection"). At first, his injections were administered every two hours, but whatever inconvenience and pain this represented, he wrote Stieglitz: "The serum seems to be, — well, it seems like sort of a trick. I feel I will wake; it is not possible. If it be true what it is doing, — then, well then, I can hardly imagine outside of our world, — too, there must be the few who 'know.'"[127] He wrote to Barnes about the same time: "The serum so far is proving a miracle. It must be magic. I know that I'll wake up and find it only another dream. Have gained ten pounds and can eat bread!"[128]

By the following September, some 25,000 American diabetics were receiving insulin, and nearly 7,000 physicians regularly prescribed it.[129] Demuth was right in the middle of the first wave of American patients to be treated with it. Not desperately ill enough to qualify for the first trials when supplies were limited, he now benefited from its wide availability, which meant he could return home where his condition was monitored by his Lancaster doctor.

While Demuth's health improved markedly with insulin, his treatment remained, as it did for anyone with the disease, experimental and highly individualized. For an artist who enjoyed socializing in New York cabarets and bars, he found his new regimen difficult to follow, sometimes neglecting to eat properly and to take his insulin regularly when away from home. But generally he submitted to the strict routine

Fig. 38
Charles Demuth
*Bermuda: Houses Seen Through Trees*, 1918

imposed by his treatment, a commitment ultimately mirrored in the rigorous visual discipline of his late architectural paintings. It was his mother who carefully weighed his food and monitored his diet when he was in Lancaster. Vegetables were prominent on the list of recommended foods, and the excellent produce that was readily available locally — and that inspired so many paintings — was also good for his health.

As his condition improved, so did his mood, making him impatient to see his friends: "Dear Stieglitz, I would love to see you, — but I must grow fat. Already I've gained ten pounds, — so you see it may not be so long until I do see you."[130] Demuth was eventually able to manage short trips to the city and visited Stieglitz in New York sometime between February and mid-March 1923. Stieglitz took the opportunity to make some portraits of his friend, producing a series of photographs of the artist at the Anderson Galleries that document his startling emaciation, especially evident in his hands and face. Demuth wrote his friend from Morristown when he saw the prints:

*You have me in a fix: shall I remain ill, retaining that look, die, considering that moment, the climax of my 'looks,' or live and change. I think the head is one of the most beautiful things that I have ever known in the world of art. A strange way to write of one's own portrait but, — well, I'm a perhaps frank person. I send it this morning to my mother. The hands, too, — Stieglitz, how do you do it? The texture in this one is — simply is! …Yes, — I grow fat, 12 or 13 pounds. It is beyond belief, the power and subtlety of the serum.[131]*

The photographs Stieglitz took reveal the shocking condition of his friend. One showing a profile view of his face, his eyes looking downward, graphically reveals his thin, sickly aspect (fig. 39). Stieglitz also took two photographs of his elegant hands. In one, his wrists are surrounded by shirt cuffs now much too big (fig. 40).

Early in September he wrote Stieglitz, still in Morristown:

*There is so little to write. Of course, you know the meager background we all have to work before, and with this fact, and the fact that I am completely cut off from any contact with ones interested in the 'thing,' makes writing hard. I don't know what will come of it; if I were a genius it might be all right, complete isolation, — and it is that here. On the other hand I grow fat, — and fatter, — which is something! And I garden & cut grass and stay on the move, — as is expected.[132]*

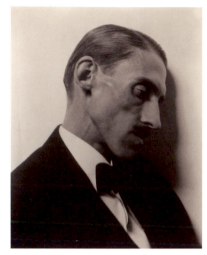

Fig. 39
Alfred Stieglitz (1864–1946)
*Charles Demuth*, 1923

Some of the tedium of Demuth's lengthy stay at the sanatorium, which at the beginning confined him to bed, was broken when he felt well enough to write letters. Only occasionally did he feel well enough to paint. His slow recovery was further enlivened by occasional visits from his friends. Reading was a primary occupation, and he must have been pleased when Robert Locher arrived bearing a smuggled copy of James Joyce's *Ulysses*, then banned in the United States.[133]

Fig. 40
Alfred Stieglitz
*Charles Demuth*, 1923

Demuth's longtime friend, William Carlos Williams, lived in Rutherford, located a little north of Newark. With Marianne Moore, Williams paid him a visit in Morristown early in April 1923. Moore's letter to her brother gives a vivid account of the artist and his surroundings:

*Tuesday I went to Morristown with W. Williams to see Charles Demuth who is at a sanitarium there. The drive was delightful and I looked about sharply at the chicken coops and cedar trees and polarine stations as we passed, everything looking very much as usual. It took us about an hour from Newark. The sanitarium I had never seen before—an immense private mansion on a hill with Italian terraces and box borders, garden statuary and so forth. Mr. Demuth is so invalided, he has to stay in his room so we were shown upstairs. He has a small room about twice the*

*size of the Halliday's [sic] bathroom, with a high window extending all along one side of it, looking towards some mountains and woods and a broad white windowsill on which were some tulips, geraniums, a small jade cat, a few books and a shaving brush. There was also a bureau and a white iron bed and a pink linen laundry bag hanging by a cupboard door; also a very pretty blue and orange striped cotton bathrobe hanging on the door. We discussed Lancaster, Carlisle, Alice Meynell, Henry James, Gertrude Stein, the flower show, the Williamses plan of going abroad next fall and so on. It was delightful, also heartrending as it doesn't look to me as if Mr. Demuth is going to get well. He is very game, jokes about the cure he is taking and says if you get too much of the serum all you need to do to counteract it is eat a handful of candy; he has diabetes and the proprietor of the sanitarium has discovered a new cure. On leaving he gave me an Easter egg with a rabbit on it from a box of elaborate candy which someone had given him.* [134]

Moore and Demuth kept in contact, and in July 1934 she wrote Winifred Ellerman:

*Charles Demuth has been an invalid since 1915, perhaps longer, and his mind for me is tinged with disability; perhaps I should say eccentricity, but his flower water-colors at their best are marvels of interpreted accuracy I think. His imitator, Elsie Driggs, I like exceedingly when she is not imitating.* [135]

She retained an interest in news of the artist, and Williams wrote her during the summer of 1928: "Demuth is very well, as well as a man can be who has to have two hypodermic injections every day of his life and whose food must be weighed at every meal. His mother is his patron saint."[136]

Although their acquaintance was brief, Moore's visit to the ailing painter obviously made a deep impression on her. She long recalled her visit with Demuth, writing of it to Williams in 1951, though the details, impressions, and emphasis had been adjusted in her memory in the more than quarter century hence:

*I remember Charles Demuth clearly, in the rather high enormous hospital room at Morristown, and his touching little objects, jade and something china, and I think a few flowers. I was awed by the fact that he made nothing of his disability and gave the impression of being normal.* [137]

After Demuth returned to Lancaster in June 1923, Charles Daniel reported to collector Ferdinand Howald that the artist was "in marvelously improved condition," observing that "if it is permanent, and it seems so, truly a miracle."[138] By early July, Daniel observed: "He is feeling quite well, and is planning his new work."[139]

A setback precipitated Demuth's return to Morristown in early September 1923. But as he convalesced he was able to work again, finishing about a dozen new paintings—all floral still lifes—which he planned to show Stieglitz later in the fall. *Cineraria* dates from this year (fig. 13). However, despite his initial optimism, the progress of his recovery was slow and erratic, which is evident in his correspondence over the next several years. The vicissitudes of his health would be a dominant part of his life until his death. As he observed to Stieglitz in January 1924: "I wish that I had some 'go,'—such as yours. Mine seems to be used up these days after two or three hours of work and maybe a walk."[140] He was frustrated by how slowly he improved: "I'm about the same, am painting, & am on my feet. I know that this is enough really,—still I fuss."[141]

In 1925 he painted a series of lovely floral, vegetable, and fruit still-life paintings in watercolor, including one of his finest, *Eggplants and Pears* (fig. 41). He continued to show his work in various group exhibitions. His technical mastery and formal powers were never stronger. But the year 1926 was especially discouraging, as he wrote in July: "I've never felt so 'low.' There seems to be nothing, nothing. I haven't painted for weeks. Everything seems to have been painted."[142] Debilitated by the heat, he was further disappointed not to be able to go to Provincetown as he had hoped, complaining to Ettie Stettheimer: "The summer has not added to my work or to my charm."[143] To Stieglitz he revealed his depression more thoroughly:

*My summer has been a very bad one. No painting,—and such a feeling of it all being too much for the ones really trying. It would be grand to have a bit of a background,—the effort to make that new each morning for the day is a great one, too great. Still, if we don't try, will there ever be one?*[144]

His output that year comprised a series of still-life watercolors. Again, the high quality of his work from this year, including *Grapes and Turnips*, belies the unpredictable state of his health. By June 1927, he could observe:

*I really have been working, —quite hard for me these days. No one has seen these three new things, —I wonder about them from day to day as I work on them. Have a lot of things in mind but it is such slow 'going' that I don't know if they will ever reach canvas or paper.*[145]

Fig. 41
Charles Demuth
*Eggplants and Pears*, 1925

In that year he produced one of his masterworks, *My Egypt* (pl. 1), as well as his striking poster portrait, *Calla Lilies (Bert Savoy)* (fig. 42). Still, he chafed at being increasingly homebound:

*I would love to go somewhere—where I don't know—any place is almost impossible. Maybe it's just something that always goes along with me, that I'm tired of having around, and think a change of place would help me, there. I'm really all right here,—but at times I almost wish I could 'go in for' hysterics; but all I can go in for is another picture. Well, there's almost four new ones of these to date.*[146]

Fig. 42
Charles Demuth
*Calla Lilies (Bert Savoy)*, 1927

Occasional gardening was one thing Demuth could manage, though that activity served as a reminder of his absence in the studio: "How is your garden,—ours seems thin. Have painted no flowers, which means that I'll have less money next winter. How the collectors love flowers."[147] He was more likely to tend flowers, however, than to paint them: "I expect I'll start some day soon,—the flowers are all around the garden,— I can only look at them and dig around them so far this season."[148]

A drawing by Peggy Bacon is one of the last portraits made of Demuth[149] (fig. 43). The notations Bacon made on the paper characterize his mustache as "high," and she indicates that he was clad in a gentian

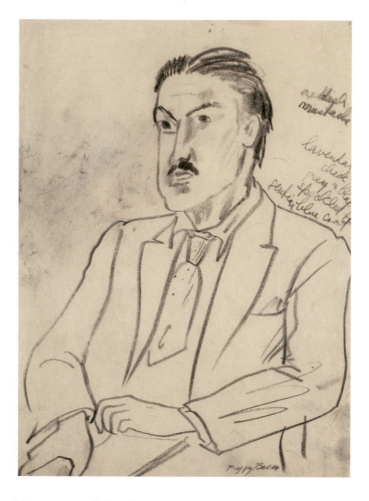

Fig. 43
Peggy Bacon (1895–1987)
*Charles Demuth*, ca. 1935

blue coat, and that his tie was a lavender check, speckled with gray and black. His energy depleted, little painting resulted, as he wrote in October 1927: "Must say the summer didn't add much to my work. Tried some water-colours several weeks ago, — they were terrible. The field is to Marin, — if it always wasn't anyway."[150] A month later there was no improvement: "Things are upset here but maybe I'll get some work done."[151]

Throughout 1928, the year he executed *The Figure 5 in Gold* (fig. 44), the steady progression of his illness and the inability to work remained a regular theme of his letters, and he remained socially isolated: "I'll stay here & work, — I don't see anything else. I like a few places and a few people but I see them seldom. Perhaps I wouldn't work at all if I did, — still, I don't like most of my work, and maybe that's what keeps me working."[152] Months would pass when he would not be able to paint:

*…my work which has been going, but going very strangely this summer. They — the paintings — have a strange, inner strange look about them.*

*They look sometimes like I think my own things do or should and then…*
*strange with a strange strangeness. Really, I can't tell, — you'll see them*
*unless they look too strange some morning and I do away with them,*
*— only remembering the summer of '28 without any work to help me*
*remember some terrible days.*[153]

By November 1928 it was hard for him to sort out the difference between painter's block and illness:

*My work has gone very badly this past season, — I feel that I'll never*
*get hold of it again. My living and my work seem, at the moment, quite*
*beyond control, both smothered by trifles. Of course, I know this happens*
*to one, at times, but this time it seems involved past straightening out.*[154]

The next spring, his mood improved as he completed a watercolor — *Red Cabbages, Rhubarb, and Oranges* (1929) — with which he was especially pleased and hoped to charge $1,400 for it, as he wrote to Stieglitz in April:

*I know, from the quiet of the country, that I won't do many like that one,*
*no matter how long a time I paint…It's been so long a time since I painted*
*a water-colour just that good, — maybe I never did, in some ways, — that I*
*don't much care, unless I get a good price if I sell it, or not.*[155]

But more commonly, his letters document his increasing discouragement: "I'm working but it ain't much. I can't work here. Maybe no where any more as I once did. Once, — well, that was grand, anyway."[156] He confided in August 1929: "I've been here since seeing you, — and very low all summer, — so low that this is the first letter that I've written."[157] The next summer was not much better, as he observed to Stieglitz in October 1930:

*Just couldn't write you before. Was not very well part of the summer,*
*and then something else happened which almost finished me in another*
*direction. So, all in all, my summer was one of the worst. However!! —*
*here I am again back in New York, not much changed. Didn't work at all,*
*but have been again painting before I came to town for the last couple of*
*weeks. Was going to bring what I've finished, one oil, along to show you*
*but didn't, just as well now that I find you still in the country. You will see*
*it next time I come over. I think you will like it. It's quite American, I think*
*— no one will want it.*[158]

The only oil from that summer was *Buildings, Lancaster* (pl. 2).

Learning Centre, Canolfan Dysgu
Coleg Y Cymoedd, Campus Nantgarw Campus
Heol Y Coleg, Parc Nantgarw
CF15 7QY
01443 65.... ..3168

Fig. 44
Charles Demuth
*The Figure 5 in Gold*, 1928

As diabetics were prone to catching other infections (more dangerous, of course, to someone with a weakened immune system), Demuth was cautious at any first sign of illness. The beginnings of a cold early in March 1931 forced him to cancel a trip he had planned to New York, and for most of the spring and summer he remained in Lancaster; he wrote to Stieglitz on September 10, 1931:

*My summer, — well, it's almost over and as I realize this fact I also realize that most of it found me numb. I've gardened and I've sun-burned myself — and maybe I've painted. I think, really, my summer's painting — only one — is all right. I think that you will like it too. It's an oil. And seems more to the point than most, — different, I feel. Perhaps I'm just, in my suffering, making myself feel this, — from my others. Anyway it has a grand name — it's called And the Land of the Brave.*[159]

His illness earlier in the year and reference to having painted "only one" oil during the summer together suggest that *Buildings Abstraction, Lancaster* (pl. 5) and *Chimney and Water Tower* (pl. 3) were both executed during the fall of 1931.

Feeling stronger, Demuth planned to visit Stieglitz in October 1931, but he had no sooner arrived when he fell ill and returned to Lancaster without having seen him. Recovery from even small bouts of sickness could take months. A photographic portrait taken by Dorothy Norman documents Demuth during the latter part of the period when he was working on his late architectural paintings (fig. 45). Demuth met Norman when he stopped by Stieglitz's gallery An American Place in 1932. He was able to make a visit to Provincetown during the summer of 1934. But after his return to Lancaster, the artist's worsening condition meant he was unable to paint for the fourteen months that remained of his life until his death on October 25, 1935.

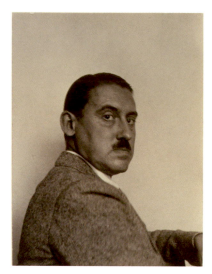

Fig. 45
Dorothy Norman (1905–1997)
*Charles Demuth*, 1932

## Charles Demuth's Lancaster:
## The Late Architectural Paintings

Fig. 46
Undated view of Lancaster showing
the spire of Trinity Lutheran Church
at left, along with the smokestacks and
water tower prevalent in Demuth's late
architectural works

In 1927, Demuth commenced what would turn out to be his last major body of work, a series of Precisionist architectural paintings of Lancaster whose scale and formal power stand unsurpassed by any of his previous work. They remain the masterpieces of his last years. *My Egypt* (pl. 1), painted on board as are the others, signals the commencement of his renewed interest in local industrial subjects. That it was acquired by the Whitney Museum of American Art in 1931 must have confirmed to him the rightness of his decision to proceed in this direction, though, as it turned out, it was the only one of this late series to sell during his lifetime.

These paintings are emphatically of Lancaster, as seen in a photograph recording a distant view of the city, broadly summarizing Demuth's characteristic architectural subject matter (fig. 46). Preserved in a scrapbook assembled by Richard Weyand, the image presents a panoramic vista of Demuth's connection to place. While we do not know if the photograph in Weyand's scrapbook ever belonged to Demuth, many of his sources of inspiration are visible along the Lancaster skyline, including the County Court House, the Lorillard Factory, Trinity Church, and various water towers and smokestacks. A billboard suggests the common examples of urban commercial lettering that fascinated him as well and that would become visual prose poems in his paintings.

### CHOOSING A SUBJECT

Demuth's late architectural paintings can be located within the broad discourse of 1930s art. Cultural nationalism, a subject brilliantly explored by Wanda M. Corn in *The Great American Thing: Modern Art and National Identity, 1915–1935*,[160] was a significant issue for American artists during the first half of the twentieth century. Seeking inspiration in native themes, which they then expressed in terms of the new modernist movements they encountered, and no longer intimidated by their European counterparts, American artists were confident in their technical abilities and aesthetic sophistication. John Dewey's famous article, "Americanism and Localism," was published in 1920, just at the time Demuth began his Precisionist architectural explorations,

his most emphatically grounded body of work. In declaring "The locality is the only universal,"[161] Dewey aligns himself intellectually with Demuth's friend, William Carlos Williams, who proclaimed the validity of indigenous subjects and forms as a rich source of inspiration for our native-born artists and writers: "We will be American, because we are of America."[162]

Demuth kept a distance regarding issues of nationality, sharing a frustration often voiced by American artists regarding the perceived favoring of anything European by cultural leaders, a situation made problematic by a generation of expatriates. In preferring to live abroad, the artists themselves ironically reinforced this view. But many searched for a usable past and present for inspiration, often finding it close to home. Native artists measured themselves against their own country and against what they saw in Europe. Subject matter and style varied considerably, but the discussion negotiated artistic thinking nationwide.

The term Precisionism dates from 1947, though its characteristic elements had been noted long before then. Later termed "Cubist-Realism" by Milton Brown, referencing its strongly formalist blending of abstract and representational modes, the style first emerged during the 1920s. Its practitioners did not organize themselves as a group, but they were linked in their focus on utilitarian architecture (industrial structures were favorite subjects), carefully rendered compositions composed of crisp geometric lines and flat planes. Rigorous and austere, the streamlined images are still today emblematic of the Machine Age. Paintings by Demuth and Sheeler are among the strongest examples of this style.

Although he was not a Regionalist, Demuth's Precisionist aesthetic evinces a strongly regional sensibility, and Lancaster was as significant a source for his art as was the New York avant-garde. Grounded in Pennsylvania, his localized sense of place was as emphatic as that displayed by Thomas Hart Benton in Missouri, John Steuart Curry in Kansas, and Grant Wood in Iowa — the triumvirate of painters who were most identified with Regionalism. While these artists' derivations and populist aims were different, Demuth shared their goal of defining a distinctive American art. (Demuth, whose work was almost never completely abstract, was not by nature an artist interested in politics; the civic messaging of Franklin D. Roosevelt's New Deal art would have held little appeal for him.) Both Regionalism and Precisionism began in

the 1920s and continued strongly through the 1930s and 1940s. Simple labels like "Regionalism," "American Scene," and "Social Realism" skew the sophistication both of the practitioners of representational styles and the moderns with whose work they often overlap. As Marlene Park and Gerald Markowitz have observed:

*American Scene painting is about American life in general; Regionalism and Social Realism are more polemical. Regionalism focuses on small farmers at work in their fields and other scenes of midwestern farm or small-town life. Regionalist works are pious in attitude and neat in form; self-reliance and individualism are the great virtues.*[163]

Such stylistic terms create artificial boundaries, and in practice there was considerable crossover between artists working during this period.

Although artists like Demuth were wary of what they regarded as the one-dimensional chauvinism inherent in Regionalist narratives, the movement is less polarized from modernism than would be superficially apparent. Leading practitioners of Precisionism — particularly Demuth and Sheeler — defined their vision in works inspired by specific sites, ones imbued with considerable personal meaning, rendering their lenses emphatically local. Those artists identified with Regionalism often worked in public mural venues, choosing narrative themes drawn from past and contemporary events that could be rendered in an easily understood representational style. By contrast, Demuth and Sheeler appropriated history and place in the service of modernist ends, rather than those that were overtly didactic.

Although there are international parallels — for instance with the German movement of the 1920s *Neue Sachlichkeit* (New Objectivity or New Realism) — Precisionism was essentially an American movement whose artists produced sharply focused images of architectonic subject matter. The movement lasted, with variations, until the beginning of World War II and has a strong relationship with photography; but unlike Sheeler, Demuth was not a photographer and he did not use photographs as studies for his paintings.

Modern industrial architecture was the quintessential Precisionist subject. Along with his fellow Pennsylvanian Sheeler, Demuth defined this style in the 1920s and 1930s. In abstracting the modern industrial landscape, their works recorded the clean lines and Machine Age geometry of the factories, bridges, grain elevators, skyscrapers, and warehouses that were their favored subjects. Their imagery references

the growth of American industry during this period, as well as a national fascination with modern technological advancement. But no matter how stylized their work, these artists' sources of inspiration are generally recognizable. The hard edges of the highly practical buildings they painted appealed to their sense of linear abstraction. They carefully edited what they painted, however, creating a compelling visual and iconographical resonance grounded in actual structures, comparable to a line from a William Carlos Williams poem: "no ideas but in things."[164] Demuth added dynamic force lines that tethered the visual elements as they might have had they been wires at actual sites.

Some of the structures Demuth painted were historic, while others had been recently constructed, creating the thematic tension between past and present that is characteristic of his architectural painting. Less literal and hagiographic, Precisionism is an intriguing dichotomy, including urban and rural, realist and abstract, descriptively situated in region yet informed by the sophistication of New York and Europe. Some sources over-emphasize clinical and scientific aspects of its vision, though it was actually highly subjective, replete with textured personal meaning. The fluid lines and washes of Demuth's vaudeville pictures and still lifes are now brought into crisp focus in his architectural renderings.

Demuth's first works in this style date to 1920, when he began a series of paintings inspired by structures in Lancaster. (The two notable exceptions are *End of the Parade, Coatesville, Pa.* [fig. 48] and *Incense of a New Church* [1921], both of which portray an industrial site in nearby Coatesville.) Works from his earliest architectural series are smaller and more detailed than those of the late 1920s and early 1930s. Executed in oil and painted on board, they mark a shift from his previously favored watercolor medium, something they share with his poster portraits (1923–29) and which they overlap chronologically. In size and formal monumentality, they achieve a striking balance between abstraction and realism.

His industrial images remain identifiably specific, yet are rendered in strongly formalized and highly structured compositions, ordered in simplified Cubist planes and animated by Futurist lines of force, some of which echo actual power lines with elegant arcs and jazzy curlicues sprinkled throughout. These formal devices Demuth had employed earlier, as seen in *Piano Mover's Holiday*, but while the red brick

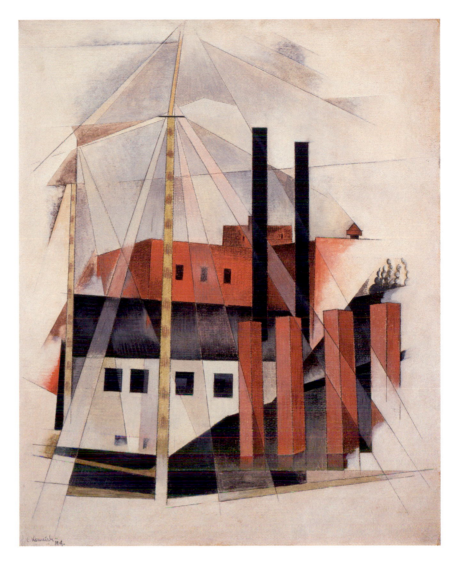

Fig. 47
Charles Demuth
*Piano Mover's Holiday*, 1919

structures and smoke stacks do reference an industrial site, it is treated in summary fashion and cannot be identified (fig. 47).

While the same is to some extent true in *End of the Parade, Coatesville, Pa.*, the town and the structures he has painted are consistent with those on the site of the Lukens Steel Company, indicating that recognizability here was important to him (fig. 48). These earlier architectural renditions have energetic compositions, in contrast to the ascetic monumentality of the later ones. The lively array of lines crisscrossing the sky, steeples, and the buildings of *Lancaster* keeps the composition in motion (fig. 49).

Many of the first series were shown in two exhibitions held at the Daniel Gallery in 1920 and 1922. The works represent a Herculean effort on the part of the artist and are bracketed by his last trip to Paris

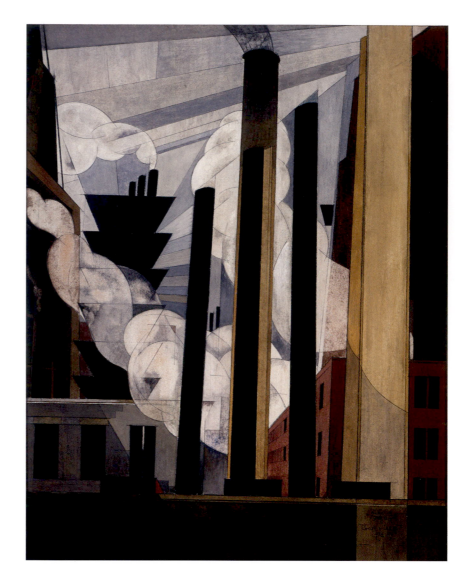

Fig. 48
Charles Demuth
*End of the Parade, Coatesville, Pa.*, 1920

and his first treatment with insulin. They were not popular with the critics, who did not respond positively to either the unusual structures depicted or the hermetic and ironic titles he chose for some of them.

*Arrangements of the American Landscape Forms* of 1920 was the title of Demuth's sixth show at the Daniel Gallery. Shown were two paintings titled simply *Pennsylvania* and four titled *New England*. The others were *After Sir Christopher Wren* (fig. 68); *Waiting*; *The Merry-Go-Round*; *For W. Carlos W.*; *End of the Parade, Coatesville, Pa.* (fig. 48); and *Chimnies, Ventilators or Whatever*. McBride noted:

*Charles Demuth has painted little during the last year, but he has painted well. He grows more earnest and eloquent with the times; his exhibition which has just opened at the Daniel Galleries proves*

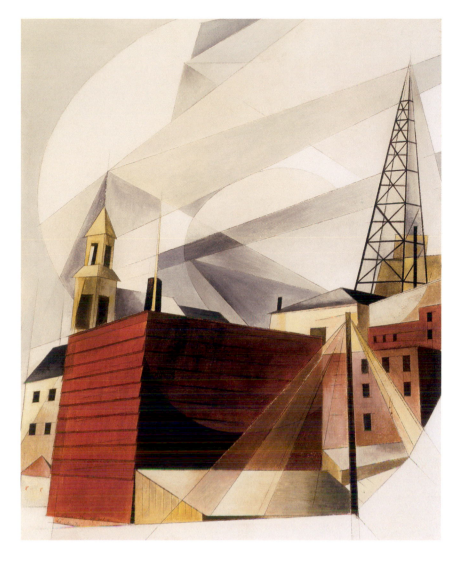

Fig. 49
Charles Demuth
*Lancaster*, 1921

*that: but he also grows more ascetic. His studies of New England and Pennsylvania would be quite terrible — if they were not so beautiful.*[165]

While the critic noted a "chill" in his Coatesville steel mills, he also commented that the artist had arranged "his impressions of the unspeakable buildings in which our American dollars are gained — into a lovely report."[166] A writer for the *New York Times* captured the dichotomies inherent in these paintings: "He is one of the most advanced of the modernists and his talent is great. Another welcome bridge between the old and the new."[167] The title of one work, *Chimnies, Ventilators or Whatever*, reveals the ambiguity he believed his new subjects might convey to his viewers.

In December 1922, Demuth opened another show of recent paintings at Daniel; the exhibition included *Welcome to Our City*; *Nospmas M.*

*Egiap Nospmas M.*; *Aucassin and Nicolette* (fig. 50); *From the Garden of the Château* (fig. 32); *Our Mary in "As You Like It"*; *Fruit*; *Vegetables*; *Spring*; *Modern Conveniences*; *Incense of a New Church*; *Paquebot "Paris"*; *Rue de Singe qui Pêche* (fig. 37); and a group of watercolors. Royal Cortissoz was sharp in his assessment: "Just what Mr. Demuth is driving at we cannot imagine, nor does it much matter, for his rigidly careful drawings of dull objects, though redeemed by an occasional flash of agreeable color, do not seem to us to have any artistic interest whatever."[168] Even critics who knew the artist's work well were perplexed, though Henry McBride declared *End of the Parade* "one of the most important pictures in modern American Art," observing "the result, in spite of the concrete, is beautiful."[169]

In a second review, McBride was more emphatic in his assessment:

*The newest formulas of the artist, though not in water color, seem to have grown from his former experiments. The mills and factories which loom so largely across the modern horizon continue to dominate his thoughts and in spite of the jump into a new medium, the artist's feeling is more vigorously expressed than ever. His towering smokestacks, relentless iron girders and violent red bricks are implacably of this era, and the strange thing of the matter is that these red bricks and iron girders, in Mr. Demuth's versions of them, seem beautiful.[170]*

McBride was fascinated by Demuth's new work:

*Although he sees beauty in smokestacks, Mr. Demuth is not above laughing at them, or perhaps at us. He puts titles upon them that disturb academicians. One pair of stacks, lovingly supporting each other, is labeled Aucassin et Nicolette, and another glimpse of something strictly industrial is called Incense of a New Church. This last one is one of the finest of the new pictures. The color scheme is limited to blues, blacks and browns. Black stacks raise themselves in the rear against blue skies, and a mass of something light, incense, or perhaps steaming molten metal floods the foreground like lava from a Vesuvius. It is intense and rich.[171]*

He predicted of *Incense of a New Church*: "Perhaps some museum will have the courage to acquire it. Sooner or later it will land in one anyway."[172] Writing in *The Dial*, he observed: "He makes of it a thing that seems to glorify a subject that the rest of us have been taught to consider ugly."[173] A. E. Gallatin confirmed this view: "These unlovely

things, belonging so distinctly to our era of commercialism and mass production, have been made lovely by Demuth's rare art."[174]

**CRITICAL RECEPTION**

The critical reception of Demuth's late architectural works has a different history than that of his first series.[175] They were not shown in a group, as were those executed earlier in the 1920s. His last solo show at the Daniel Gallery (his eighth) was held during November and December 1923, and in 1925 Stieglitz began to present his work, mounting annual solo shows at The Intimate Gallery between 1926 and 1929. Stieglitz's final solo show of Demuth's paintings was held at An American Place in 1931. In none of these exhibitions did architectural themes dominate as they had at Daniel, though this is likely due to their smaller numbers, Stieglitz's ongoing ambivalence regarding Demuth's work, and — perhaps most importantly — the health issues that made Demuth's production erratic during his last years.

The 1931 show was retrospective in nature, presenting work from several different periods, including his early illustrations for Henry James, a series of still-life paintings of flowers and fruits, and poster portraits (among them *The Figure 5 in Gold*, fig. 44). The architectural paintings therefore received no special emphasis in their presentation, though one reviewer was struck by what she saw:

*When he goes out to paint a city street, Mr. Demuth will never set up his easel until he comes to a big fine advertisement plastered across a building. It need not be a very elaborate advertisement nor a very distinguished one. It will be distinguished, you may be sure, before Demuth has got through with it, and, like a good actor, letter-perfect. Surely they could never entice Demuth into any society for the preservation of the countryside — he would murmur admiring incantations before every rural signboard and think how stunning it would look in a landscape.*[176]

She was not the only one to be struck by his "passion for lettering," and Edward Alden Jewell noted: "When an artist reacts as intensely as this to the symbols of the alphabet he ought really to be called not a letterer, but a letterist. Some of his most recent pictures, though in their elements crystal-clear, are inclined to baffle."[177] While he may have been

referring to Demuth's poster portraits, these are qualities characteristic of the words and letters found in his architectural paintings as well.

Paul Rosenfeld recognized the fundamental strength of the work. "For all their delicacy, the forms as tense, stripped, and steely" paintings "bring one into relation with life, with American life in particular."[178] He found "The exhibition was rich in new revelations of the chance harmonies of the American scene," which included "the grotesque and monstrous forms of the industrial landscape."[179] He catalogued the artist's characteristic devices:

*He uses vulgar motives, painted signs, ventilators, fire-escapes, directive arrows, machine-made numerals, sometimes with a metaphorical intention, sometimes with a realistic one; but invariably with a keen appreciation of their humor and identities. Indeed, many of the freshest, most original perceptions of the chance beauties of wharves, grain-elevators, chimneys, office-building rears and fronts, are to be found in the aristocratic company of his paintings, with their Vermeer-like surfaces; far more than in the rival performances of Charles Sheeler, Peter Blume, Niles Spencer, and other accomplished craftsmen.*[180]

In his prose, the critic captured the astringent harmony of the heterogeneous elements of Demuth's work:

*There is also a certain nervous erotic suffusion in his paintings of wharves and chimneys: the blush and incandescence of things severe, angular, unyielding, and instantaneously charged by incalculable ecstasy. But even these feelings are of the race like the elegance and snap: products of the soil, the light and the blood of the people. And, like the elegance, the fine coolness, the smartness that speak so triumphantly from these paintings, these feelings merely help to identify the general expression as part of an American self-consciousness, a symbol of American life.*[181]

Angela E. Hagen regarded them as "highly sublimated posters" that defied their own commonplace subjects with immaculate workmanship: "houses bearing signs of feed and grain dealers, ships' funnels, a stark water tower, a maze of telegraph wires stretched between shacks."[182] Painter Henry Schnakenberg regarded them as "adventures into the realms of more abstract ideas."[183] Their strong formality struck Edward Alden Jewell: "As applied to houses and landscapes the device, possibly deriving from chance shafts of sunlight, is often puzzling. One

is always respectful, however, suspecting that it must be profoundly connected with higher mathematics."[184] An architectural painting included in a group show of the work of five artists at An American Place was pronounced "powerful in its pure, deeply pondered simplicity of statement."[185] When it was shown at the first Whitney Biennial in late 1932, Dorothy Grafly admired the austerity of the "clean-cut realistic geometry"[186] of *Buildings Abstraction, Lancaster* (pl. 5). Henry McBride regarded his "clean factories" as "an elegant reaction to the Machine Age."[187]

**THE ROLE OF THE SKETCH**

When Cortissoz dismissed Demuth's architectural paintings as "rigidly careful drawings of dull objects,"[188] he inadvertently referenced the intriguing role the artist's sketches played in their creation. That these paintings were significant productions for the artist may be seen in the drawings he made before beginning at his easel. Demuth rarely did preliminary studies, and the importance of the late architectural paintings to the artist, as well as the technical difficulties they represented, is attested to by the fact that he produced more pencil drawings for them than for any of his other works, including the series of 1920–21 (six studies can be linked to *And the Home of the Brave*, pl. 6). His compulsion to make these preliminary sketches, even in a minor fashion, suggests both an ambivalence as he commenced his last series and a recognition that they were major works. His unpredictable health may have also made him wish to work out several preliminary ideas before applying paint to his boards. When working on subjects from adjacent sites, the artist made studies of details for several paintings at the same time. While these drawings set out the basic compositional details, they lack the sharp delineation and energizing diagonal lines and arcs, which, combined with a strong sense of geometry and structure, give such tightness to the finished paintings. Unlike Sheeler, Demuth did not regard his drawings as finished works of art. The careless, stained pages of his sketchbooks were not intended to last like the fine watercolor paper he used for his still lifes. That he made the sketches on site also accounts for their condition.

Watercolor was a medium Demuth could work in even when he was ill, as he did when he was hospitalized in Morristown. But the larger scale of his architectural compositions, the shift to oil, and the

greater energy these works required of an artist often in ill health all led Demuth to sketch out the main details of these compositions ahead of time. For some he made several drawings before beginning to paint, sometimes including brief color notations. But his studies varied in the amount of detail he felt it necessary to put down, and his approach to painting was surprisingly intuitive. Demuth frequently changed his mind as he worked, a point addressed in depth in Barry's essay.

The artist made scant comment regarding his working processes and the techniques he employed. He tended to work directly on his surfaces, whether they were paper, canvas, or board. This may seem surprising for an artist for whom clarity and control are apparent hallmarks of his work, but in his paintings his pencil lines are carefully inscribed and paint is laid on thinly. He recognized that each painting medium required a different kind of discipline, as he observed to Stieglitz in September 1923: "I've only painted in water-colour; the strain is greater, but I don't have to return and fuss if it goes bad as one always does in oil or tempera."[189]

Demuth executed many more watercolors than he did oils, laying fluid washes over an underlayer of pencil drawing. He would give a hard edge to his washes by employing something with a firm side to stop the flow of the watercolor and concentrate his color. Demuth applied his washes thinly, in contrast to his contemporary John Marin, who laid on his paints densely, employing a strongly graphic stroke. One was as apparently intuitive as the other was analytical. The Lancaster artist was more cerebral, intellectual, and deliberate in technique.

Demuth's mature watercolor style was established around 1915, becoming more geometric after his 1917 trip to Bermuda. Watercolor was less physically taxing, as compared to the more exhausting and time-consuming discipline of oil painting. His was a measured process of distillation and editing, carefully considering his compositions before quickly sketching his subjects on paper with his pencil, after which he would add watercolor washes. His luminous surfaces were achieved through a range of techniques, including blotting to increase the painterly effect, and shunts (perhaps the edge of a piece of paper) to create the crisp lines that structure his compositions. The bright colors and fluid lines of these paintings are typical of his mature work.

The pencil drawing that provides the scaffolding for his watercolor washes contrasts with the pencil studies he made for his architectural paintings. For all their lightness and transparency, these watercolors

were fully conceived and finished works of art. Drawings and other works on paper were significant areas of artistic activity for American modernist artists, including those in the Stieglitz circle.[190] This is documented by Stieglitz's private collection: "It is noteworthy that of the more than 600 works of art (not including photographs by Stieglitz) donated from his estate to five American museums in 1949, approximately 470 were drawings, watercolors, and prints."[191] Demuth produced major works in watercolor, but his pencil drawings were clearly personal and not intended for exhibition. The precise delineation possible in pencil did not interest him. For him, it was his least expressive medium.

Most of his studies for his late architectural paintings are allusively sketchy, suggesting the location of buildings. In one for *Chimney and Water Tower* (pl. 3), he has made notations of "Dark" and "Little" near the red-brick building in the middle foreground and near the tank of the water tower, respectively (fig. 85). Major details and final formal features are laid out in what was his usual practice with these paintings, but missing are most of the energizing diagonals that so powerfully animate his painting. Another sketch could relate to either *Chimney and Water Tower* (pl. 3) or *Buildings* (pl. 4), conveying an ambiguity of identification that documents the intuitive nature of his working methods (fig. 92). The tank is stubby like that in *Chimney and Water Tower*, with a low pitched top, though the formal configuration seems closer to *Buildings*. Neither have the distinctive rounded bottom.

Three drawings for *After All* (pl. 7) are from the same sketchbook and are made on cheap paper;[192] the grease spots attest to the informality of the process. That Demuth made a series spoke to the complexity of the buildings, surrounding structures, and their formal relationships — and perhaps to the greater difficulty of getting to the site, some distance from his house. Still, the artist obviously relied a good deal on a sharp visual memory.

One sketch in particular presents most of the final details of the finished oil (fig. 93). The major features are in their final positions, though he altered many of the smaller details as he worked on the painting. The basic organizing lines, which have nothing to do with the actual structures, are precisely included in the finished piece, though some correspond to the power lines that must have been on the site. Some of the color notations he made at the bottom right — "Red" and "Black" — he only followed in the wedge of red in the finished piece. The

lighting feature on a pole is near the center of the drawing, but is in front of the building at the left in the end. Other small features disappear entirely. Interestingly, his color notations are generalized and minimal as compared with the complex coloration of his final canvases.

The configuration of the cyclone separator — such a distinctive feature in the lower right corner of the painting — clearly fascinated Demuth, and he made two detailed studies of it. Its unusual shapes would have appealed to an artist who had many friends within the American Dada movement and who was a significant delineator of Machine Age imagery. One separator was in the drawing just discussed. The other was in a second drawing, where it and the top features of the central building are laid out, each at right angles to the other (fig. 91). The baroque curves of the pipes provided him with an intriguing contrast to the zigzag of the exterior set of stairs to the right of the central building.

In a third study he made quick sketches of individual details of specific elements (fig. 90). These include the lighting fixture and the pole to which it is attached, the piping on the top of the central building, the external balcony feature on the building to the left, and the bracket area between the brick top and solid red bottom of the same building. Above this he has written "Red," the color in which it is painted. A pipe topped by a conical cover resembling a hat appears at left.

Georgia O'Keeffe also made preliminary sketches for her architectural works, though they have not been widely reproduced. Barbara Buhler Lynes has observed that these sketches "are largely important only in that they reveal a relatively unknown dimension of O'Keeffe's working methods — a lifelong habit of making preparatory drawings for works in other mediums." The artist herself "rarely referred to this aspect of her activity,"[193] though in truth there was a great deal regarding her artistic practice about which she did not elaborate. The drawing *Untitled (New York Street with Moon)* lays out the edges of the buildings, with notations of "dark," "purple," and "pink" made on the paper (fig. 84). It did not give the artist much to work from, but rather served as a quick notation made as an aide-mémoire. Such studies by Demuth and O'Keeffe were never exhibited.

While Demuth's drawings for his paintings vary in how closely they relate to the final work, they serve as a strong reminder of just how important color was to the artist. Their lack of detail suggests that he worked quickly while on site, and that it was in the privacy of his studio

that he took the time to thoroughly conceptualize his ideas: "the form came gradually."[194] The practical lessons of academic drawing he had been taught at the Pennsylvania Academy of the Fine Arts or the School of Industrial Art in Philadelphia at the turn of the century were of no use to him here. A process of intuitive working, aided by a good visual memory, was essential to his artistic method.[195]

## PORTRAITS OF LANCASTER ARCHITECTURE

In 1927, Demuth resumed his portrayal of Lancaster architecture. His most famous work from this series is the first, *My Egypt* (pl. 1), which, like most of the related works, records a specific site in the city not far from the artist's home on East King Street. In connecting the structures of American industry with the great architecture of ancient Egypt and Greece, the work highlights an irony of contemporary American life and the grandeur it represents. Critics were again perplexed by what Royal Cortissoz regarded as the "bleak caprices"[196] of this painting. Edward Alden Jewell found it "a very curious venture," which, he indicated with some understatement, "has nothing whatever to do with the Nile or the pyramids."[197] But a statement from An American Place asserted it captured "perhaps the finest sense of a modern age that has been expressed."[198] Another critic observed: "The Demuth piece is a factory fantasy of inspired angles. Diagonal light-rays lance two central cylindrical towers and drive the eye to the center of the picture."[199] William Carlos Williams evokes the painter's visual effects in "The Crimson Cyclamen,"[200] the poem he wrote in Demuth's memory:

*Upon each leaf it is*
*a pattern more*
*of logic than a purpose*
*links each part to the rest,*
*an abstraction*
*playfully following*
*centripetal*
*devices, as of pure thought —*
*the edge tying by*
*convergent, crazy rays*
*with the center —*
*where that dips*
*cupping down to the*

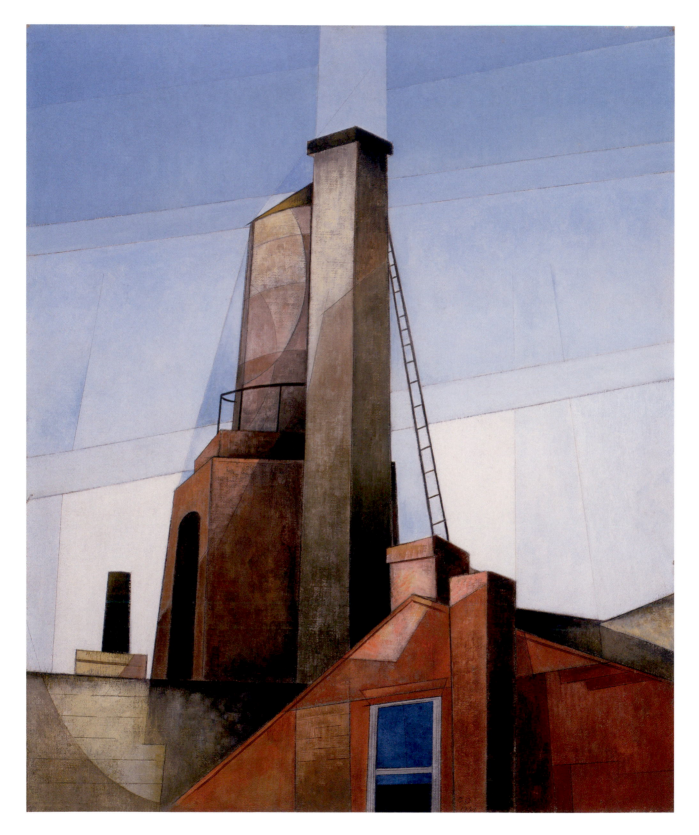

Fig. 50
Charles Demuth
*Aucassin and Nicolette*, 1921

*upright stem — the source*
*that has splayed out*
*fanwise and returns*
*upon itself in the design*
*thus decoratively —*

*My Egypt* (pl. 1) is a painting of considerable iconographical richness, and the reinforced concrete grain elevator, constructed in 1919, held a complex meaning for the artist. It alludes to local agribusiness, the monumental tombs of the ancient pyramids suggestive of death (and by extension, Demuth's own fragile health), and even the biblical stories the artist had been told as a child. It was a stunning beginning for Demuth's last series.

Three of the late architectural paintings were inspired by a single site: the Armstrong Cork factory complex (now Armstrong World Industries), then a major producer of linoleum. The structures of the factory clearly intrigued Demuth, for he painted more works of this site than he did of any other in Lancaster. (*Machinery* [fig. 57], another of his great Precisionist paintings, derived from the Armstrong plant as well.) Armstrong was located several miles from the artist's home, too far a distance for him to easily walk with his sketchbook. Either friends drove him there, or he took public transportation (given the number of people the company employed, this would likely have been a convenient option).

The earliest in the Armstrong series is *Chimney and Water Tower* (pl. 3), which presents a stark view of the factory. A staid relative to the later *After All* (pl. 7), the painting assumes the impassive iconic status of *My Egypt* (pl. 1). The reds and grays are infused with purple, the surface more painterly than at first apparent, and the composition less assured. He had been fascinated by the formal configuration of such tall elements in his architectonic and anthropomorphic *Aucassin and Nicolette*, which features a chimney stack and water tower as its central motif (fig. 50). As with *Chimney and Water Tower* (pl. 3), the site is identifiable, but the shift in the artist's aesthetic and formal language in the intervening decade is unmistakable. In its busier composition and arcane literary title, the earlier painting pales before the formal power of the later work. The configuration of the distinctive tank and water tower closely resembles Demuth's composition for *Chimney and Water Tower* (pl. 3). *Buildings* (pl. 4) pictures the same industrial elements (fig. 51), though in a different configuration and with the addition of a second tank.

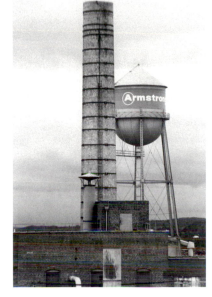

Fig. 51
Lew Engle
Armstrong's water tower and smokestack,
ca. 1986

*After All* (pl. 7) is one of Demuth's most complex compositions and the artist's last major work. His interest in industrial subjects found strong confirmation in the poetry of William Carlos Williams. Williams, who met Demuth at an early age and remained friends with him throughout the artist's life, offers powerful parallels to Demuth's paintings in the theme and style of his poetry and in an "aesthetic of place" grounded in the local. Like Demuth, Williams' work shares connections with Cubism, Dada, and Precisionism. Both found their voices in an American idiom about 1920, aiming to achieve a balance between the literal and the symbolic. The poet's sense of the allusive fragment, whose visual counterpart so powerfully animates Demuth's paintings, may be seen in two lines from an architectonic poem published in 1917, which could practically be a detail from one of the artist's works:

*To the right, jutting in,*
*a dark crimson corner of a roof.* [201]

Its visual analogue is a Gloucester painting, *Masts*, purchased by Albert Barnes in 1921 (fig. 52).

Demuth drew inspiration from the earlier industrial enthusiasms of another poet, Walt Whitman. Whitman's poem "Song of the Exposition," published in *Leaves of Grass*, is the source of the title of *After All* (pl. 7). An ode to American industry, it was read at the opening of the 40th National Industrial Exhibition in New York in September 1871, where a wide range of manufactured products was shown. Originally titled "After All, Not to Create Only," taken from the first lines, Whitman revised and re-titled it in 1876 for the centennial. The first edition of *Leaves of Grass* was published in 1855, and nine editions appeared before the author's death in 1892; he regularly made revisions and added new poems. Whitman's ardently lush celebration of the American local was a theme of continuing interest to American artists like Demuth.

In "After All" Whitman "reflects on the uses to which European ideologies and material cultures have been put,"[202] shifting the emphasis to national themes:

*After all not to create only, or found only,*
*But to bring perhaps from afar what is already founded,*
*To give it our own identity, average, limitless, free,*
*To fill the gross the torpid bulk with vital religious fire,*

Fig. 52
Charles Demuth
*Masts*, 1919

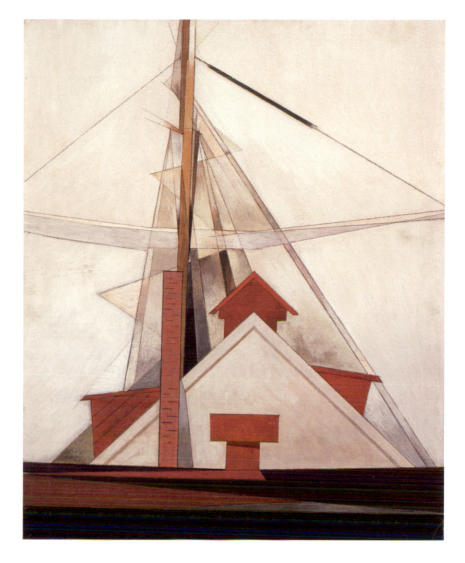

*Not to repel or destroy so much as accept, fuse, rehabilitate,*
*To obey as well as command, to follow more than to lead,*
*These also are the lessons of our New World;*
*While how little the New after all, how much the Old, Old World!*

Other lines celebrate the "…thud of machinery and shrill steam-whistle…" as he lauds a "…waking vision" of "earth's modern wonder…":

*Mightier than Egypt's tombs,*
*Fairer than Grecia's, Roma's temples,*
*Prouder than Milan's statued, spired cathedral,*
*More picturesque than Rhenish castle-keeps,*
*We plan even now to raise, beyond them all,*

Learning Centre Canolfan Dysgu
Coleg Y Cymoedd Campus Nantgarw Campus
Heol Y Coleg, Parc Nantgarw
CF15 7QY
01443 654168 663168

*Thy great cathedral sacred industry, no tomb,*
*A keep for life for practical invention.*

The line "Mightier than Egypt's tombs" might also provide a gloss on *My Egypt* (pl. 1). For Whitman, such modern industry represented a "world of works, trade, products," and workmen full of "…practical, busy movement…" with "…bugles sounding loud and clear" for "industry's campaigns." [203]

As a source of inspiration for practitioners of visual culture in both the nineteenth and twentieth centuries, Whitman's work transcended visual and ideological boundaries, offering the possibility that their nationalist goals as artists could be expressed through populist themes and indigenous sources. Charles Demuth was among that generation of artists and writers for whom Whitman affirmed a desire to achieve a distinctly American modernism firmly grounded in familiar national experience.

Whitman served as a touchstone for the early moderns, as well as an "energizer and guide."[204] Miles Orvell asserts: "For the Precisionist movement especially, a central cultural icon…was Walt Whitman."[205] Negotiating this territory was a complex process for American artists:

*The American response was not simply a wholehearted embrace of the new (as it was for the Italian Futurists); it was significantly tempered by an effort to connect the new age of the machine with some cultural tradition that would give it sanction. It was a characteristic of American modernism generally that the search for the new was accompanied by a backward look, a retrospective yearning to identify with the nineteenth-century past.*[206]

### THE ARMSTRONG COMPLEX

Such Whitmanesque considerations need to be brought down to the local level of Lancaster and the artist's specific inspiration for *After All* (pl. 7), for the corporate history of Armstrong is intertwined with the imagery of Demuth's painting[207] (fig. 53). The complex of buildings he pictured and the company whose operations it housed had roots in late nineteenth-century Pennsylvania, and the chronicle of Armstrong, cork, and linoleum in that state begins in 1860, when Thomas Morton Armstrong (1836–1908) acquired a small cork-cutting business in Pittsburgh. A resilient material, cork had broad domestic and commercial uses,

Fig. 53
Armstrong Floor Plant, Lancaster,
Pennsylvania, 1908–09

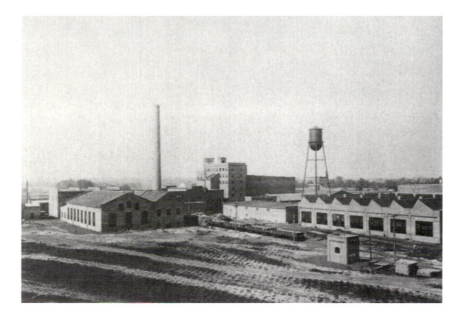

especially as stoppers and seals. Throughout the last quarter of the nineteenth century the company expanded nationally, and when the invention of the Mason screw-top jar and spring stoppers for bottles diminished the need for corks, Armstrong found other products it could market.[208]

In 1907 the company bought thirty-one acres of land in Manheim Township, just outside the northern city limits of Lancaster. That summer, construction began on a linoleum factory, a move that marked the end of the company's focus on corks and insulation. Production commenced in 1908, and by 1929 the Floor Division of the Lancaster plant accounted for 50 percent of all of Armstrong's business; by 1937, just after Demuth's death, Armstrong was the leading United States producer of linoleum. Eventually, the plant comprised 300 buildings on 250 acres.

The many structures on the site housed the various parts of the operation. Large tanks contained the linseed oil, which was combined with the cork flour to make linoleum. Tanks for a variety of purposes abounded on the site, and one is prominently featured in *Buildings* (pl. 4). The name linoleum derives from two Latin words for flax (*linum*) and oil (*oleum*). When the heavy amber-colored liquid made from flax seed was exposed to air, it thickened as it oxidized into a tough, elastic material. All forms of linoleum were "made from pigments, mineral fillers, cork or wood flour, and linseed oil. The oil, first whipped into a rubbery mass in steam-jacketed drums (fig. 54), is ground with the

Fig. 54
Undated image showing tanks for boiling
linseed oil, Armstrong factory complex,
Lancaster, Pennsylvania

Fig. 55
Linoleum being cured by festoon hanging
in stoves, Armstrong factory complex,
Lancaster, Pennsylvania, 1909

other substances"[209] before being "calendered," or pressed on burlap under high pressure between "ponderous, hot rolls."[210] The burlap was sized so that it could be hung in great festoons one hundred feet high in large drying stoves (rather than on racks), where it would hang to harden for three weeks (fig. 55). The building in which this activity took place dominates the left side of *After All* (pl. 7) and can be seen in a photograph taken in 1986 (fig. 56).

The cyclone separator, such a plumply baroque element in *After All* (pl. 7), is the main subject in *Machinery*, a painting that he dedicated

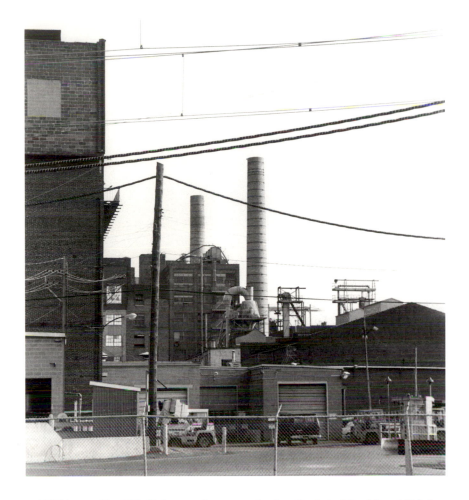

Fig. 56
Armstrong factory complex, 1986

to Williams (fig. 57). It is not the same device depicted in *After All* (pl. 7); but if it was not one from the Armstrong site, it was nevertheless a structure common in manufacturing complexes.

An aerial view taken in the late 1920s documents the factory complex, with the structures Demuth painted clearly visible (fig. 58). The spire of Trinity Lutheran Church can be seen in the upper right corner; the edifice, very near Demuth's house, was visible from his studio window.

Throughout the 1920s, the Armstrong complex continued to expand as new manufacturing technologies and burgeoning markets necessitated the construction of new buildings. A ten-story warehouse was erected, as was a nine-story structure to house the molding operation. Another to house general office functions was begun in 1925, and one for administration was erected in 1926. Further additions were made to these buildings several years later. By 1925, the Linoleum Division alone had 2,000 employees (one out of eleven of the local

Fig. 57
Charles Demuth
*Machinery*, 1920

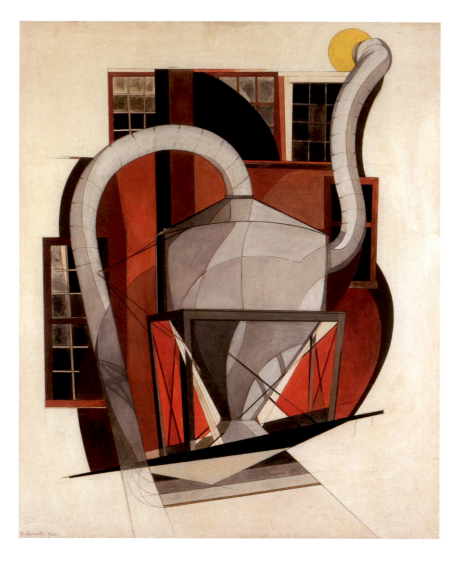

populace). What had begun as a means of diversification and making use of "cork scrap" now dominated the company's sales and earnings.[211] By the time Demuth began to paint the Armstrong complex, it had become the single largest industry in the city.[212]

*Chimney and Water Tower* (pl. 3) and *After All* (pl. 7) were executed two and four years, respectively, after the beginning of the Depression in October 1929. That year had actually been a record one for Armstrong earnings, as it was for many American businesses.[213] The economic downturn did not begin to affect them until the fourth quarter of 1930, and by 1932 sales were only a third of what they had been in 1929. By May 1933, the workforce had been trimmed by nearly 50 percent. Sales, stock values, salaries, and hourly wages plummeted, though the plant continued to produce a wide array of commercial, industrial, and

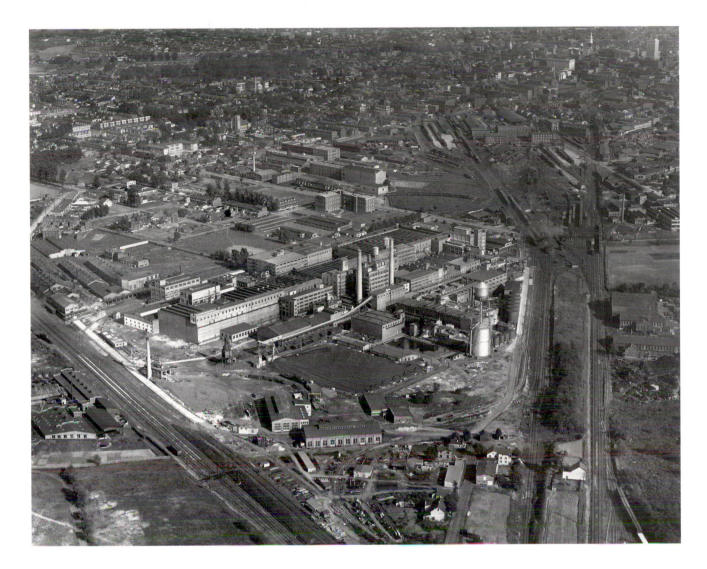

Fig. 58
Armstrong Cork Company, Lancaster,
Pennsylvania, May 21, 1927; the spire
of Trinity Lutheran Church, near
the Demuth home, can be seen in the
upper right

domestic flooring. Through rigorous management, the company made
it through the worst of the Depression. In 1935, the year of Demuth's
death, the company's recovery is documented by the listing of Armstrong
Common Stock on the New York Stock Exchange.

## LANCASTER AND THE TOBACCO INDUSTRY

The warehouses associated with tobacco storage and curing inspired
two of Demuth's late architectural paintings: *And the Home of the Brave*
(pl. 6) and *Buildings Abstraction, Lancaster* (pl. 5). The structures
they portray were adjacent to each other, not far from the Armstrong
complex. Demuth had a personal interest in the business his family had
operated in the city since the eighteenth century.

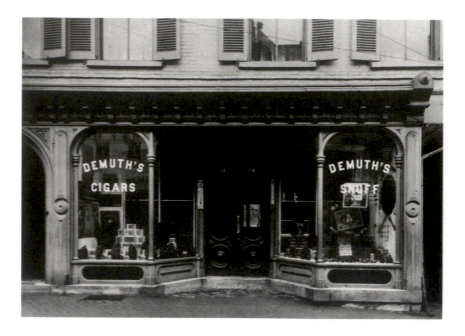

Fig. 59

Undated image of the Demuth tobacco shop

Like cork, tobacco was also a significant agricultural business, and by 1880 only New York State exceeded Pennsylvania in tobacco production. But where cork was imported, tobacco farming is an old enterprise in the state of Pennsylvania, dating from the Colonial period. However, it did not become a profitable crop until the late 1830s, a decade or so after Lancaster had been chartered as a city in 1818 (the county had been established in 1729). By the late nineteenth century, tobacco had become not only a leading cash crop in the state, but also in the county. Pennsylvania Seedleaf (later called Broadleaf) was primarily used as filler for cigars, for which the state was also a chief manufacturer. By 1924 more than 91 percent of the tobacco produced in Pennsylvania was grown in Lancaster County.[214]

Tobacco production proceeded according to a regular annual cycle. Planted in June and cultivated throughout the summer, it was harvested in September, cured between November and December, and stripped from December through March, when it was delivered to buyers. A combination of soil and climate made growing conditions in the county highly favorable, and a well-organized system of production, curing, and marketing made it profitable for local producers.

By the time of Demuth's birth, his family economics were strongly connected with tobacco. The Demuth tobacco shop opened in 1770 (fig. 59). Beginning as a snuff manufacturer and tobacco retailer, the firm later produced cigars and chewing tobacco and sold pipes and other products related to tobacco consumption. The Demuth shop featured

Fig. 60
Young Charles in the family tobacco store,
early 1890s

Fig. 61
Undated image of Ferdinand Demuth inside
the Demuth tobacco shop

its own cigar brand, the "Golden Lion," which had been first made in 1870. The shop was close to many sites the artist painted, including Trinity Lutheran Church to the rear and the Lancaster County Court House a few blocks south. In a photograph made in the early 1890s, young Charles is seated in the store's interior with two patrons (fig. 60). Demuth's father, Ferdinand, appears in a photograph standing behind a counter in the shop (fig. 61).

Labor intensive, the considerable hand work connected with its growing, harvesting, curing, grading, and packaging meant that tobacco was cultivated on small farms of five to ten acres, a scale well suited to Lancaster County. Fields of its tall plants that could reach to the height of a farmer's shoulders were a distinctive sight. At harvest time, the entire plant was cut down and left on the ground for several hours to wilt before being gathered up and hung in tobacco barns, where they were air-cured for several months. The barns, full of carefully hung, fragrant plants, were a common sight, as seen in one photographed near Churchtown (fig. 62).

Farmers were, of necessity, both practical and entrepreneurial and often earned money by using the exteriors of these barns for advertising purposes. One Lancaster County barn featured signs urging viewers to "Chew Red Man" and to "Chew Tub Tobacco" (fig. 63), while another urged potential customers to "Chew Mail Pouch Tobacco: Treat Yourself to the Best" (fig. 64). Signage and lettering appear in a number of Demuth's architectural works; its source was in what Wanda

Fig. 62
Sheldon Dick (1906–1950)
*Tobacco Hanging in a Barn, Churchtown Vicinity, Lancaster County*, 1938

Fig. 63
Sheldon Dick
*Barn, Lancaster County or Vicinity,*
May 1938

Corn has termed the "billboard poetics" of New York, as well as in announcements found in rural areas of the country. By the turn of the century, advertisers increased their use of billboards and painted signs. Lancaster had many such vernacular promotions, both in the city and in the countryside.

Demuth had a practical relationship with the barns of Lancaster County. William Carlos Williams recalled: "He once decorated the side of a barn near his home with original designs on the theme of the hex insignia common in that country. I don't know which barn it was, but the innovation was successful with the local people."[215] The barn was likely quite similar to one recorded by FSA photographer Sheldon Dick in 1938 (fig. 65).

Such visual cues were common in downtown Lancaster, as seen in the bright yellow and blue sign on the side of the red brick building in *Buildings, Lancaster* (pl. 2). Over two stories tall, the painted sign was practically a Williams poem in brevity of word, typographical arrangement, and practical orthography:

*Office & Plant*
*Eshelman*
*EST. 1881*
*FEED*

The grain elevators that inspired *My Egypt* (pl. 1) stood adjacent to this building.

Some of the lettering Demuth includes in his paintings is real, and in other instances it is metaphorical. Words are an important element of his poster portraits, works that functioned as literal signs, abstracted

Fig. 64
Arthur Rothstein (1915–1985)
*Dutch Barn, Lancaster County*,
December 1941

Fig. 65
Sheldon Dick
*Lancaster County, Pennsylvania, Rural
Scene*, May 1938

renditions of friends. Demuth's late architectural works are austere, lacking in language, with the exception of a partially cut off number "72" in *And the Home of the Brave* (pl. 6). This refers quite literally to the route number of the street passing by the structures pictured, though New York viewers could not have been expected to get that particular reference. In borrowing a line from the national anthem for the title of one of his paintings, he conveys the Americanism of these works.

Demuth's late architectural work possesses a muralistic monumentality, as seen in *After All* (pl. 7). It was also recognizable in subject — the structures he painted are easily identified — but he does not intend to tell the story so typical of the didactic nature of mural painting. Nor does he include the workers so central to the conceptions of many muralists. Generally it is the structures, not those laboring inside them, that most interest the Precisionists. Such an emphasis also reflects the fact that Demuth is painting outside the site. It isn't that Demuth was uninterested in the human figure. The elegant fluidity of his watercolor vaudeville scenes and figures speaks to his delight in studying figures in motion. But they had no place in his industrial paintings.

### A LASTING FRIENDSHIP

Georgia O'Keeffe remained a close friend of Demuth's. The only woman celebrated in his poster portrait series,[216] she shared a psychological bond with him, for they both occupied an uneasy position within the Stieglitz circle. In contrast to Dove and Marin, Demuth was often "X," the wild card of his stable of artists, set outside by sexual preference. The heterosexuality of the Stieglitz circle was as vigorously

Fig. 66
Postcard from Georgia O'Keeffe to Charles
Demuth, postmarked July 14, 1931

THE BLACK MESA, ESPANOLA VALLEY, NEW MEXICO

proclaimed as was the masculine virility of Robert Henri a generation earlier. O'Keeffe was more privileged, first as Stieglitz's lover, then as his spouse, but she was still circumscribed by her gender, which simultaneously placed her both at the center and at the edge of the group. Both she and Demuth felt an intense need to create, and their regular self-imposed isolation from New York was in many ways a survival strategy forged from personal and emotional necessity. The imperatives of mental and physical health and work that impelled O'Keeffe to move to the Southwest kept Demuth grounded in Lancaster.

Demuth wrote a short essay for O'Keeffe's 1929 exhibition at The Intimate Gallery, and in July 1931 she sent him a postcard from New Mexico, on which she wrote her friend a short note: "A strange

world but a good one. My love to you. Georgia" (fig. 66). Early in May 1932, Demuth visited O'Keeffe in New York, and Carl Van Vechten, who recorded so many cultural notables of the period, took several photographs as they chatted in the sunshine on the sidewalk outside the old Museum of Modern Art building. One captures them smiling and talking, the mutual pleasure in their company evident (fig. 67). O'Keeffe is dressed with her typical severity, a black jacket over a white blouse, her hair covered in a black scarf pulled tightly around her head. Demuth had likely come to New York to see O'Keeffe's triptych of Manhattan buildings on exhibition at the Museum of Modern Art, part of the exhibition *Murals by American Painters and Photographers*. Two months before Van Vechten took their picture, in March 1932, Demuth made a codicil to the will he had drawn up in August 1911:

*I give and bequeath all paintings by my own production other than watercolors which may be owned by me at the time of my death, to Georgia O'Keeffe, Hotel Shelton, New York City, her heirs and legal representatives, absolutely.*[217]

The bequest, which comprised five of the late architectural paintings, included *Chimney and Water Tower* (pl. 3), a painting that resonated strongly within the web of their friendship. Its quiet monumentality memorializes the artist's most ambitious series of work, where he staked his claim as a Pennsylvania painter deeply established in region, yet easily moving within the sophisticated milieu of an international avant-garde. All seven late architectural

Fig. 67
Carl Van Vechten
*Charles Demuth and Georgia O'Keeffe*, 1932

masterworks remain emblematic of Lancaster, the artist's personal and aesthetic touchstone.

The Lancaster that Demuth depicted remains remarkably present. Although a number of the structures that inspired him have been demolished, much of the character of the physical fabric of his city remains. Spirit-lifting farmland vistas may still be found throughout the county, and the farmer's market remains in operation at the city's center. The tidy character of the red-brick architecture that still surrounds the artist's home (now a museum) conveys the visual structure that was the fundamental source of his work.

When Marsden Hartley wrote "Farewell, Charles," his moving tribute mourning his dear friend's early death, he referred not only to a friendship that had sustained him, but also to the continuing resonance of the structures Demuth had portrayed in his native town: "Charles is only just gone, and our private airs still resound with wave-length sharpness of his so recent presence. Charles has only just gone, rest his winsome bones."[218] The artist and his work remain solidly anchored in his province, which retains the palpable historical presence of Demuth's Lancaster.

# Notes

Abbreviations used in notes:

AS: *Alfred Stieglitz*

CD: *Charles Demuth*

YCAL: *Yale Collection of American Literature, Beinecke Rare Book and Manuscript Library, Yale University*

1. The artist earlier portrayed structures from this site in *Nospmas M. Egiap Nospmas M.* (1921, Munson-Williams-Proctor Arts Institute).

2. See Emily Farnham, "Charles Demuth: His Life, Psychology and Works," PhD diss. (Columbus: Ohio State University, 1959): 631–33.

3. Scholars have tended to distance him from Lancaster, but his chronology reveals that he spent all but three or four of his fifty-two years in residence there. He spent six months in Europe between October 1907 and March 1908, and again between December 1912 and spring 1914. He had an apartment on Washington Square South in New York City between the fall and spring of 1915–16, spending fall until spring 1917 in Bermuda. In August 1921 he left on his last European visit, returning in November. Emily Farnham, *Charles Demuth: Behind a Laughing Mask* (Norman: University of Oklahoma Press, 1971), 193–94.

4. A. E. Gallatin, *American Water-Colourists* (New York: E.P. Dutton, 1922), 23.

5. Matthew Baigell, "American Art and National Identity: The 1920s," *Arts Magazine*, 61 (February 1987): 49.

6. William Carlos Williams, *The Autobiography of William Carlos Williams* (New York: Random House, 1951): 151.

7. Bradford Fuller Swan, "In Perspective: Portrait of the Artist's Mother," *Providence Journal*, ca. March 1950, Weyand Scrapbook, V (Yale Collection of American Literature [YCAL], Beinecke Rare Book and Manuscript Library, Yale University): 301. Swan, a reporter, was married to Lila Locher, the niece of Robert Locher, Demuth's dear friend.

8. Emily Clark Balch to Carl Van Vechten, August 6, 1928. Carl Van Vechten Papers (YCAL); quoted by permission of the Carl Van Vechten Trust. Published in Bruce Kellner, "A 1928 Visit to 114 East King Street," *Demuth Dialogue*, 20:1 (September 2002): 2.

9. Marsden Hartley, "Farewell, Charles," in Alfred Kreymborg, Lewis Mumford, and Paul Rosenfeld, editors, *The New Caravan* (New York: W. W. Norton, 1936): 559.

10. When Henry C. Demuth died in 1906 after running the business since 1864, his two sons Ferdinand and Henry took it over. Ferdinand died on January 26, 1911, and his brother ran the business until his death in 1937. The Demuth Foundation, established in 1981, opened Demuth's house to the public in 1984. The foundation purchased the Snuff Mill in 1986 from Dorothea Demuth, and she continued to live at 118 E. King Street until her death at the age of 93 in 1992. She had managed the operation since the death of her husband, Christopher (a cousin of Charles Demuth), in 1978. In 1982, the foundation began publication of a newsletter, *Demuth Dialogue*.

11. Charles Daniel to Ferdinand Howald, July 7, 1923, as quoted in Bruce Kellner, *Letters of Charles Demuth, American Artist, 1883–1935* (Philadelphia: Temple University Press, 2000), 55.

12. Henry McBride, "Charles Demuth, Artist," in *Charles Demuth Memorial Exhibition* (New York: Whitney Museum of American Art, 1937): n.p.

13. Henry McBride to Florine Stettheimer, July 4, 1927, in Steven Watson and Catherine Morris, editors, *An Eye on the Modern Century: Selected Letters of Henry McBride* (New Haven: Yale University Press, 2000), 163.

14. Hartley, "Farewell, Charles," 560.

15. McBride, "Charles Demuth, Artist," in *Charles Demuth Memorial Exhibition*, n.p.

16. Floral watercolors by his aunt, Louisa Demuth, and grandmother, Caroline Demuth, are reproduced in Andrew Carnduff Ritchie, *Charles Demuth* (New York: Museum of Modern Art, 1950), 8–9.

17. Rita Wellman, "Charles Demuth: Artist," *Creative Art*, 9:6 (December 1931): 484.

18. Karen Davies, "Charles Sheeler in Doylestown and the Image of Rural Architecture," *Arts Magazine*, 59:7 (March 1985): 136.

19. Emily Clark Balch to Carl Van Vechten, August 6, 1928, *Demuth Dialogue*, 20 (September 2002): 2. She did not realize that Trinity Lutheran Church was not Moravian.

20. His friend Elsie Everts reported that no work hung in his studio: "The walls were barren and white-washed or painted white." Farnham, "Charles Demuth: His Life, Psychology and Works," 953. Others recalled that Augusta left everything as it had been during Demuth's lifetime.

21. Emily Clark Balch to Carl Van Vechten, August 6, 1928, *Demuth Dialogue*, 20 (September 2002): 2.

22. Henry McBride to Malcolm MacAdam, July 8, 1927, Watson and Morris, *An Eye on the Modern Century*, 168.

23. Ibid.

24. Augusta Demuth Will, dated May 24, 1941, Lancaster County Courthouse.

25. Swan, "In Perspective: Portrait of the Artist's Mother," Weyand Scrapbook, V (YCAL): 301.

26. Henry McBride, "Charles Demuth, Artist," *Magazine of Art*, 31:1 (January 1938): 21. For the larger context of Demuth's floral still lifes, see Ella M. Foshay, *Reflections of Nature: Flowers in American Art* (New York: Knopf, in association with the Whitney Museum of American Art, 1984).

27. Hartley, "Farewell, Charles," 561.

28. See Allan Antliff, *Anarchist Modernism: Art, Politics, and the First American Avant-Garde* (Chicago: University of Chicago Press, 2001).

29. Williams, *The Autobiography of William Carlos Williams*, 151.

30. Demuth never showed at Stieglitz's gallery 291, however. Rather, the Daniel Gallery (1913–32), which presented the work of many significant early American modernists, featured Demuth's work and gave him his first solo exhibition in 1914.

31. Jonathan Weinberg, *Ambition & Love in Modern American Art* (New Haven: Yale University Press, 2001), 78.

32. Barbara J. Bloemink, *The Life and Art of Florine Stettheimer* (New Haven: Yale University Press, 1995), 172.

33. Florine Stettheimer diary as quoted in Bloemink, *The Life and Art of Florine Stettheimer*, 212.

34. Muriel Draper, "Art," typescript, n.d. (after 1926), Muriel Draper Papers (YCAL), Box 11, folder 349.

35. Ibid.

36. Ibid.

37. CD to AS, April 1, 1929. Kellner, *Letters of Charles Demuth*, 117.

38. Lindsay Smith, editor, *I Shock Myself: The Autobiography of Beatrice Wood* (San Francisco: Chronicle Books, 1988): 33.

39. Ibid.

40. Ibid.

41. Steven Watson, *Strange Bedfellows: The First American Avant-Garde* (New York: Abbeville Press, 1991), 153.

42. Both artists showed at the Daniel Gallery. See Rachael Sadinsky and William G. Sackett, *Edward Fisk: American Modernist* (Lexington: University of Kentucky Art Museum, 1998). During the 1920s, Fisk was married to the sister of Agnes Boulton O'Neill, Cecil Boulton. He moved to Lexington to take a teaching position at the University of Kentucky in 1926.

43. Hartley, "Farewell, Charles," 556.

44. Interestingly, the Amon Carter Museum's painting bears the number seven in the title, implying there were at least four more. No other similar inscriptions are known.

45. CD to Agnes Boulton and Eugene O'Neill (ca. 1919), Kellner, *Letters of Charles Demuth*, 8.

46. CD to John Reed (ca. Autumn 1916), Kellner, *Letters of Charles Demuth*, 4.

47. CD to Albert C. Barnes, n.d. (ca. late April 1922); and CD to Albert C. Barnes, n.d. (ca. September 13, 1921), respectively. The Barnes Foundation Archives, Merion, Pennsylvania. Reprinted with permission.

48. CD to Agnes Boulton, Shane, and Eugene O'Neill (ca. late December 1919), Kellner, *Letters of Charles Demuth*, 10.

49. CD to Ettie Stettheimer (ca. September 1926), Kellner: 84.

50. Paul Rosenfeld, "Art: Charles Demuth," *The Nation*, 133:7 (October 7, 1931): 373.

51. CD to AS, August 31, 1921, Kellner, *Letters of Charles Demuth*, 20.

52. CD to Albert C. Barnes, n.d. (ca. August 28, 1921), The Barnes Foundation Archives, Merion, Pennsylvania. Reprinted with permission.

53. CD to Albert C. Barnes, n.d. (ca. October 11, 1921), The Barnes Foundation Archives, Merion, Pennsylvania. Reprinted with permission.

54. CD to William Carlos Williams, October 11, 1921, Kellner, *Letters of Charles Demuth*, 32.

55. For more on this phenomenon see Betsy Fahlman, "American Expatriate Artists Abroad," in Mary Kupiec Cayton and Peter W. Williams, editors, *Encyclopedia of American Cultural and Intellectual History*, vol. II (New York: Charles Scribner's Sons, 2001): 293–302.

56. CD to Henry McBride (ca. November 25, 1917), Kellner, *Letters of Charles Demuth*, 7.

57. CD to AS, November 28, 1921, Kellner, *Letters of Charles Demuth*, 37.

58. Ibid., 38.

59. CD to Albert C. Barnes, n.d. (ca. August 28, 1921), The Barnes Foundation Archives, Merion, Pennsylvania. Reprinted with permission.

60. *Drawings and Paintings by Picasso and Braque* was at 291, December 9, 1914 through January 11, 1915.

61. Albert C. Barnes to CD, November 27, 1922, The Barnes Foundation Archives, Merion, Pennsylvania. Reprinted with permission. Forty-four Demuth paintings remain in the collection of the Barnes Foundation.

62. One mark of their friendship is documented by the artist's will. When Marsden Hartley returned from Mexico in 1933, he presented Demuth with a carved stone Mayan toad he had purchased while there. It was kept on the dining room hearth in Lancaster until Demuth sent it to Stieglitz in 1934 or 1935. At Augusta's death, she honored her son's wishes and left it to Barnes' wife, Laura, who had formed a collection of the creatures for her garden. Augusta also left Barnes a set of dining room chairs that he must have admired on one of his visits.

63. CD to Albert C. Barnes, October 10, 1921, The Barnes Foundation Archives, Merion, Pennsylvania. Reprinted with permission.

64. CD to AS, March 7, 1931, Kellner, *Letters of Charles Demuth*, 132.

65. CD to Augusta Demuth, October 17, 1921, Kellner, *Letters of Charles Demuth*, 34.

66. CD to Albert C. Barnes, n.d. (spring 1921), The Barnes Foundation Archives, Merion, Pennsylvania. Reprinted with permission.

67. Ibid.

68. CD to Scofield Thayer, June 12, 1921, Kellner, *Letters of Charles Demuth*, 14.

69. CD to AS, October 12, 1930, Kellner, *Letters of Charles Demuth*, 130.

70. CD to AS, January 2, 1921, Kellner, *Letters of Charles Demuth*, 11.

71. CD to Albert C. Barnes, n.d. (ca. early April 1922), The Barnes Foundation Archives, Merion, Pennsylvania. Reprinted with permission.

72. Frederick M. Allen, "The Physiatric Institute: Address at Its Opening at Morristown, N.J., April 26, 1921," *Journal of the Medical Society of New Jersey*, 8 (June 1921): 192.

73. The first American to receive insulin was James Dexter Havens (1900–1960) in mid-May 1922.

74. Allen, "The Physiatric Institute: Address at Its Opening," 191.

75. Ibid.

76. Ibid.

77. Farnham, who did not have access to Barnes' correspondence, credited Augusta as funding his treatment. Farnham, *Charles Demuth: Behind a Laughing Mask*, 137.

78. Kellner indicates that it was Dr. Richard Reisman who made the diagnosis. Kellner, *Letters of Charles Demuth*, 11.

79. Albert C. Barnes to Charles Demuth, February 15, 1922, The Barnes Foundation Archives, Merion, Pennsylvania. Reprinted with permission.

80. Frederick M. Allen and James W. Sherrill, "Clinical Observations on Treatment and Progress in Diabetes," *Journal of Metabolic Research*, 1 (1922): 426.

81. Frederick M. Allen, "Clinical Observations with Insulin. 3. The Influence of Fat and Total Calories on Diabetes and the Insulin Requirement," *Journal of Metabolic Research*, 3 (January–June 1923): 61.

82. Williams, *The Autobiography of William Carlos Williams*, 152.

83. Michael Bliss, *The Discovery of Insulin* (Chicago: University of Chicago Press, 1982): 37.

84. Allen and Sherrill, "Clinical Observations on Treatment and Progress in Diabetes," 378.

85. Ibid., 380.

86. Ibid., 381.

87. Ibid., 414.

88. Albert C. Barnes to Charles Demuth, November 27, 1922, The Barnes Foundation Archives, Merion, Pennsylvania. Reprinted with permission.

89. CD to Albert C. Barnes, n.d. (ca. November 25, 1922), The Barnes Foundation Archives, Merion, Pennsylvania. Reprinted with permission.

90. James W. Sherrill to Richard Weyand, November 19, 1952, Weyand Scrapbook, x (YCAL): 194. Demuth's letters to Barnes also mention his having seen a Dr. Richard Reisman. Demuth gave Sherrill *Purple Iris* (1921, Farnham no. 685). It was sold at Durlacher Brothers in 1953. In 1988, the work was at Berry-Hill Galleries (see *American Paintings V*, 162–3).

91. Alexander Lieberman to Richard Weyand, October 5, 1940, Weyand Scrapbook, III (YCAL): 43. Lieberman owned *In Vaudeville* (ca. 1916, Farnham no. 176), *In Vaudeville: Vaudevillians* (1916, Farnham no. 186), *Field Flowers: Daffodils and Bluebells* (1922, Farnham no. 423), *Gladiolas* (1922, Farnham no. 427), and *White Tulips* (1922, Farnham no. 433). At least two were purchases.

92. CD to AS, August 31, 1921, Kellner, *Letters of Charles Demuth*, 19.

93. CD to Albert C. Barnes, n.d. (ca. October 11, 1921), The Barnes Foundation Archives, Merion, Pennsylvania. Reprinted with permission.

94. Ibid.

95. Hartley, "Farewell, Charles," 554, 560.

96. Emily Farnham interview with Charles Daniel, January 27, 1956, in Farnham, "Charles Demuth: His Life, Psychology and Works," 991.

97. CD to Albert C. Barnes, n.d. (ca. September 13, 1921), The Barnes Foundation Archives, Merion, Pennsylvania. Reprinted with permission.

98. Ibid.

99. CD to Albert C. Barnes, October 10, 1921, The Barnes Foundation Archives, Merion, Pennsylvania. Reprinted with permission. See also Farnham, *Charles Demuth: Behind a Laughing Mask*, 130.

100. CD to Albert C. Barnes, n.d. (ca. September 13, 1921), The Barnes Foundation Archives, Merion, Pennsylvania. Reprinted with permission.

101. Ibid.

102. CD to Albert C. Barnes, n.d. (ca. October 11, 1921), The Barnes Foundation Archives, Merion, Pennsylvania. Reprinted with permission.

103. Hartley, "Farewell, Charles," 558.

104. Ibid.

105. Ibid., 559

106. CD to Albert C. Barnes, n.d. (ca. October 11, 1921), The Barnes Foundation Archives, Merion, Pennsylvania. Reprinted with permission.

107. CD to Albert C. Barnes, October 17, 1921, The Barnes Foundation Archives, Merion, Pennsylvania. Reprinted with permission.

108. CD to AS, November 28, 1921, Kellner, *Letters of Charles Demuth*, 38.

109. Carl Van Vechten, "Pastiches et Pistaches," *The Reviewer*, 2:5 (February 1922): 270. Van Vechten owned two Vaudeville watercolors: *At Marshall's* (1915, Farnham no. 94) and *Juggler* (1916, Farnham no. 189). He is depicted in *Cabaret Interior with Carl Van Vechten* (1917, Private Collection). *At Marshalls* was once owned by Stettheimer.

110. Ibid., 269.

111. Ibid., 269–70.

112. CD to Carl Van Vechten, postmarked March 26, 1922, Kellner, *Letters of Charles Demuth*, 40–1.

113. CD to Albert C. Barnes, n.d. (ca. early April 1922), the Barnes Foundation Archives, Merion, Pennsylvania. Reprinted with permission.

114. CD to Albert C. Barnes, n.d. (ca. late April 1922), The Barnes Foundation Archives, Merion, Pennsylvania. Reprinted with permission.

115. Ibid.

116. CD to Albert C. Barnes, n.d. (ca. April 30, 1922), The Barnes Foundation Archives, Merion, Pennsylvania. Reprinted with permission.

117. Albert C. Barnes to Charles Demuth, May 1, 1922, The Barnes Foundation Archives, Merion, Pennsylvania. Reprinted with permission.

118. Barnes wrote Demuth: "The eight framed water colors came this morning and two unframed ones on Saturday. They are all nice but I don't think they would make you any better represented in my collection of yours, which comprises already forty-nine examples. If it would ease your mind to be free of the five hundred I loaned you, I'll cancel it in exchange for five of the framed Bermuda ones. You can't kick at that rate when I paid you forty each for the Nana set. However, I'll send the lot back if you wish." Albert C. Barnes to Charles Demuth, February 26, 1923, The Barnes Foundation Archives, Merion, Pennsylvania. Reprinted with permission.

119. CD to Albert C. Barnes, n.d. (ca. May 2, 1922), The Barnes Foundation Archives, Merion, Pennsylvania. Reprinted with permission.

120. CD to Albert C. Barnes, n.d. (ca. late May 1922), The Barnes Foundation Archives, Merion, Pennsylvania. Reprinted with permission.

121. CD to AS, July 30, 1922, Kellner, *Letters of Charles Demuth*, 43.

122. Daniel Papers, 23, as quoted in Julie Mellby, "A Record of Charles Daniel and the Daniel Gallery," PhD diss. (New York: City University of New York, Hunter College, 1993): 74.

123. CD to AS, July 30, 1922, Kellner, *Letters of Charles Demuth*, 43.

124. CD to AS, January 29, 1923, Kellner, *Letters of Charles Demuth*, 46.

125. Ibid.

126. CD to A. E. Gallatin, postmarked March 28, 1923, Kellner, *Letters of Charles Demuth*, 52.

127. CD to AS, April 16, 1923, Kellner, *Letters of Charles Demuth*, 53. Once the injections became more routine, the artist was apparently unselfconscious about them, as Charles Daniel recalled: "He would come into the gallery, roll up his sleeve, shoot the insulin in and go out to lunch. He did it religiously." Daniel Papers, 23, as quoted in Mellby, "A Record of Charles Daniel and the Daniel Gallery," 75. On January 9, 1925, Carl Van Vechten reported: "Demuth has to take injection of insulin every two hours to keep alive." Bruce Kellner, editor, *The Splendid Drunken Twenties: Selections from the Daybooks, 1922–1930* (Urbana: University of Illinois Press, 2003): 70.

128. Charles Demuth to Albert C. Barnes, n.d. (ca. April 15, 1923), The Barnes Foundation Archives, Merion, Pennsylvania. Reprinted with permission.

129 Ironically, the wide availability of insulin signaled the end of Allen's primacy in the field in which he had been a pioneer. With insulin readily available and broadly prescribed, Allen no longer dominated the clinical field, and the need of the institute he had established disappeared. Lacking the patients once willing to pay his high fees when his treatment represented their only hope of survival, Allen's finances deteriorated; plagued by debt, he finally lost the Morristown property in 1936. All the buildings were razed soon thereafter.

130. CD to AS, April 21, 1923, Kellner, *Letters of Charles Demuth*, 54.

131. CD to AS, May 2, 1923, Kellner, *Letters of Charles Demuth*, 55.

132. CD to AS, September 3, 1923, Kellner, *Letters of Charles Demuth*, 56.

133. Joyce's novel had been published in Paris in 1922, and several subsequent editions were seized by postal authorities in New York and England the next year. Not until 1933 did the United States District Court rule that the novel was not obscene.

134. Marianne Moore to John Warner Moore, April 8, 1923, Bonnie Costello, et al., editors, *The Selected Letters of Marianne Moore*, (New York: Alfred A. Knopf, 1997), 195–6.

135. Marianne Moore to Bryher (pen name of Winifred Ellerman), July 24, 1934, Costello, *The Selected Letters of Marianne Moore*, 326.

136. William Carlos Williams to Marianne Moore, August 23, 1928, John C. Thirlwall, editor, *The Selected Letters of William Carlos Williams*, (New York: McDowell, Obolensky, 1957), 107.

137. Marianne Moore to William Carlos Williams, September 23, 1951, Costello, *The Selected Letters of Marianne Moore*, 493.

138. Charles Daniel to Ferdinand Howald, June 22, 1923, as quoted by Kellner, *Letters of Charles Demuth*, 55.

139. Charles Daniel to Ferdinand Howald, July 7, 1923, as quoted by Kellner, *Letters of Charles Demuth*, 55.

140. CD to AS, January 16, 1924, Kellner, *Letters of Charles Demuth*, 58.

141. CD to AS, June 2, 1924, Kellner, *Letters of Charles Demuth*, 63.

142. CD to AS, July 12, 1926, Kellner, *Letters of Charles Demuth*, 79.

143. CD to Ettie Stettheimer (ca. September 1926), Kellner, *Letters of Charles Demuth*, 83.

144. CD to AS, September 19, 1926, Kellner, *Letters of Charles Demuth*, 85.

145. CD to AS, June 29, 1927, Kellner, *Letters of Charles Demuth*, 96.

146. CD to AS, ca. July 1927, Kellner, *Letters of Charles Demuth*, 98.

147. CD to Henry McBride, August 19, 1927, Kellner, *Letters of Charles Demuth*, 102.

148. CD to AS, June 18, 1928, Kellner, *Letters of Charles Demuth*, 108.

149. "Peggy Bacon did my portrait this summer," CD to AS, October 30, 1927, Kellner, *Letters of Charles Demuth*, 103.

150. Ibid., 104.

151. CD to AS, November 20, 1927, Kellner, *Letters of Charles Demuth*, 105.

152. CD to AS, June 4, 1928, Kellner, *Letters of Charles Demuth*, 106.

153. CD to AS, August 6, 1928, Kellner, *Letters of Charles Demuth*, 109.

154. CD to AS, November 6, 1928, Kellner, *Letters of Charles Demuth*, 110.

155. CD to AS, April 1, 1929, Kellner, *Letters of Charles Demuth*, 117.

156. CD to Edward Fisk, April 6, 1929, Kellner, *Letters of Charles Demuth*, 119.

157. CD to AS, August 13, 1929, Kellner, *Letters of Charles Demuth*, 121.

158. CD to AS, October 12, 1930, Kellner, *Letters of Charles Demuth*, 129.

159. CD to AS, September 10, 1931, Kellner, *Letters of Charles Demuth*, 133.

160. Wanda M. Corn, *The Great American Thing: Modern Art and National Identity, 1915–1935* (Berkeley: University of California Press, 1999).

161. John Dewey, "Americanism and Localism," *The Dial*, 68, no. 6 (June 1920): 687.

162. William Carlos Williams in *Contact*, 1 (December 1920): 1.

163. Marlene Park and Gerald E. Markowitz. *Democratic Vistas: Post Offices and Public Art in the New Deal* (Philadelphia: Temple University Press, 1984): 156.

164. William Carlos Williams, "Patterson," *The Complete Collected Poems of William Carlos Williams, 1906–1938* (Norfolk, Connecticut: New Directions, 1938): 297.

165. Henry McBride, "News and Reviews of Art — Attractive Winter Exhibitions in Many Galleries: Charles Demuth Displays His Beautiful Landscapes at Daniels [*sic*]," *The New York Herald*, December 5, 1920.

166. Ibid.

167. "The World of Art: Russian and American Paintings and a Group of Etchings," *New York Times*, December 19, 1920.

168. Royal Cortissoz, "Random Impressions in Current Exhibitions," *New York Times*, December 24, 1922.

169. Henry McBride, "Modern Art," *The Dial*, 70 (February 1921): 235.

170. Henry McBride, "Art News and Reviews — Important New Work on Watercolors: Remarkable paintings by Charles Demuth," *The New York Herald*, December 17, 1922.

171. Ibid.

172. Ibid.

173. Henry McBride, "Modern Art," *The Dial*, 74 (February 1923): 218.

174. A. E. Gallatin, *Charles Demuth* (New York: William Edwin Rudge, 1927), 8.

175. Emily Farnham compiled detailed lists of exhibitions in her diss., and Marilyn Kushner's "Exhibition History," which was included in Barbara Haskell, *Charles Demuth* (New York: Whitney Museum of American Art, 1988), lists reviews. The late architectural paintings were little seen in Demuth's lifetime. According to

Farnham, *My Egypt* was included in three group exhibitions: two at the Museum of Modern Art (1929, 1932) and in Venice at the Nineteenth Biennale (1934). Only the 1929 MoMA show, *Paintings by Nineteen Living Americans*, was reviewed, receiving five notices. *Buildings, Lancaster* was in the first Whitney Biennial (1932), and *After All* was in the second (1934). Only the 1932 show was reviewed. The other four paintings had no exhibition history, nor were they presented in solo shows in the artist's lifetime.

176. Ruth Green Harris, "Demuth," *New York Times*, April 19, 1931.

177. Edward Alden Jewell, "Demuth's Retrospective Show," *New York Times*, April 14, 1931.

178. Rosenfeld, "Art: Charles Demuth," 372.

179. Ibid.

180. Ibid., 372–3.

181. Ibid., 373.

182. Angela E. Hagen, "Around the Galleries: Demuth Watercolors and Oils at 'An American Place,'" *Creative Art*, 8:6 (June 1931): 442.

183. Henry E. Schnakenberg, "Charles Demuth," *The Arts*, 17:8 (May 1931): 581.

184. Jewell, "Demuth's Retrospective Show."

185. Edward Alden Jewell, "Art: Works by Five Artists Shown," *New York Times*, May 20, 1932.

186. Dorothy Grafly, "The Whitney Museum's Biennial," *American Magazine of Art*, 26:1 (January 1933): 5.

187. Henry McBride, "Attractions in the Galleries," *New York Sun*, May 21, 1932.

188. Cortissoz, "Random Impressions in Current Exhibitions."

189. CD to AS, September 3, 1923, Kellner, *Letters of Charles Demuth*, 57.

190. The literature on modernist watercolors is more substantial than that for drawing, and with the latter medium, the work of Georgia O'Keeffe has received the most attention. See Theodore E. Stebbins Jr., *American Master Drawings and Watercolors: A History of Works on Paper from Colonial Times to the Present* (New York: Harper and Row, 1976); Barbara Haskell, *Georgia O'Keeffe: Works on Paper* (Santa Fe: Museum of New Mexico Press, 1985); Carol Troyen and Erica E. Hirshler, *Charles Sheeler: Paintings and Drawings* (Boston: Museum of Fine Arts, 1987); Peter H. Hassrick, editor, *The Georgia O'Keeffe Museum* (Santa Fe: Georgia O'Keeffe Museum, 1997); Ruth E. Fine, et al., *O'Keeffe on Paper* (Washington, D.C.: National Gallery of Art, 2000); and Barbara Buhler Lynes and Russell Bowman, *O'Keeffe's O'Keeffes: The Artist's Collection* (Milwaukee: Milwaukee Art Museum and the Georgia O'Keeffe Museum, distributed by Thames and Hudson, 2001).

191. Ruth E. Fine and Elizabeth Glassman, "Thoughts Without Words: O'Keeffe in Context," in Fine, *O'Keeffe on Paper*, 14.

192. See "Acquisitions, January 1994–December 1995," *Yale University Art Gallery Bulletin 1995–96*, 90–4, 127. A gift of Dr. and Mrs. William R. Hill, in Memory of Richard Weyand. The Hill gift numbered forty-three items, as well as a sketchbook and a needlepoint under glass.

193. Lynes, *O'Keeffe's O'Keeffes: The Artist's Collection*, 54. The artist retained approximately 700 sketches (mostly pencil) in her personal collection.

194. "The Crimson Cyclamen," Williams, *The Complete Collected Poems of William Carlos Williams, 1906–1938*, 281.

195. A pencil study (Demuth Foundation) for the painting *Welcome to Our City* (1921, Terra Museum of American Art), which pictures the dome of the Lancaster County Court house, again has many of the main formal details worked out, though there are still significant changes in the final canvas. Related to this process are the five studies

for *Paquebot "Paris"* (1921–22, Columbus Museum of Art, Ohio, Gift of Ferdinand Howald). The number may be due to the fascination shipboard architecture held for Demuth, but also the tedium of a November crossing of the Atlantic. Having ample free time, he occupied himself by sketching. Two of the sketches have the visual jazziness of the final canvas, and on another he has made brief color notations (red, white, black) on the ship's funnels. These are recorded in Farnham, "Charles Demuth: His Life, Psychology and Works," 730–1, and reproduced in Ritchie, *Charles Demuth*, 75.

196. Royal Cortissoz, "Another Show at the Modern Museum," *New York Herald Tribune*, December 15, 1929.

197. Edward Alden Jewell, "Modern Art Museum — Art 'Twixt Covers," *New York Times*, December 22, 1929.

198. "It Must Be Said," An American Place, November 1935, reproduced in Farnham, *Charles Demuth: Behind a Laughing Mask*, 161.

199. "Modern Americans, Daniel Gallery," *Art News*, 26:13 (December 31, 1927): 9. Quoted in Mellby, "A Record of Charles Daniel and the Daniel Gallery," 92.

200. "The Crimson Cyclamen," Williams, *The Complete Collected Poems of William Carlos Williams, 1906–1938*, 282.

201. From "Woman Walking," A. Walton Litz and Christopher MacGowan, *The Collected Poems of William Carlos Williams, Volume I, 1909–1939* (New York: New Directions, 1986): 66.

202. Celeste Connor, *Democratic Visions: Art and Theory of the Stieglitz Circle, 1924–1934* (Berkeley: University of California Press, 2001): 173.

203. "Song of the Exposition," James E. Miller Jr., *Walt Whitman: Complete Poetry and Selected Prose* (Boston: Houghton Mifflin Co., 1959): 143–50. The comma is in the original title and as well as in the first line. But it was changed sometime thereafter, and since

the poet died in 1892, the final orthography had been set long before Demuth began his artistic consideration of Whitman. See Justin Kaplan, *Walt Whitman: A Life* (New York: Simon and Schuster, 1980): 341–2.

204. Ruth L. Bohan, "'I Sing the Body Electric': Isadora Duncan, Whitman, and the Dance," in Ezra Greenspan, editor, *The Cambridge Companion to Walt Whitman* (New York: Cambridge University Press, 1995): 167.

205. Miles Orvell, "The Artist Looks at the Machine: Whitman, Sheeler, and the American Modernism," *Amerika Studien / American Studies*, 41:3 (Stuttgart: J. B. Metzlersche Verlagsbuchhandlung, 1996): 362.

206. Ibid.

207. Incorporated as the Armstrong Cork Company in 1895, seven manufacturers were now under its management. The three located in Lancaster were eventually combined to form the Lancaster Cork Works. For information on the history of Armstrong, see *History of the Floor Plant, 1908–1980* (Lancaster, Pennsylvania: Armstrong, 1980) and William A. Mehler Jr., *Let the Buyer Have Faith: The Story of Armstrong* (Lancaster, Pennsylvania: Armstrong World Industries, 1987).

208. In addition to the most obvious ones as sealers for soda water bottles, beer kegs, and jars, the material was also used for automobile gaskets, shoe insoles, disks and washers for metal caps, bulletin boards, bathmats, centers for baseballs, brick for cow stalls, life preservers, yacht fenders, anchorage buoys, fishing line bobbers, tips for pen holders, hat linings, friction clutches, cigarette tips, strips for pince-nez glasses, handles for fishing rods, whips, bicycles, and trowels. In factories it could provide noise absorption, and it was widely used for acoustical tile and insulation in commercial and residential structures.

209. "Armstrong Cork," *Fortune*, 15 (May 1937): 103.

210. Ibid.

211. Mehler, *Let the Buyer Have Faith*, 28.

212. There were fourteen staff departments. The number of departments gives a sense of the scale of the operation Demuth painted: Credit, Purchasing, Sales Promotion, Advertising, Office Management, Traffic, Scheduling, Statistical, Patent, Industrial Engineering, Research, Forestry, and Technical. There were five divisions: Cork, Insulation, Floor (formerly Linoleum), Corkwood, and Foreign Manufacturing and Sales; and there were fourteen subsidiaries (seven domestic, seven foreign). The plant employed about 170 people the first year. By 1913 that number had increased to over 600, and to 1,600 in 1922. The annual sales volume in 1907 was $5 million, and in 1929 it was $48 million. Linoleum manufacture and sales continued to remain successful until well after World War II. By about 1950, more versatile vinyl and plastic floor coverings made their debut. In 1974, technological changes in the flooring industry rendered the manufacture of linoleum no longer viable, and the company ceased production and the operation of the cork mill.

213. World events could impact the company in interesting ways. With the establishment of the Spanish Republic in 1931, there was political unrest, especially in the north where the cork operations were located. Civil War began in Spain in 1936 and ended in 1939. The need for burlap sandbags had a similar effect during World War I.

214. Some comparative figures document the development of the industry. In 1839, Lancaster County produced more than forty-eight thousand pounds of tobacco, but by 1919 the tonnage had reached fifty million pounds.

215. Williams, *The Autobiography of William Carlos Williams*, 153.

216. For more on his poster portraits, see Robin Jaffee Frank, *Charles Demuth: Poster Portraits 1923–1929* (New Haven: Yale University Art Gallery, 1994). Other significant literature relating to these works is cited in her bibliography.

217. "Codicil to My Last Will and Testament"; the will is dated August 31, 1911; the codicil, March 12, 1932. Transcription in Weyand Scrapbook V (YCAL): 360. In 1931, he gave O'Keeffe *Landscape With Two Houses* (ca. 1912, Metropolitan Museum of Art). It came to the museum in 1949 as part of the Stieglitz bequest.

218. Hartley, "Farewell, Charles," 552.

Learning Centre, Canolfan Dysgu
Coleg Y Cymoedd Campws Nantgarw Campus
Heol Y Coleg, Ffordd Nantgarw
CF15 7QY
Ffôn 01443 653055 / 663166

# ACROSS THE FINAL SURFACE

*Observations on Charles Demuth's Painting Materials*
*and Working Methods in His Late Industrial Oil Paintings*

Claire Barry

Learning Centre, Canolfan Dysgu
Coleg Y Cymoedd, Campus Nantgarw Campus
Heol Y Coleg, Parc Nantgarw
CF15 7QY
01443 653655 / 663168

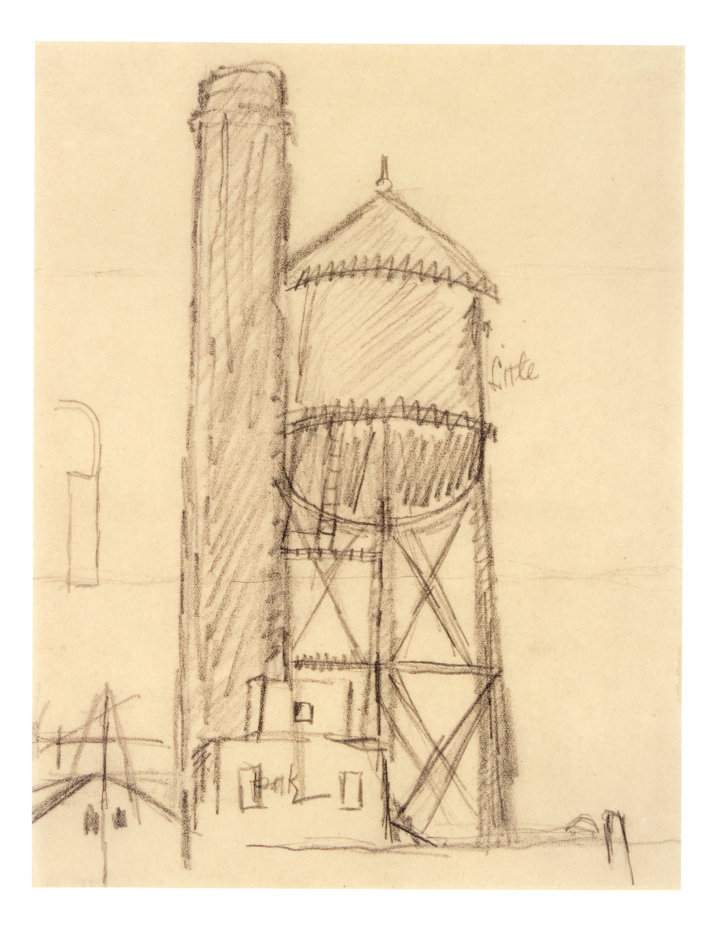

Charles Demuth once wrote, "Pictures must be understood through the eye — no writing, no singing, no dancing will explain them. They are final."[1] This technical study of Demuth's industrial paintings was initiated to gain a better understanding of the artist's working methods through a direct examination of the works of art themselves. Seminal examples of the American Precisionist style, they became Demuth's most lasting work. The fact that they were executed entirely in oil on panel is of special interest, since this aspect of the artist's painting technique has heretofore received little attention. Charles Demuth, along with Charles Sheeler, was the painter most closely linked with Precisionism, a modernist movement that flourished in America during the 1920s and 1930s. Finding inspiration from the development of Cubism in Europe as well as from the rapidly developing industry of the United States, Demuth combined realism with geometric form to create unique architectural abstractions. Yet published conservation studies have previously overlooked discussion of the working methods that engendered Demuth's Precisionist paintings.

Fig. 85
Charles Demuth
Study for *Chimney and Water Tower*,
ca. 1931

Although he and Sheeler shared the visual language of Precisionism, Demuth was more influenced by the working methods of some Stieglitz circle artists. The exchange of technical information that occurred among painters in the Stieglitz group informed a number of Demuth's choices regarding painting materials and framing — an exchange that influenced his initial aesthetic decisions and that today is reflected in the excellent condition of his paintings. His close friendships with fellow artists, especially Marsden Hartley and Georgia O'Keeffe, encouraged a creative dialogue about art that nurtured some of the most innovative examples of modern painting. Demuth's bond with O'Keeffe was so close that in 1932 he willed her all of his unsold oil paintings. As caretaker of these paintings after his death, O'Keeffe played an active role both in preserving the works and in distributing them among major American museum collections.[2]

Painting materials preserved from the artist's studio in the archives of the Demuth Foundation in Lancaster, Pennsylvania, provide insight into Demuth's working methods.[3] Although he wrote extensively about art during his lifetime, publishing commentary on artists such as Peggy Bacon, Georgia O'Keeffe, and Florine Stettheimer among others, Demuth wrote little about his own work. If he kept any journals, none

Fig. 68
Charles Demuth
*After Sir Christopher Wren*, 1920

survives. Demuth maintained an active correspondence, however, with a wide circle of friends. His letters to Alfred Stieglitz, in particular, contain numerous references to Demuth's use of painting materials, frames, and artistic goals.

Foremost a master of the watercolor medium, which comprises the majority of his oeuvre, Demuth's inquisitiveness and technical command as an artist were evidenced in his ability to work simultaneously in a wide range of media and styles, including even needlepoint and china painting. The industrial oil paintings evolved from his earlier treatment of the subject in tempera. That Demuth made a dramatic shift in material, palette, and scale to initiate such an ambitious series in oil — while battling the effects of advanced diabetes — underscores the importance he placed on these paintings, as discussed in Betsy Fahlman's essay. These factors, among others, were explored for this essay in an effort to better understand Demuth's creative process and artistic intentions in his last series of paintings in graphite and oil.

All seven of the late industrial oil paintings were examined for the technical study itself, including: *My Egypt* (pl. 1); *Buildings, Lancaster* (pl. 2); *Chimney and Water Tower* (pl. 3); *Buildings* (pl. 4); *Buildings Abstraction, Lancaster* (pl. 5); *And the Home of the Brave* (pl. 6); and *After All* (pl. 7). The paintings were examined in the conservation studio with the stereomicroscope, X-radiography, and ultraviolet light. Examination did not include infrared reflectography because of the benefits of magnification and because Demuth's graphite drawing remains clearly visible on the painting surfaces. All of the oil paintings were examined unframed. The reverses as well as the edges of the panels and their frames were studied in order to find evidence of the artist's technique and proof of original frames.

The investigation also included four earlier architectural views in tempera: *After Sir Christopher Wren* (fig. 68); *Lancaster* (fig. 30); *In the Province #7* (fig. 29); and *Machinery* (fig. 57). Several poster portraits,[4] as well as paintings in the Howald Collection at the Columbus Museum of Art, were also assessed in order to consider Demuth's oil painting technique within the broader context of his artistic career.

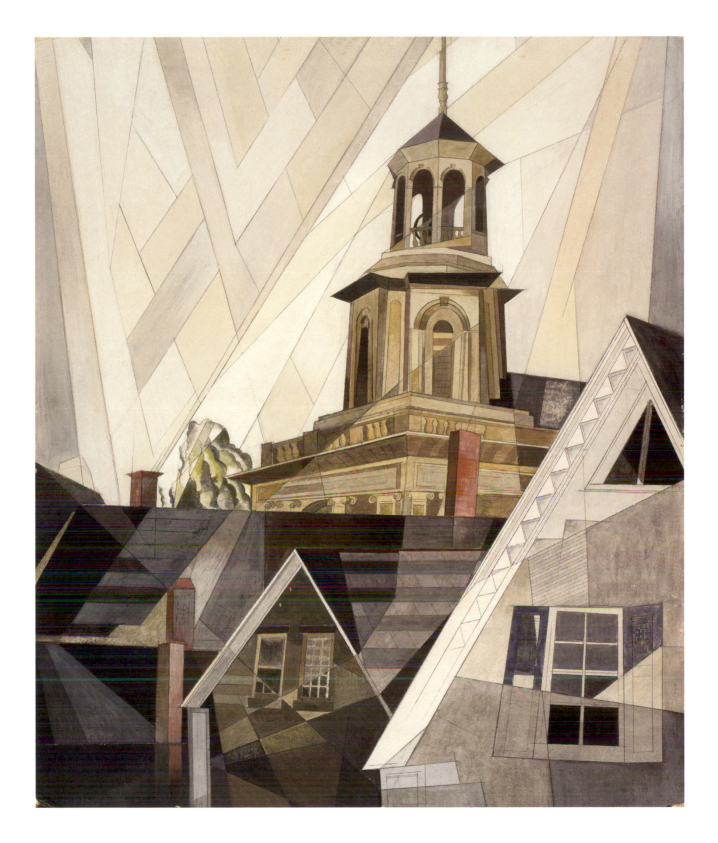

Demuth's artistic formation began during his childhood in Lancaster, where he took lessons from a number of local artists.[5] Some of his youthful sketchbooks recorded his early artistic efforts (fig. 3). Miss Martha Bowman of Lancaster supervised his sketches of the Lancaster countryside,[6] and by the age of ten Demuth had learned the art of china painting under the direction of Miss Letty Purple of Columbia. He became practiced in the art of needlepoint as well, examples of which were preserved in the King Street house in Lancaster (fig. 2). The artist continued these hobbies into adulthood, long after he had launched a successful career in painting. As later recounted by fellow art student Samuel P. Ziegler, the young Demuth also used his developing artistic talent to assist in his family's business. At the start of the week, a new poster, drawn by Charles, would appear in the right window of the tobacco shop (fig. 59), generally to promote Demuth snuff. Many of these billboards were based on variations of the theme of "Johnny on the Spot," an adage adopted by the local Pennsylvania German community. Another poster was captioned with the Mother Goose rhyme: "Jack Sprat and his wife lead a happily married life."[7] It related the story of how someone persuaded the couple to try another brand of snuff, but that eventually their return to Demuth snuff led to their happy reconciliation.[8] The wordplay and inventiveness of these early storefront advertisements seem to have anticipated Demuth's later series of poster portraits, as well as his use of commercial signage and billboards in his later Precisionist cityscapes.

After graduating from the Franklin and Marshall Academy in 1901, Demuth began his formal art training in Philadelphia at the Drexel Institute. From 1905–10 he continued his studies at the Pennsylvania Academy; his teachers there included Thomas Anshutz, who exerted the greatest influence on the young artist, and William Merritt Chase.[9] H. H. Breckenridge, Henry McCarter, Robert Vonnoh, and J. Alden Weir also numbered among the faculty during Demuth's time, and his fellow students included Paul Manship and Charles Sheeler.[10]

While at the academy, Demuth enjoyed the company of the "Smudge Group." These students were known as "smudgers" because of their hurried manner of drawing in charcoal when inspiration struck. Apparently, they worked at fever pitch until the spell was broken, often producing a "smudgy mess" because they deposited as much charcoal

powder on themselves as on the drawings. As recalled by a fellow student, Demuth was particularly attracted by the smudgers' desire to free themselves artistically from conventional patterns of thinking. However, in actual practice his own drawing followed a more "formal calculating procedure" and "honest, workman-like methods," consistent with his Pennsylvania German heritage. Demuth was united with the smudgers in their independence of spirit if not in their technique.[11]

Demuth eventually became a frequent visitor to New York galleries and museums, and following his formal training he later supplemented his artistic development with three European sojourns. The artist first traveled to Paris for a five-month trip in 1907; while there, he "developed an appreciation for modernism, especially the art of Paul Cézanne."[12] Demuth returned to Paris for his most important stay from late 1912 until spring of 1914, when he was exposed to Cubism and became acquainted with artists and collectors in the Parisian avant-garde. During this period Demuth established contact with several American expatriates active in vital artistic pursuits. He was befriended by Gertrude Stein and met the poet Ezra Pound and the painter Marsden Hartley. The two artists developed a close friendship, and soon after their introduction Demuth accompanied Hartley to Berlin. Later, Hartley and Demuth traveled together to Bermuda during the winter of 1916–17, when Demuth made his first experiments with Cubism in landscape abstractions, marking an important turning point toward his later experiments with Precisionist themes.[13]

Demuth's final trip to Europe transpired in the early 1920s. This visit had perhaps a greater sense of meaning since by then he was battling diabetes and must have been aware that it would likely be his last European tour. His letters from Europe recorded his thoughts about European and American painting as he reflected on his role as an American artist. In addition to contemporary painting, Demuth studied the art of the past, and his correspondence with Stieglitz relayed his enthusiasm on seeing works by J. M. W. Turner and William Blake at the Tate and an El Greco at the National Gallery of London, where he praised the hanging of the collection.[14] Demuth also voiced his desire to return to America to create a new form of painting: "I feel 'in' America, —even though its insides are empty. Maybe I can help fill them."[15] Upon returning to the States, Demuth resumed painting in order to address this deeply felt, aesthetic void. From the 1920s through 1934 his art found some of its purpose in painting industrial sites located in and around his hometown of Lancaster, Pennsylvania.

The artist painted his Precisionist oils exclusively in the second-floor studio of his family home (fig. 5). The small corner room measured approximately thirteen feet square. Two windows with southern and eastern exposures overlooked a walled garden, and the southern view included the tower of the Trinity Lutheran Church; both prospects would inspire a number of Demuth's paintings.[16] Although no photographs of the workroom survived from Demuth's time, it was described as a tidy, white-washed room, whose walls "were hung at various times [with] a Lautrec lithograph, a Marin watercolor, an O'Keeffe work,[17] an early Louis Bouché watercolor, and Man Ray's photographs of Robert and Beatrice Locher."[18] Some of the artist's materials — including his drawing pencils, watercolors, brushes, oil paints, tins, easel, and even a china painting kit[19] — were saved by Demuth's mother, Augusta, providing evidence of his working methods.[20]

It is not surprising that more than a dozen pencils were found among Demuth's materials. Drawing was such an integral part of his work, from his early watercolors to his later Precisionist landscapes, where ruled graphite lines played an important compositional and aesthetic role. The artist managed his pencils with special care, hand-sharpening all of the No. 2 and 3 tips with a knife, emphasizing the importance he placed on the quality of his graphite lines. Demuth kept a set of carving tools, which he may have used to shape his pencils to fit his particular needs (fig. 69). Among the artist's pencils that his mother preserved are several short stubs whose ends have been chiseled on two sides to create customized finger grips, suggesting that they served a unique purpose.[21] Less cumbersome than conventional pencils, short pencils also rotate with the fingers and could have aided Demuth in making rapid preliminary sketches on site (fig. 70). The longer pencils, on the other hand, were probably more useful when precision was required, as when he incised graphite lines onto fiberboard in preparation for painting. They would have allowed Demuth to apply lines with greater pressure and accuracy, drawing with his whole hand or arm.[22]

For a palette, the artist used the underside of the lid of the metal paint box holding his oil paint tubes[23] (fig. 71). Judging from the used tubes of oil color it contains (the box, filled with paints, is still on display in the artist's studio), Demuth obtained his oil paints from a variety of

European and American suppliers. Although the labels on some of the tubes are illegible, the following colorants can be identified: zinc yellow (F. Weber & Co.), mineral blue (Mussini Oil), ultramarine (Winsor & Newton), cobalt green (Winsor & Newton), and unidentified white (F. W. Devoe).[24] Other tubes include an unnamed yellow as well as unidentified oil pigments from Winsor & Newton, Schmincke, and Devoe. Demuth's letters also refer to his use of vermillion.[25]

Fig. 69
A set of carving tools from Demuth's era, collection of the Demuth Museum

Fig. 70
Demuth's pencil stubs with hand-chiseled finger grips

Fig. 71
Demuth's paint box with various brushes and tubes of oil color

Fig. 72
Demuth's easel

The artist's pine easel, which may have been purchased from F. W. Devoe, was a collapsible framework with two horizontal shelves that could easily be stored in a corner or a closet (fig. 72). The New York art supplier's 1914 catalogue illustrates a model called "'Rusticana' Studio Easel" with features similar to Demuth's. The product copy reads, "When not in use, can be closed up and put away in a corner. This Easel is now used in all the large Art Schools."[26] This lightweight structure enabled Demuth to work on medium-to-large-sized oil paintings within the restricted confines of his studio. The random brushwork covering Demuth's easel suggests that he used the wood surface to wipe excess oil paint from his brushes or test his colors as he worked.

## TEMPERA PAINTINGS

Beginning in 1919, Demuth began to explore the use of tempera and oil in his architectural paintings, moving away from the watercolor medium he had preferred throughout most of his career for his still-life and figure paintings. His turn to tempera and oil may have been motivated by a desire to satisfy a public that favored paintings over watercolors on paper.[27] Subject matter also played a role in determining Demuth's choice of medium. Tempera and oil provided a sense of weight and opacity that was better suited to architectural paintings than transparent watercolor. Marsden Hartley approved of Demuth's choice of tempera for his hard-edged architectural images: "Demuth has… stepped out of the confinement of watercolor pure, over into the field of tempera, which brings it nearer to the sturdier mediums employed in the making of pictures evolving a greater severity of form and a commendable rigidity of line. He has learned like so many moderns that the ruled line offers greater advantages in pictorial structure."[28]

The change in medium, however, presented challenges to Demuth as he began to work with less familiar techniques. While the artist had exceptional command over watercolor, by his own admission he felt less control when working in oil or tempera. "I've only painted in water-colour," he wrote in a letter to Stieglitz in September 1923. "The strain is greater, but I don't have to return and fuss if it goes bad as one always does in oil or tempera."[29]

Four of Demuth's earliest tempera paintings of Lancaster architecture were examined for the artist's use of tempera in this period of transition between his earlier watercolors and later oil paintings. In

what would be one of his most creative periods, Demuth returned to architectural abstractions in Lancaster in 1920, a few years after his first attempts at Cubism in Bermuda in 1916–17. His compositions of architectural motifs and tree forms, suspended in a flattened space, may have been inspired by his experience of seeing Cézanne's paintings of rooftops and trees at an exhibition in the Montross Gallery in New York in 1916.[30]

Demuth's transition from watercolor to tempera and oil was accompanied by a corresponding change in support as he sought the most appropriate surface for each medium. For his Precisionist works in tempera and oil, the artist turned to mass-produced solid supports, following the same inclination of other contemporary artists. A proliferation of new fiberboards designed for the construction industry came on the market in America during the early twentieth century, an active period of experimentation when manufacturers developed numerous new patents for converting wood pulp into board. Their goal was to manufacture panels with all the benefits, and none of the defects, of natural wood. W. H. Mason, the inventor of Masonite, was just one of the new patent holders.[31] Competition was intense as companies worked to get their new patents approved and adopted toward gaining control of this burgeoning industry.[32]

Although fiberboard, or hardboard, was produced primarily as a building material, several factors may have contributed to the trend of American artists to use the material for painting supports during the late teens and early 1920s. Among the American realist painters, Thomas Hart Benton, John Steuart Curry, and Reginald Marsh also used fiberboard as a painting support. During the war, artist's materials were scarce, and fiberboards provided a more readily available, cost-efficient and time-saving alternative to canvas.[33] The fiberboard support also possessed unique surface qualities that may have been considered desirable in furthering the modernists' artistic goals. Demuth's choice of fiberboard was particularly well-suited to his Precisionist landscapes, where the ruled line played such a pivotal role. This use of a new industrial product as a painting material also resonated with his subject matter: the growing industrial might of the United States as a metaphor for American culture.

All of Demuth's 1920 tempera paintings of Lancaster were executed on Beaver Board, a trademarked brand of laminated wallboard described by its manufacturer as the "twentieth century wall and

ceiling."[34] Hartley and O'Keeffe were among the Stieglitz circle artists who also used this machine-made support. First produced in 1906, Beaver Board was made from the fiber of Canadian spruce. After being shredded by powerful steam shredders, these fibers were chemically treated and fabricated into rolls of single-ply stock. Four layers of stock were then cemented together under great pressure by laminating machines. The panel reverse was imprinted with the manufacturer's

Fig. 73
Illustration of man lifting a Beaver Board panel from a stack; from the brochure *Beaver Board and its Uses*, 1920

Fig. 74
Beaver Board logo on reverse of manufactured panel that was cut down and used as a painting support

logo and instructions for use (figs. 73 and 74). A sturdy yet lightweight material, Beaver Board came in a variety of thicknesses and could easily be cut down to any shape or size. The trade catalogue boasted that "paint forms a perfect bond with the 'Sealtite' sized surface," and although the product was primarily intended for purposes of light construction, it was also marketed as an artist's board for its "knotless, crackless, flawless" surface.[35]

In addition to sharing Beaver Board supports, the four 1920 tempera paintings examined also have similar dimensions. *After Sir Christopher Wren* (fig. 68), *Lancaster* (fig. 30), and *Machinery* (fig. 57) all measure approximately 24-by-20 inches,[36] while *In the Province #7* (fig. 29) is slightly smaller. Two of the paintings are cut from different parts of Beaver Board panels: *Lancaster* came from the upper half, with the manufacturer's logo on the reverse, while *Machinery* originated from the lower half and bears the manufacturer's printed instructions for use.

Marsden Hartley may have introduced Beaver Board to Demuth. In 1917 the two artists spent the winter together painting in Bermuda, and Hartley wrote to George F. Of (1876–1954), a New York framer and artist, requesting "twenty-four composition boards of the same dimensions," presumably referring to Beaver Board.[37] Hartley had earlier used the board for his serial investigation of sailboat forms in oil in his Provincetown abstractions in 1916; the two standard formats he used for this sequence (20-by-16 inches and 24-by-20 inches) were similar to those adopted by O'Keeffe and Demuth respectively in 1920 for their paintings on Beaver Board.[38] This suggests the possibility that Of provided all three artists with precut panels in standard formats.[39] Of, a painter in his own right, played a key role in providing frames for Stieglitz circle artists and most likely served as a convenient source of painting supports as well.

George F. Of's contribution not only to the Stieglitz circle but also to the American art scene of the early twentieth century in general has been overlooked. In addition to his work as a framer and painter, he was also an astute collector of art, including contemporary American and European painting and Greco-Roman, Asian, Gothic, and African sculpture. In 1907 he purchased Henri Matisse's 1906 painting *Nude in a Wood*, the first work by Matisse to enter an American collection.[40]

As the reverse of Beaver Board was imprinted in black with the company logo and instructions for use, Demuth used the unmarked side of the board for his tempera landscape abstractions. In some of his surfaces, such as *In the Province* #7 (fig. 29), he randomly dispersed wood fibers bound up with the paint layer as he worked (figs. 75–80). In some cases, Demuth began by applying a thin layer of white tempera for the ground; in other cases, he painted directly on the unprimed panel. He then executed his industrial landscapes following a step-by-step process. First, he established the composition by applying ruled, graphite lines, using sufficient pressure to incise the relatively soft surface of the fiberboard support. Demuth then filled in distinct areas with color, building up the thickness of the paint layer along compositional lines following a Cubist-inspired method. This technique produced paint surfaces with a palpable relief, in which the graphite lines were recessed while the paint layer was raised. Demuth continued to use drawing throughout every stage of the painting process, first as working lines and later as shading lines or finishing lines[41] (fig. 75).

By 1921, the year of Demuth's last trip to Europe, he turned increasingly to the oil medium. His decision by 1926 to undertake large-scale, architectural oil paintings exacted a greater toll on his energy than watercolors during this period of failing health, underscoring the meaning he invested in the project.[43] Demuth's decision to create significant architectural paintings in oil may have been motivated by a desire to attract a wider audience to his work,[44] since it was generally understood that oil was appropriate for large-scale paintings intended for public viewing, while watercolor was associated with small-scale, personal works.[45]

Demuth would also have known that after 1918 O'Keeffe began to work exclusively in oil, because Stieglitz had made it clear that it was the only way she would survive as an artist.[46] Perhaps Demuth's ambition to work in oil was motivated in part by his knowledge that Stieglitz favored John Marin's watercolors above those of any of his other artists. As Demuth wrote to Stieglitz on October 30, 1927, "Tried some water-colours several weeks ago, — they were terrible. The field is to Marin, — if it always wasn't anyway."[47] Demuth also may have adopted oil to gain Stieglitz's approval for his new ideas about modern painting. By 1927, Demuth was exhibiting with Stieglitz at The Intimate Gallery, having severed ties with the Daniel Gallery, where the last exhibit of his work was held in 1926. During the early 1930s, the period when Demuth was actively working on the Lancaster oils, his letters were sprinkled with references to oil paintings. Writing to Stieglitz on September 10, 1931, Demuth mused: "I think, really, my summer's painting — only one — is all right. I think you will like it too. It's an oil. And [it] seems more to the point than most, — different, I feel. …Anyway it has a grand name — it's called *And the Land of the Brave*."[48]

Demuth's last series of industrial oils resulted from careful planning. His compositions evolved from on-site preparatory sketches of factory buildings located in and around Lancaster. These drawings confirm that Demuth was capable, despite his illness, of traveling within a certain distance of his Lancaster home, as discussed by Fahlman, to locate and record subjects for his industrial oils.[49] The artist never painted on location, but executed the finished works back in his studio. It was perhaps curious that Demuth relied on sketching rather than photography to record his subjects, especially since his father,

Ferdinand, was an excellent amateur photographer whose interest in local history had inspired him to document Lancaster architectural monuments, including some of the same subjects that Charles would later paint. Ferdinand once took an hour-long exposure of the steeple of the Lutheran Church of the Holy Trinity, an event that seemed to foreshadow his son's later preoccupation with architectural abstractions of Lancaster church spires and factories.[50]

But while Charles Sheeler, the other leading practitioner of the Precisionist style, used high-definition photography to inspire his industrial paintings, Demuth eschewed the use of this medium as a foundation for his oils. Sheeler used an 8-by-10-inch view camera for his 1917 photographs of Bucks County to take advantage of the increased detail provided by large negatives.[51] In light of Demuth's physical limitations, especially the chronic limp he suffered as a result of Perthes disease,[52] such equipment would have been for him too heavy and cumbersome to use. As O'Keeffe later recalled, even the effort of walking was difficult for Demuth, whose collar regularly "wilted" from the effort even in cold weather.[53] Although little box cameras, such as those used by Stieglitz in his street views of New York in the 1890s, were available by the turn of the century, even the use of such lightweight equipment required a certain physical dexterity that Demuth could likely ill afford to assume.[54]

Despite the fact that Demuth surrounded himself with leading modernist photographers including Man Ray, Alfred Stieglitz, Paul Strand, and other members of the Stieglitz circle, he did not incorporate photography into his creative process, further underscoring the distance between photography and his painting. Even O'Keeffe and Hartley adopted photography as a technical aid for painting. O'Keeffe "discovered a whole new set of aesthetic possibilities in the photographic process" when she worked alongside Stieglitz in Lake George and New York City from 1919–29.[55] Although she never admitted it, she clearly used photography to discover new and different directions in her abstractions.[56] O'Keeffe also used "a wide array of photo optics, including convergence, halation, and flare, to render her skyscrapers of the twenties."[57] Hartley made photography an integral part of his creative process. In *Adventures in the Arts*, his first book, Hartley devoted an essay to the medium entitled "The Appeal of Photography," in which he declared, "I have always said for myself that the Kodak offers me the best substitute for the picture of life that I have found."[58]

Fig. 81
Charles Demuth
Study for *And the Home of the Brave*,
ca. 1931

Fig. 82
Charles Demuth
Study for *Buildings, Lancaster*, ca. 1930

Demuth's exclusive reliance on drawing, without the apparent help of photography and from both the inception to the final surfaces of his Precisionist landscapes, distinguishes his technique from that of Sheeler and, in this regard, even that of Hartley and O'Keeffe. He consistently followed a more direct approach than these artists, relying solely on preparatory sketches before laying out his compositions by drawing directly onto his painting supports.[59]

The fragile graphite sketches that provided the source material for Demuth's paintings were never intended for public viewing. Working from a small sketchpad with perforated pages, the artist sometimes used both sides of the page to capture different subjects. A study for *And the Home of the Brave*, with multiple stoplights, appeared on the verso of one such sheet, while one for *Buildings, Lancaster*, inscribed "Office and Feed," was on the recto (figs. 81 and 82).

Although his painting technique was based on memory, Demuth's architectural pictures remained uncannily faithful to his original subjects, despite their simplified and flattened Cubist appearance.[60] While he didn't follow their use of photography, Demuth's drawing practice closely followed Hartley's and O'Keeffe's habit of making preliminary sketches to absorb a mental image of a site[61] (figs. 83 and 84). All three of these artists sometimes made several sketches of a

Fig. 83
Marsden Hartley (1877–1943)
Preparatory sketch with color notes for
*Whale's Jaw Rock, Dogtown*, ca. 1931–34

Fig. 84
Georgia O'Keeffe (1887–1986)
*Untitled (New York Street with
Moon)*, 1925

particular subject, including color notations as a guide for later painting. In 1925, O'Keeffe made a group of small graphite sketches of New York City industrial sites in preparation for her own series of architectural paintings in oil. Demuth executed his graphite drawings with the sensitive, nervous style that also characterizes some of his work in watercolor. He apparently worked rapidly, recording his subjects with energetic, inexact outlines and using parallel hatching or zigzag lines to indicate volume and shading (fig. 85). Although their function was to inform sharp-edged, Precisionist paintings, the preliminary sketches were notable for their looseness and spontaneity. They effectively simplified complex industrial sites into diagrams of geometric forms that became the compositional framework for his oil paintings (figs. 86–93).

These pencil sketches, apparently made in rapid succession of individual sites, illustrated the progression of Demuth's thoughts. While some captured specific details, such as the stoplight in *And the Home of the Brave* (pl. 6, fig. 87), other drawings explored a subject from different viewpoints, such as the view of the water towers in the same work (figs. 88 and 89). His preparatory drawings for *After All* (pl. 7), based on the Armstrong Cork Company plant, were particularly complex. In separate studies, the artist broke down the architectural structure into smaller elements such as pipes, electrical lines, and fire escape, and documented the subject in a more elaborate finished drawing with color notes and shading[62] (figs. 90, 91, and 93).

Fig. 85
Charles Demuth
Study for *Chimney and Water Tower*,
ca. 1931 (right)

Fig. 86
Charles Demuth
Study for *My Egypt*, ca. 1927

Fig. 87
Charles Demuth
Study for *And the Home of the Brave*,
ca. 1931

Fig. 88
Charles Demuth
Study for *And the Home of the Brave*,
ca. 1931

Fig. 89
Charles Demuth
Study for *And the Home of the Brave*,
ca. 1931

For his last series of architectural paintings in oil, beginning with *My Egypt* (pl. 1), Demuth abandoned the Beaver Board supports used for his 1920 tempera paintings in favor of a more substantial type of fiberboard or hardboard panel that had the characteristics of a low-density Masonite-process board.[63] Unlike Beaver Board, the new Masonite-type panels were manufactured with one smooth side and the other crisscrossed with the pattern of a wire screen. Produced by exploding wood fiber under intense steam pressure, then pressing the wood fibers under heat onto wire screens, these boards were sturdier and better suited for Demuth's Precisionist works in oil. Demuth painted all but one of his industrial oil paintings on the wire side of Masonite

Fig. 90
Charles Demuth
Study for *After All*, ca. 1933

Fig. 91
Charles Demuth
Study for *After All*, ca. 1933

Fig. 92
Charles Demuth
Sketch of a water tower

Fig. 93
Charles Demuth
Study for *After All*, ca. 1933

Fig. 94
Raking-light detail of *Chimney and Water Tower*; this is the only painting from the industrial oil series the artist executed on the smooth side of the Masonite panel, making it closer in appearance to a traditional oil on panel painting

panels. Only *Chimney and Water Tower* (pl. 3) was executed on the smooth side, giving this austere image of the Armstrong complex a more polished surface than the rest, closer to the appearance of a traditional oil on panel painting (fig. 94). Interestingly, Demuth continued to use canvas for oil paintings of other subjects during this period. As discussed by Fahlman, he painted the oil-on-canvas *Landscape, Peach Bottom* (1931) for his friend Elsie Everts, which underscores the point that his use of fiberboard for his industrial oils was a deliberate choice.

While Beaver Board was marketed as a wall and ceiling panel, Masonite was sold as structural insulation and was widely used in the housing and flooring industry. The broad applications of Masonite were highlighted at the 1934 Chicago World's Fair (held the year following the completion of Demuth's last painting, *After All*), where "millions of feet of boards" were built into the Century of Progress exhibits,

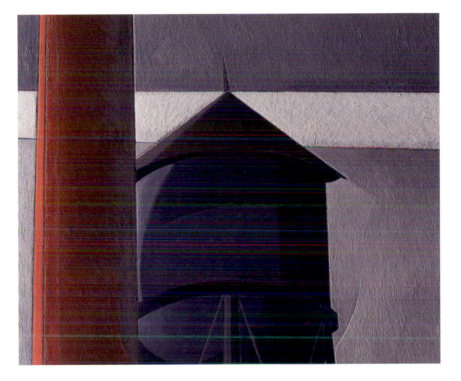

including the "Masonite Home," which was largely constructed from the material[64] (fig. 95).

Demuth was only one of several early twentieth-century American artists, including Hartley and O'Keeffe, who painted on Masonite; but his preference for this modern, factory-made material seemed particularly suited to his industrial paintings. In contrast, O'Keeffe

**MASONITE HOME AT THE WORLD'S FAIR**

Here is a thoroughly modern home, built almost entirely of good wood products. The framing is sound wood sills, joist, studding, rafters. The exterior is Masonite Tempered Presdwood over Masonite Structural Insulation, the insulation being nailed directly to the wood studs.

Various finishes are used inside. The front hall and stair well walls and ceiling are finished with Tempered Presdwood, a portion of which is left natural, waxed and polished. The other portion of the walls is painted. The horizontal joints of the Presdwood are covered with aluminum strips. The edges of the ceiling panels are slightly beveled.

The beautiful kitchen installed by General Electric Company makes use of Kitchenmaid Cabinets, the work areas of which are Tempered Presdwood. Its gleaming walls are Marshtile.

The living room and bedroom walls are Masonite Insulation or Quartrboard to which wallpaper has been applied.

The bathroom walls are Gibbs Boardtile—this remains unchanged from last year.

Floors throughout the house, which attracted so much favorable comment last year, are covered with Masonite Cushioned Flooring. This rich warm floor covering has a surface that defies indentation, yet it is highly resilient because of its in-built shock and sound absorbing core of Masonite Quartrboard.

The boy's study upstairs is finished in Tempered Presdwood left natural, with metal trim. Furniture designed by Mr. Daly and executed by Marietta Chair Company makes use of Tempered Presdwood for table tops, panels of chairs, bookcases and pier cabinets.

Fig. 95

Cover and interior spread of brochure *Masonite Home* (1934); the broad applications of Masonite were highlighted at the 1934 Chicago World's Fair, held the year following the completion of *After All*, Demuth's last painting

used oil on canvas exclusively for her architectural paintings of New York City despite her own experimentation with fiberboard support. The Armstrong complex was the subject of three of Demuth's oils — *Chimney and Water Tower*, *Buildings*, and *After All* — during the period when the company was a leader in the linoleum flooring industry. Their development of the process of cementing linoleum to a material called Temboard, a dimensionally stable Masonite panel, changed the course of the linoleum business as the product became widely used as flooring rather than simply as a loose floor covering.[65] Temboard underlayment came in thicknesses of about a quarter inch and, in some cases, perhaps a half inch. It was used as an underlayment when linoleum was installed so as to provide a smooth, level substrate for the flooring.[66]

Armstrong sold Temboard, a Masonite panel similar to the one used by Demuth, during the period when he painted his industrial oils.[67] The artist enjoyed wordplay and double entendres and might well have enjoyed the coincidence resulting from his use of an industrial flooring material for the support of his painting of a linoleum factory. On the other hand, he once wrote to Stieglitz: "A good painting is not a floor covering, nor is it a complete textbook on some imagined aesthetic principle."[68] If Demuth acquired his panels from the Armstrong Cork Company, he left behind no evidence. However, just as Wanda Corn has observed similarities between Demuth's earlier poster portraits

and billboards,[69] his use of factory-made panels for his industrial oils enhances the modernist aesthetic inherent in these images. Emily Farnham reflected: "Demuth was painting in the right way for his time.... Similar to architecture, a good building always has to suit its time, the time it's being built, when there are certain new materials that create new forms."[70]

As with his earlier work on Beaver Board, Demuth's use of Masonite followed the practices of fellow Stieglitz circle artists. Among the variety of panels he appropriated for painting, Marsden Hartley used "Genuine Masonite Presswood" as early as 1931 in *Masks*, placing his use of this panel at the same time as Demuth's.[71]

Demuth's friendship with O'Keeffe extended to the two artists sharing information about painting materials, particularly rigid supports, and they even joked about doing a flower painting together.[72] O'Keeffe sometimes sent Demuth samples of board, which she may have obtained from George F. Of. During the course of painting his poster portrait series, Demuth wrote to Stieglitz: "Tell O'Keeffe that I received a sample of the board. It looks grand for working — haven't yet been able to find out what it is! Will take it back to New York when I go over. I do want some for the posters yet to come — Marcel [Duchamp's] and [John] Marin's. I want all the help that materials can give for this effort."[73]

O'Keeffe painted on Masonite early in her career, a period when she actively experimented with a variety of boards, including mahogany and laminated wooden panels, for different paintings in her Alligator Pear series, one of which Demuth owned.[74] In contrast to Demuth, however, when using Masonite, O'Keeffe favored the smooth side of the panel. The fiberboards she used for *Untitled (Skunk Cabbage)* and *Calla Lily in Tall Glass, No. II* bore a close resemblance to those used by Demuth in terms of the density of the screen pattern left from the manufacturing process, suggesting they may have shared a common source for the support[75] (figs. 96 a and b).

There are many reasons why Demuth may have found the Masonite panels "helpful as to surface." First, they provided him the choice between working on a smooth or a textured side. Masonite also provided a practical alternative to canvas, without a loss of surface texture, because the imprint of the screen pattern produced an impression not dissimilar to plain weave fabric. Canvas was more expensive, of course, and it also required stretching — an exhausting task for an artist in Demuth's weakened physical condition. It would have been easier and

Fig. 96 a and b
Details of the reverse of Georgia O'Keeffe's
*Untitled (Skunk Cabbage)*, ca. 1927, and
*Calla Lily in Tall Glass, No. II*, 1923; both
works are oil on Masonite. Like Demuth,
O'Keeffe primed the reverses of her panels,
which appear similar to those used by
Demuth for his industrial oils. O'Keeffe
also tested her colors on the reverse of
*Untitled (Skunk Cabbage)*.

more efficient for the artist to draw on board, working flat, with the aid of supplementary tools such as a ruler or compass, than on canvas. The panels had the added advantage of being sturdy, yet lightweight and easy to transport.

Following a practice that was also used by O'Keeffe, Demuth primed both the front and reverse surfaces of his boards prior to painting. Painting both sides of the panel likely minimized the potential for the hygroscopic material to warp on exposure to changes in relative humidity[76] (figs. 97 and 98). This also may have contributed to the excellent condition of Demuth's oil paintings today. Demuth also sometimes signed the reverses of his panels with his name, titles, and dates of his paintings, as well as with inscriptions and doodles that contained special meaning for the painting or reflected the artist's humor. He decorated the reverse of *Chimney and Water Tower*, for example, with a sketch of a dove, a form of the artist's signature[77] (fig. 98). On the verso of *Buildings, Lancaster* the artist wrote the message: "A fragment overlooked by Henry James who conveniently named the whole." On the front surface of his panels, Demuth applied a thin layer of white ground as a preparation for painting. The light ground influenced the luminosity of the final images and enhanced the visibility of the pencil outlines he used to establish his working drawings prior to painting.

The exact method Demuth followed to translate his rough preliminary sketches into fully resolved, Precisionist compositions

Fig. 97
Reverse of *Buildings* showing blue primer

Fig. 98
Detail of primed reverse of *Chimney and Water Tower* showing Demuth's dove signature

is unknown, but it obviously involved a simplification of elements in which many details were eliminated. Demuth honed his compositions at an intermediate stage by carefully measuring the geometric forms of cylinders, cones, and spheres to prepare precise "blueprints" before committing their graphite outlines onto board. While the artist left behind no physical evidence of these "blueprints," the paintings themselves provide proof that he arrived at his final compositions through the use of precise mathematical calibrations. Calculating measurements in whole, half, quarter, and eighth inches, the artist converted the dimensions of forms in his small-scale sketches to fit the large vertical formats of his standard-sized panels. Each of the oil paintings examined confirmed that Demuth consistently used predetermined measurements to lay out his compositions, both to determine the scale of individual elements and to locate their position on the panel.

The grain elevators in *My Egypt* (pl. 1), for example, measured 7½ inches wide, while each of the two white diagonal force bands radiating from the top left corner were 2 inches wide. The pinnacle of the water tower in *Chimney and Water Tower* (pl. 3), furthermore, was positioned 11 inches from the right edge, while the two sides of the water tower were drawn 8 and 10¾ inches from the left. The hairpin-curved pipe on top of the brick building of the Armstrong factory complex in *After All* (pl. 7) was placed at the center of the painting's width.

As in his earlier architectural paintings in tempera, Demuth applied sufficient pressure while drawing on the white ground to ensure that the graphite lines pressed into the fiberboard support became recessed. These lines served as a "working drawing" to provide the artist with a pattern to follow during the painting process (fig. 99). Unlike the more traditional forms of underdrawing associated with European panel paintings, such as those found in early Netherlandish painting, Demuth's graphite lines were not later concealed by the paint layer but remained an integral part of the final image. In this way, the artist acknowledged the process of painting as a technical pursuit, perhaps to emphasize the mechanical nature of his subjects and to reinforce the American Precisionist aesthetic.[78]

Demuth filled in areas defined by the drawing by applying his brushwork on either side of the graphite lines, building up paint layers as he worked. The artist continued to apply graphite lines throughout the painting process, sometimes drawing through wet paint, while

Fig. 99
Raking-light detail of *Buildings* showing
Demuth's use of incised working lines

Fig. 100
Photomicrograph detail (6x) of *Chimney and
Water Tower* showing drawing in graphite
through wet paint along curved bottom edge
of stovepipe

Fig. 101
Photomicrograph detail (6x) of *Chimney and
Water Tower* showing drawing in graphite
over dry paint to create brick façade

applying other lines after the paint had dried (figs. 100 and 101). The
extent of his drawing can be glimpsed along the edges of forms where
often several layers of graphite lines and paint appear. In spite of
the immaculate, Precisionist aesthetic evoked by Demuth's Cubist
landscapes, when viewed in raking light they create quite a different
effect. The combined use of textured fiberboard support, incised graphite
lines, and active brushwork with low impasto imbues these paintings
with a surprisingly dynamic surface variation that is often missed in
photographic reproduction (figs. 99, 102, and 108).

Such a premeditated approach to painting did not prevent Demuth
from modifying his compositions as he worked, recalling his confession
to Stieglitz that he tended to "return and fuss" when painting in oil.[79]
Numerous pentimenti, or artist's changes, are visible when Demuth's
oil paintings are viewed in raking light, revealing instances where he
covered over the recessed graphite outlines of earlier compositional
elements (fig. 103). In one case, X-radiography confirmed that Demuth

Fig. 102
Raking-light detail of *Buildings* showing
texture of Masonite support

Fig. 103
Photomicrograph detail (6x) showing
pentimento in *Chimney and Water Tower*
where Demuth covered over earlier
recessed graphite working line with
zigzag brushwork

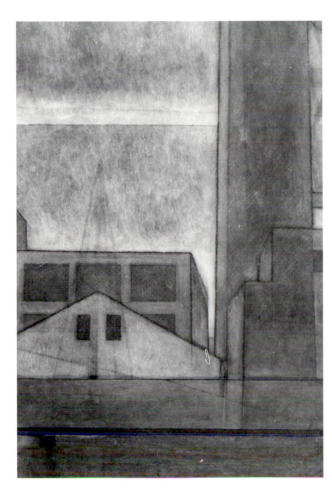

Fig. 104
X-radiograph detail of *Chimney and Water Tower* showing pentimento in the elimination of a tipi-like structure in the lower left of the painting

Fig. 105
X-radiograph detail of *Buildings* showing Demuth shifted the tower to the right, as seen in the repositioning of the legs

simplified his composition by concealing a tipi-like structure in the lower left of *Chimney and Water Tower* during painting (fig. 104), a detail that was present in one of his preparatory drawings of the Armstrong plant (fig. 85). Perhaps as a result of these changes, Demuth also repositioned horizontal force lines in the lower half of the painting. In *Buildings*, the artist shifted the supporting legs of the water tower significantly to the right (fig. 105).

Demuth continued to develop his drawing at every stage of the painting process, applying graphite lines on top of paint layers in order to reestablish boundaries between areas of painting. Since the artist's technique relied strongly on the application of flat areas of opaque color with little use of chiaroscuro and shading, the outlining helped Demuth to maintain the separation between forms throughout the painting process. In at least one instance, he even added incised lines in a final stage of painting to enhance the precision of elements, as seen in the railings of the fire escapes and the smokestack in *After All* (fig. 106). In

addition to graphite, Demuth occasionally employed a second drawing medium as well, such as the black crayon he used to delineate lines in the lower left and right corners of *Chimney and Water Tower*, where the painted images fade away. He also inscribed his signature, "C.D. '31," with black crayon into wet paint (fig. 107).

Similar to Hartley, who created distinctive surface textures by changing the orientation of individual brushstrokes,[80] Demuth also enlisted both the direction and type of brushwork to reinforce compositional elements. For example, the artist applied brush strokes with a horizontal orientation within the boundaries of horizontal force lines in *Chimney and Water Tower*, while he used swirling strokes for the billowing smoke in *Buildings* (fig. 108). He treated each zone, as defined by the working lines, individually, as evidenced by the variations of brushwork throughout his paint surfaces. Demuth's brushwork

Fig. 106
Detail of *After All* showing incisions in railings of fire escapes

Fig. 107
Photomicrograph detail (6x) of *Chimney and Water Tower* showing signature "C.D. '31" in black crayon

technique could be described as one of "controlled spontaneity" in that it added palpable textural variation to his paintings while simultaneously respecting and reinforcing the Precisionist outlines of his compositions. He frequently applied his paint with careful strokes that stopped specifically at pencil lines, and he modulated his use of impasto in different areas of painting to achieve desired effects. The careful calibration of Demuth's brushwork is reflected in his previously mentioned practice of wiping his brushes on the surface of his easel as he worked to better control his paint strokes. Together with Demuth's brushwork, his calculated use of color served to animate and enliven the surfaces of his industrial oils.

Working with a relatively simple palette, Demuth's color evolved from the neutral tones of his earliest work, *My Egypt* (pl. 1), to the saturated colors in *Buildings, Lancaster* (pl. 2) and *Buildings*

Fig. 108
Raking-light detail of *Buildings* showing the swirling brushstrokes in the chimney pipe and smoke

Fig. 109
Detail of *Buildings* showing nuances in
shades of red and attesting to Demuth's skill
as a colorist

*Abstraction, Lancaster* (pl. 5). Images of advertising are evoked by his
bold use of primary colors to depict the billboards in these two works.
The artist used yellow and blue pigments to highlight their commercial
lettering, reproduced with stencil-like precision, in contrast to the red
industrial facades; however, Demuth fractured all of these colors into a
prismatic array of tones. His use of the bold colors used in advertising,
combined with a splintered and painterly treatment of these hues,
imbues these works with a double meaning.

Demuth's keen sense of color was reflected in his praise for this
aspect of O'Keeffe's work: "In her canvases each color almost regains
the fun it must have felt within itself, on forming the first rain-bow."[81]
Demuth once wrote her: "Your color was the most exciting thing in this
year's art world."[82] The nuances of red found in the building facades
of Demuth's architectural paintings attest to his gifts as a colorist
and recall the elegance of his watercolors (fig. 109). As in his tempera
paintings, Demuth worked from dark to light in his oils, adding light
scumbles as finishing layers.

Examination of the paint surfaces under the stereomicroscope
suggests that Demuth almost obsessively reworked the surfaces of
his oil paintings to get the color he desired. Evidence of multiple paint
layers shows that he frequently altered the color of his building facades.
His color changes were sometimes so slight as to escape immediate
detection, as in the range of mauve tones he used for the background
of *Buildings* (pl. 4) or the variety of blues used throughout the skies in

Fig. 110
Ultraviolet-light detail of *Buildings* showing that Demuth repainted the billowing smoke and much of the sky; the repainted areas are revealed as light purple

Fig. 111
Ultraviolet-light photograph of *Buildings Abstraction, Lancaster* revealing that Demuth changed the color of the background surrounding the steam (middle right) and repainted the background (lower right); again, the repainted areas are revealed as light purple

*Buildings Abstraction, Lancaster* (pl. 5) and *Buildings, Lancaster* (pl. 2). These subtle color variations seem almost intended to play tricks with the eyes.

Other color changes that Demuth made throughout his backgrounds are less obvious but can be detected under ultraviolet light due to his use of different white pigments, possibly including zinc white, which exhibits a considerable fluorescence.[83] Ultraviolet light examination of *Buildings* revealed that Demuth repainted the billowing smoke and much of the sky, though the changes are so slight as to be nearly imperceptible (fig. 110). *Buildings Abstraction, Lancaster* also reveals numerous scattered retouches throughout the background when viewed under ultraviolet light. Demuth adjusted the color of the steam emitted from the smoke pipe (middle right) and repainted the background (lower right corner), always working within the graphite guidelines (fig. 111). Unlike watercolor, which leaves no room for changes, Demuth surely found the oil medium more forgiving because it allowed him to revise his paintings on a regular basis. In this regard his oil painting techniques betrayed a tentativeness or indecision not felt in his watercolors, and the artist felt no hesitation for returning to rework a painting even after it had left his hands.[84]

While most, if not all, of Demuth's industrial oils were left unvarnished at the time of his death, the artist's letters suggest that he had probably intended to varnish them. He wrote Stieglitz on January 3, 1929: "The new oil [*The Figure 5 in Gold*] you will have next week too. I looked at it today and it seemed dry enough to travel. I can varnish it there sometime."[85] Some of the industrial paintings, including *Chimney and Water Tower* (pl. 3) and *After All* (pl. 7), exhibit an uneven gloss, possibly due to varying amounts of medium in different colors — evidence that unvarnished paintings do not necessarily appear uniformly matte. When *Chimney and Water Tower* was examined under ultraviolet light, however, a runny, localized varnish fluoresced, particularly in the chimney, where a drippy tide line appeared[86] (fig. 112). Whether or not Demuth locally varnished this element could not be determined; however, it recalled Marsden Hartley's practice of locally adding linseed oil and possibly even amber to maintain the brilliance of his colors.[87]

As caretaker of Demuth's oil paintings following his death, Georgia O'Keeffe reflected her interest in maintaining the pristine appearance of her own paint surfaces. To this end, she maintained an ongoing collaboration with New York painting conservators Caroline and Sheldon Keck, who had cared for the collections of both the Brooklyn Museum and the Museum of Modern Art and helped establish the first conservation training programs in the United States.[88] O'Keeffe regularly sent her paintings to the Kecks to be treated, both in the form of varnishing and lining.

Whatever her motivation, when O'Keeffe arranged for two of Demuth's industrial oils to be varnished prior to the opening of the Stieglitz memorial exhibition at the Museum of Modern Art in 1947, she effectively carried out Demuth's original intentions. An internal memo from the Museum of Modern Art dated June 12, 1947, reads: "The following are the paintings which Miss O'Keeffe would like Mr. Keck to spray for her…Demuth: *Buildings* [*Abstraction*] oil on composition board,[89]…Demuth, *And the Home of the Brave*, oil on composition board, …Miss O'Keeffe asked that Mr. Keck be sure to put a label on the back of each painting he treated saying what had been done to the painting and the date."[90] Sheldon Keck sprayed

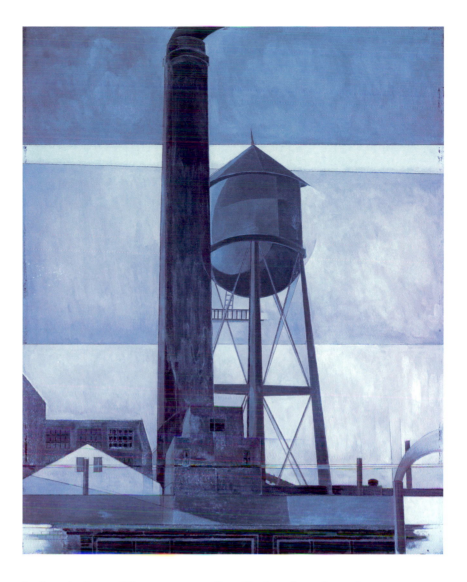

Fig. 112
Ultraviolet-light photograph of *Chimney and Water Tower* showing fluorescent drips near base of chimney

both paintings with a matte coating of n-butyl methacrylate, a synthetic varnish.

Georgia O'Keeffe wrote that Demuth was very disappointed that he only sold one of the industrial oil paintings in his lifetime: *My Egypt* (pl. 1) to the Whitney Museum of Art.[91] In a final act of friendship and stewardship, O'Keeffe purposely distributed Demuth's industrial oil paintings, along with other works from the Stieglitz collection, among a select number of American museums in the years following Stieglitz's death. By incorporating his industrial oils with the Stieglitz works, O'Keeffe solidified Demuth's membership in the Stieglitz circle and helped ensure the legacy of his Precisionist oils.

Demuth apparently framed some of his works when the paint was still wet, because the edges of a few of the industrial oils are indented from contact with the frame. Silver leaf deposits found in these areas suggest that Demuth originally placed *And the Home of the Brave* (pl. 6) and *Chimney and Water Tower* (pl. 3) in silver leaf frames. His correspondence also makes reference to the use of a black frame, probably for *Buildings Abstraction, Lancaster* (pl. 5).[92]

Fortunately, a handful of Demuth's industrial oils retain their original narrow, flat-profile, silver leaf frames, including *My Egypt*, *Chimney and Water Tower* (fig. 113), and *Buildings*.[93] The frame for *My Egypt* measures 1 7/8 inches wide with a 1/8-inch recessed liner; the silver leaf was applied on top of red bole. Similarly, *Buildings* was placed in a silver leaf frame measuring one inch wide and one inch thick, with a red-bole liner 1/8-inch wide. Acquired by Muriel Draper by 1932, *Buildings* remained in private hands until its acquisition by the Dallas Museum of Art in 1988 and so escaped reframing. The silver leaf was applied on top of a red bole and was coated with now-yellowed varnish or glaze. An inscription on the reverse along the top rail of the frame reads: "G 3997 [Armstrong?] Lancaster," while the bottom rail was signed "Demuth" in graphite. Demuth's preference for silver leaf frames for his architectural oils, like his use of Masonite supports, mirrors O'Keeffe's practices and enhances the modernist aesthetic inherent in his industrial paintings. John Marin also used silver leaf frames, suggesting that this practice found wider acceptance within the Stieglitz circle.[94] Sheeler also used silver leaf frames, notably for his Power Series.[95]

Demuth maintained a long association with George F. Of, the painter and professional framer who provided many of the artist's frames as well as art supplies.[96] Of supplied frames and painting supports for other artists in the Stieglitz circle as well, including Georgia O'Keeffe, for whom he made her famous customized "clam shell" frame. Demuth once wrote about sending an oil to Of for framing and specified that he wanted it under glass, suggesting that Demuth, like O'Keeffe, was concerned about preserving the surfaces of his Precisionist oils in pristine condition.[97]

Fig. 113

*Chimney and Water Tower* in its original silver leaf frame

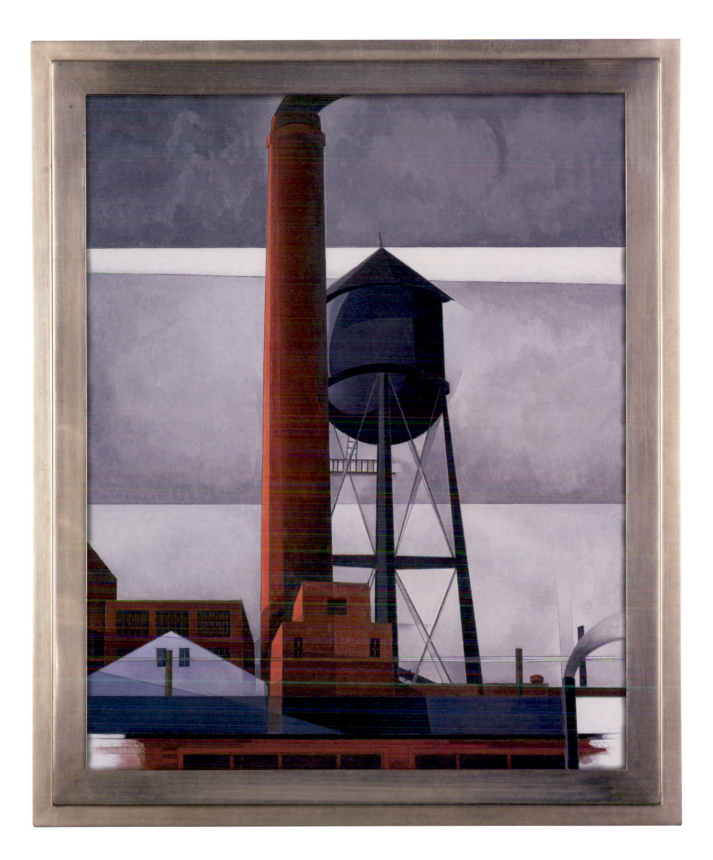

Not content to work exclusively as a watercolorist, for which he was rightly praised, Demuth overcame his uncertainty in the use of the oil medium to create Precisionist cityscapes that stand as lasting icons of modern art. The fact that Demuth's paintings were preserved in such excellent state testifies both to the soundness of his oil painting technique as well as to Georgia O'Keeffe's role as custodian of his paintings after his death. His painting materials and techniques evolved as he absorbed contemporary art in both Europe and America and as a result of friendships formed with leading artistic figures of his day, including Marsden Hartley, Georgia O'Keeffe, and Alfred Stieglitz. As Emily Farnham reflected: "A good artist did what Demuth did... keeps changing; as he changes he grows and develops and thinks and watches other people's work.... He seemed to have a genius for getting in touch with the other people of his time who were really great artists... [and] to have an ability to converse and even be with these people of great talent."[98]

Demuth recorded transcendent images of early twentieth-century industrial sites using a Precisionist style that did not sacrifice painterly expression for exactitude, which sets him apart from fellow Precisionist Charles Sheeler. In so doing, he created unique surfaces that combine the seemingly incompatible qualities of vibrant brushwork and delicate color variations with the hard-edged linearity of ruled graphite lines. His almost obsessive attention to color in these late works was informed by years of working in watercolor, as well as by his admiration for this aspect of Georgia O'Keeffe's painting. Demuth believed that paintings could only be experienced "through the eye." In creating such idiosyncratic surfaces, he ensured that the true character and originality of his industrial oils could only be known through the direct observation of the original works of art themselves. When he wrote the following words about O'Keeffe's painting, he could have been describing his own: "Across the final surface — the touchable bloom, if it were a peach — of any fine painting is written for those who dare to read that which the painter knew...or that which he hoped to find out."[99]

## Notes

1. Charles Demuth, "Across a Greco Is Written," *Creative Art*, v., 3 (Sep. 1929): 629–34.

2. *Buildings* was given to Muriel Draper during Demuth's lifetime and remained in private hands until it was sold by the dealer James Maroney to the Dallas Museum of Art in 1988. See also "The Great Draper Woman: Muriel Draper and the Art of the Salon" by Betsy Fahlman, *Woman's Art Journal*, volume 26, no. 2, 33–7.

3. Ellen Barley (curator), and Robert Fenninger (chair of the collections committee), at the Demuth Foundation generously facilitated the study of the artist's painting materials and the foundation archives. I am also grateful to Anne Lampe (director) for her generous assistance with photography and other requests.

4. *The Figure 5 in Gold* (1928), Metropolitan Museum of Art (oil on cardboard, 35½ x 30 inches), was examined in the galleries; the following poster portraits from the Collection of American Literature, Beinecke Rare Book and Manuscript Library, Yale University, New Haven, were studied in the library reading room: *Poster Portrait, O'Keeffe* (1923–24; poster paint on panel, 20 x 16 inches); *Poster Portrait: Dove* (1924; poster paint on panel, 20 x 23 inches); *Poster Portrait: Duncan* (1924–25; poster paint on panel, 20 x 23½ inches); and *Poster Portrait: Marin* (1926; poster paint on panel, 27 x 33 inches).

5. Betsy Fahlman, *Pennsylvania Modern: Charles Demuth of Lancaster* (Philadelphia: Philadelphia Museum of Art, 1983), 17–8.

6. Emily Farnham, *Behind a Laughing Mask* (Norman: University of Oklahoma Press, 1971), 46.

7. Samuel P. Ziegler was from Lancaster and knew of Charles Demuth from childhood, although their paths would not cross until later, when they became classmates at the Pennsylvania Academy of the Fine Arts. Ziegler, who later headed the art department at Texas Christian University (1925–53), wrote hundreds of short missives, stories, and recollections from his life, a few of which dealt with Charles Demuth. Gratitude is owed to Jane Myers and Scott Barker for access to Ziegler's notes and recollections on Demuth.

8. Ibid.

9. Ibid.

10. Ibid.

11. Ibid.

12. Robin Jaffee Frank, "Something Beyond Sex: Demuth's Drawings in the Hill Collection at Yale," *Yale University Art Gallery Bulletin* 2003, 74–93; *The Original Work of Art: What It Has to Teach*, 76.

13. Fahlman, *Pennsylvania Modern: Charles Demuth of Lancaster*, 17–8.

14. Demuth to Alfred Stieglitz, August 31, 1921, as quoted in Bruce Kellner, *Letters of Charles Demuth, American Artist, 1883–1935* (Philadelphia: Temple University Press, 2000): 19–20.

15. Demuth to Alfred Stieglitz, October 10, 1921, Kellner, *Letters of Charles Demuth*, 28–9.

16. Gratitude is owed to Ellen Barley at the Demuth Foundation for providing the dimensions.

17. Thanks are due to Barbara Buhler Lynes, who identified the work as *Alligator Pears* (1923), by Georgia O'Keeffe, private collection, Lancaster. *Georgia O'Keeffe Catalogue Raisonné, Volume One,* by Barbara Buhler Lynes (New Haven: Yale University Press, 1999), 225.

18. Farnham, *Behind a Laughing Mask*, 44.

19. The china-painting kit is a black enamel box from A. B. Cobden containing numerous small vials of pigments and jars of medium.

20. Conversation with the author as related by Ellen Barley (through Corinne Woodcock), May 2, 2005. After Augusta Demuth died, some palettes, brushes, pencils, and several tubes of paint were pulled from a dumpster behind the Demuth residence. Although it cannot be completely verified, it is almost certain that these materials belonged to Demuth. Not only are they entirely consistent with his working practices, but Augusta was also fastidious about preserving her son's belongings. She never disposed of his clothing, which was found neatly folded in closets after her death.

21. The sources of the pencils were varied and included: 3H British Graphite; Eberhard Faber; The S.S. White Dental Mfg. Co.; Mikado; and Eagle Pencil Co.

22. Thanks are owed Judith Walsh for this observation.

23. The interior of the metal box is organized with nineteen slots to hold tubes of color, as well as three horizontal compartments at center and one horizontal well at front. The box also contained a metal screw top vial from George Rowney and a metal cup for diluents.

24. Marsden Hartley also obtained art supplies from F. Weber.

25. In a letter to Stieglitz on May 9, 1929, Demuth wrote: "On the book shelves under Georgia's portrait are two tubes of vermillion paint, I forgot them, –they are [w]rapped in paper. Will you please send them to me,-sorry to bother you about this detail." As quoted in Kellner, *Letters of Charles Demuth*, 121.

26. *Catalogue of Artists' Materials and Architects' Supplies*, F.W. Devoe & C.T. Raynolds Co., New York, Chicago, Kansas City, 19th edition, 35. Thanks are owed to Rick Stewart for providing this catalogue.

27. Brutvan, Cheryl. *Masterworks on Paper from the Albright Knox Art Gallery* (New York: Hudson Hills Press, in association with the Albright Knox Art Gallery, 1987), 92.

28. Betsy Fahlman, *Pennsylvania Modern: Charles Demuth of Lancaster*, 44.

29. Kellner, *Letters of Charles Demuth*, 56–7.

30. Frank, "Something Beyond Sex," 78.

31. Masonite was invented by William Mason, a Mississippi inventor, in 1924. Mason wanted to find a use for tons of wood chips that were going to waste on the floors of sawmills. He invented a method for using a steam press to produce the hardboard from a slurry of wood chips.

32. Alexander W. Katlan, "Early Wood-Fiber Panels: Masonite, Hardboard, and Lower-Density Board," *Journal of the American Institute for Conservation*, 33 (1994): 301–6.

33. Stephen Kornhauser and Ulrich Birkmaier, *Marsden Hartley's Materials and Working Methods*, in Elizabeth Mankin Kornhauser, general ed., *Marsden Hartley* (Hartford: Wadsworth Atheneum Museum of Art, in association with Yale University Press, New Haven and London, 2003): 264–77.

34. *Beaver Board and Its Uses*, The Beaver Board Companies (Buffalo, New York; Thorold, Ontario; and London, England: 1920). Beaver Board came in panels measuring 3/16 inch thick, 32 and 48 inches wide, and whole-foot lengths ranging from 6, 12, 14, and 16 feet.

35. Ibid.

36. Other tempera on board paintings by Demuth of architectural subjects at this period include *End of the Parade: Coatsville, Pa.* (1920; tempera and pencil on composition board, 19⅞ x 15¾ inches, Private Collection); *In the Province (Roofs)* (1920; tempera and pencil on board, 23⅞ x 19 3/16 inches, Museum of Fine Arts, Boston); *Lancaster* (1921; tempera on board, 15 x 15½ inches, Albright-Knox Gallery); and *The Tower* (1920; tempera on board, 23 x 19 7/16 inches, Columbus Museum of Art).

37. Kornhauser, E. M., *Marsden Hartley*; Kornhauser, S. and Birkmaier, *Marsden Hartley's Materials and Working Methods*, 264–77.

38. Kornhauser, S. and Birkmaier, *Marsden Hartley's Materials and Working Methods*, 266.

39. Georgia O'Keeffe's work, *Series I — No. 3*, 1918, oil on Beaver Board, 20 x 16 inches, follows the same dimensions as Hartley's *Movement* panels. *Georgia O'Keeffe Catalogue Raisonné, Volume One* by Barbara Buhler Lynes, (New Haven: Yale University Press, 1999), 137.

40. See also *Introducing the Paintings of George Of, 1876–1954* by Walter Pach, *Art News*, Volume 55, Number 6, (October 1956), 36–8, 62–3; and "George F. Of" by Betsy Fahlman in *Avant-Garde Painting & Sculpture in America 1910–25*, Delaware Art Museum, April 4–May 18, 1975; cosponsored by the University of Delaware and Delaware Art Museum, 142–3. Thanks are also due to Barbara Buhler Lynes and David Mandel at Heydenryk framers, New York, for providing information on Of, a talented artist in his own right.

41. Although Demuth began with a preplanned composition, he made adjustments as he worked; pentimenti are visible in *After Sir Christopher Wren* (fig. 68) and *In the Province #7* (fig. 29).

42. *Charles Demuth* by A. E. Gallatin (New York: William Edwin Rudge, 1927) as quoted in *Letters of Charles Demuth,* edited by Bruce Kellner (Philadelphia: Temple University Press, 2000), 161.

43. Jonathan Frederick Walz, "The Riddle of the Sphinx or 'It Must Be Said': Charles Demuth's *My Egypt* Reconsidered." Master's thesis, University of Maryland, 2004, 4–5, quoting Emily Farnham; permission to quote granted by Ellen Barley (curator), Demuth Foundation Archives.

44. Walz, "The Riddle of the Sphinx," 15 (quoting Weinberg).

45. Walz, "The Riddle of the Sphinx", 14.

46. Author's conversation with Barbara Buhler Lynes, May 27, 2005.

47. Kellner, *Letters of Charles Demuth*, 104.

48. Kellner, *Letters of Charles Demuth*, 133. Demuth is writing about *And the Home of the Brave* (1931; oil on board, 30 x 24 inches, The Art Institute of Chicago).

49. Author's conversation with Gerald S. Lestz, May 3, 2005.

50. Farnham, *Behind a Laughing Mask*, 36, and Haskell, 14.

51. Correspondence with the author from John Rohrbach (senior curator of photographs, Amon Carter Museum), March 23, 2006.

52. Kellner, *Letters of Charles Demuth*, xviii.

53. Calvin Tomkins, Profile on Georgia O'Keeffe, *New Yorker*, March 4, 1974.

54. Correspondence with the author from John Rohrbach (senior curator of photographs, Amon Carter Museum), March 23, 2006.

55. René Paul Barilleaux and Sarah Whitaker Peters, *Georgia O'Keeffe: Color and Conservation*, (Jackson: Mississippi Museum of Art, in Association with Penn State University, 2006). "Georgia O'Keeffe: Color and Conservation" by Sarah Whitaker Peters, 17.

56. Ibid.

57. Ibid.

58. Kornhauser, E. M., *Marsden Hartley*, 17–8.

59. Correspondence with the author from Betsy Fahlman dated March 24, 2006.

60. S. Lane Faison Jr., "Fact and Art in Charles Demuth," *Magazine of Art*, 43 (April 1950): 123.

61. Kornhauser, S. and Birkmaier, 268.

Learning Centre Canolfan Dysgu
Coleg Y Cymoedd Campus Nantgarw Campus
Heol Y Coleg. Parc Nantgarw
CF15 7QY
01443 653655 : 663168

62. See also Frank, "Something Beyond Sex," 88.

63. Demuth had used a canvas support, however, for some of his earlier industrial paintings in oil, such as *Incense of a New Church* (1921; oil on canvas, 26 x 20⅛ inches, Columbus Museum of Art); *Business* (1921; oil on canvas, 20 x 24½ inches, The Art Institute of Chicago); and *From the Garden of the Château* (1921–25; oil on canvas, 25 x 20 inches, private collection).

64. *Masonite: A Souvenir of the 1934 World's Fair*, Masonite Corporation, 111 W. Washington Street, Chicago, Il., 1.

65. *The Armstrong Manual of Management and Merchandising*, Armstrong Cork Company, Lancaster, Pennsylvania, 1934. In 1924, the company even established the Armstrong Laying School in Lancaster, where thousands of linoleum mechanics were trained. The school was open to any flooring mechanics employed by Armstrong representatives, who provided the cost of transportation, room, and board for training in Lancaster.

66. Correspondence dated February 14, 2005, with C. Eugene Moore, former long-time Armstrong employee in public relations department. Mr. Moore also wrote: "In the 1920s and early 1930s Armstrong was not making a hardboard. So the company purchased this material from another company — Masonite most likely — and sold it as a private-label product under the Armstrong trademark "Temboard underlayment."

67. The linoleum was adhered to the textured, or wire side, of Temboard during the floor-laying process.

68. Kellner, *Letters of Charles Demuth*, 79.

69. Wanda Corn, *The Great American Thing,* (Berkeley: University of California Press, 1999), 203.

70. Unedited transcript, interview with Emily Farnham by Carol Morgan, Director of the Demuth Foundation, in Provincetown, Massachusetts, October 29, 1995.

71. Hartley used academy board as well as prepared boards from F. Weber Co. in addition to Masonite panels. Kornhauser, S. and Birkmaier, footnote 10, 276.

72. Tomkins, Profile on Georgia O'Keeffe, *New Yorker*.

73. Kellner, *Letters of Charles Demuth*, 63.

74. Thanks to Dale Kronkright (conservator) at the Georgia O'Keeffe Museum for his assistance with the examination of a number of panels by O'Keeffe from the museum collection, July 6, 2006. The artist John Covert (1882–1960), first cousin of Walter Arensberg and participant in the Arensbergs' salon in the early 1920s in New York City, was also painting on a hardboard with similar characteristics to that used by O'Keeffe and Demuth at this time; see his painting *Doll* (before 1923; oil on board, 24 x 26 inches, Seattle Art Museum).

75. O'Keeffe used the textured reverse of *Untitled (Skunk Cabbage)* ca. 1927 as a palette to test colors.

76. Demuth's use of a rigid support also meant that his paintings escaped surface changes due to lining during restoration.

77. The "Demuth dove" was a form of the artist's signature that Demuth created at Sunnyside (the home of his friend Isaac Hull Stauffer III) when he was asked by his host to make an inscription on a small pane of glass in an eighteenth-century window using a diamond ring. Gerald S. Lestz, *Charles Demuth and Friends*, (Lancaster: John Baer's Sons, 2003), 22–3.

78. As Judith Walsh has observed, Demuth shared this aspect of his technique with the modernist Patrick Henry Bruce, whose paintings of platonic solids incorporate graphite lines and oil paint to create the geometric still lifes for which he became famous.

79. Kellner, *Letters of Charles Demuth*, 56–7.

80. Kornhauser, S. and Birkmaier, 269.

81. Charles Demuth, Introduction to catalogue for *Georgia O'Keeffe Paintings* 1927 exhibition at The Intimate Gallery, as quoted in Farnham, *Charles Demuth: Behind a Laughing Mask*, 165.

82. Charles Demuth to Georgia O'Keeffe, March 7, 1926, as quoted in Kellner, *Letters of Charles Demuth*, 72.

83. Demuth may have used admixtures of zinc white in his underpainting, switching to the use of a different white pigment in his later revisions. As a result, the revisions appear darker under ultraviolet light, while the underlying paint containing zinc white fluoresces more strongly.

84. Kellner, *Letters of Charles Demuth*, 115.

85. Kellner, *Letters of Charles Demuth*, 113.

86. *Paquebot "Paris"* (1921–22; oil on canvas, 20 x 25 inches, Columbus Museum of Art) is unvarnished but also shows a variable surface gloss. Most of the dark smokestacks appear glossy, either due to different admixtures of medium or to possible local varnishing by the artist.

87. As a result, Hartley's paintings also exhibit a localized fluorescence when examined under ultraviolet light. Kornhauser, S. and Birkmaier, 267.

88. Caroline and Sheldon Keck helped establish the conservation training programs at both the Institute of Fine Arts, New York University, and the Cooperstown Graduate Program at the State University College of Oneonta. Their collaboration with O'Keeffe began in 1946 and continued until the artist's death. Caroline also advised O'Keeffe about painting materials and techniques, and O'Keeffe contributed funds to support conservation training. See also Barilleaux and Whitaker, *Georgia O'Keeffe: Color and Conservation*.

89. "[S]prayed June 1947 by Keck," is written in graphite on the reverse of *And the Home of the Brave*; while a label on the reverse of *Buildings Abstraction, Lancaster* states "sprayed with n-butyl methacrylate by Keck."

90. Archives, Museum of Modern Art, memo dated June 12, 1947.

91. Letter dated May 30, 1954, from Georgia O'Keeffe to E. P. Richardson, director of the Detroit Institute of Arts. Curatorial files, Detroit Institute of Arts. Thanks are due to Alfred Ackerman for making this letter available.

92. On October 23, 1932, Demuth wrote to Stieglitz: "Will you please put the enclosed ticket on that oil painting of mine, — the new one in a black frame, the one with the blue sky and yellow water-tower." Kellner, *Letters of Charles Demuth*, 134–5.

93. Letter from James Maroney to Richard Brettell, then director of the Dallas Museum of Art, dated July 18, 1988: "I might just add that *Buildings* is in its original frame and should, in my opinion, be kept that way." Curatorial files, Dallas Museum of Art. Thanks to William Rudolph and John Dennis for assistance during examination.

94. Thanks are owed to Judith Walsh for this observation.

95. *Charles Sheeler's "Power Series"* exhibition, January 15–April 9, 2006, Dallas Museum of Art.

96. Thanks to Barbara Buhler Lynes and David Mandel at Heydenryk framers, New York, for providing information on Of, a talented artist in his own right. See also Betsy Fahlman, "George F. Of (1876–1954)" in *Avant-Garde Painting and Sculpture in America: 1910–25* (Wilmington: Delaware Art Museum, 1975): 106–7; and Walter Pach, "Introducing the Paintings of George Of, 1876–1954," *Art News* 55 (October 1956): 36–8, 62–3.

97. Kellner, *Letters of Charles Demuth*, 115.

98. Unedited transcript, interview with Emily Farnham by Carol Morgan, director of the Demuth Foundation in Provincetown, Massachusetts, October 29, 1995, Demuth Foundation Archives.

99. Demuth, Introduction to *Georgia O'Keeffe Paintings*, as quoted in Farnham, 163.

# Selected Bibliography

**PUBLISHED SOURCES**

Adams, Henry. *The Beal Collection of American Art*. Pittsburgh: The Carnegie Museum of Art, 1994.

Allen, Frederick M. "Clinical Observations with Insulin. The Influence of Fat and Total Calories on Diabetes and the Insulin Requirement." *Journal of Metabolic Research* 3 (1923): 61–176.

_____. "Clinical Observations with Insulin. 1. The Use of Insulin in Diabetic Treatment." *Journal of Metabolic Research* 2 (November–December 1922): 803–985.

_____. "The Physiatric Institute: Address at Its Opening at Morristown, N.J., April 26, 1921." *Journal of the Medical Society of New Jersey* 8 (June 1921): 189–93.

_____. "The Present Status of Diabetic Treatment." *Journal of the Medical Society of New Jersey* 20 (January 1923): 1–15.

Allen, Frederick M., and James W. Sherrill. "Clinical Observations on Treatment and Progress in Diabetes." *Journal of Metabolic Research* 2 (1922): 377–455.

Antliff, Allan. *Anarchist Modernism: Art, Politics, and the First American Avant-Garde*. Chicago: University of Chicago Press, 2001.

"Armstrong Cork." *Fortune* 15 (May 1937): 102–07, 160–8.

Armstrong Cork Company. *Cork: Its Origins and Uses*. Lancaster, Pa: Armstrong Cork Company, 1930.

Armstrong Cork Company. *History of the Floor Plant, 1908–1980*. Lancaster, Pa.: Armstrong Cork Company, 1980.

Armstrong Cork Company. *Partners in Business: Compiled and Printed for the Information of the Stockholders of Armstrong Cork Company*. Lancaster, Pa.: Armstrong Cork Company, 1941.

Baigell, Matthew. "American Art and National Identity: The 1920s." *Arts Magazine* 61 (February 1987): 48–55.

_____. *The American Scene: American Painting of the 1930s*. New York: Praeger, 1974.

Bender, Thomas. *New York Intellect: A History of Intellectual Life in New York City, from 1750 to the Beginnings of Our Own Time*. New York: Alfred A. Knopf, 1987.

Bliss, Michael. *The Discovery of Insulin*. Chicago: University of Chicago Press, 1982.

Bloemink, Barbara J. *The Art and Life of Florine Stettheimer*. New Haven: Yale University Press, 1995.

Bogart, Michele H. *Artists, Advertising, and the Borders of Art*. Chicago: University of Chicago Press, 1996.

Bohan, Ruth L. "'I Sing the Body Electric': Isadora Duncan, Whitman, and the Dance." In *The Cambridge Companion to Whitman*, edited by Ezra Greenspan, 166–93. New York: Cambridge University Press, 1995.

_____. *Looking into Walt Whitman: American Art, 1850–1920*. University Park, Pa.: Penn State University Press, 2006.

Brennan, Marcia. *Painting Gender, Constructing Theory: The Alfred Stieglitz Circle and American Formalist Aesthetics*. Cambridge: MIT Press, 2001.

Breslin, James E. "William Carlos Williams and Charles Demuth: Cross-Fertilization in the Arts." *JML (Journal of Modern Language)* 6 (April 1977): 248–63.

Brock, Charles. *Charles Sheeler: Across Media*. Washington, D.C.: National Gallery of Art, in association with University of California Press, Berkeley, 2006.

Brooks, Van Wyck. "On Creating a Usable Past." *The Dial* 64 (April 11, 1918): 337–41.

Brown, Ellen. "When Reading, Writing, and Painting Converge: The Literary Life of Artist Charles Demuth." *Rapportage, the Journal of the Lancaster Literary Guild*, inaugural issue (Fall 2001): 19–29.

Brutvan, Cheryl A. *Masterworks on Paper from the Albright-Knox Art Gallery*. New York: Hudson Hills Press, 1987.

Burke, Carolyn. *Becoming Modern: The Life of Mina Loy*. Berkeley: University of California Press, 1997.

Bry, Doris. *Georgia O'Keeffe: Some Memories of Drawings*. Albuquerque: University of New Mexico Press, 1988.

Bryan, Jodelle L. "From Vaudeville to the Silver Screen: Popular Entertainment in Lancaster 1900–1930." *Journal of the Lancaster County Historical Society* 95 (Autumn 1993): 109–28.

Cassidy, Donna M. "Building Region into Modernism: Marsden Hartley's *Church at Head Tide, Maine* (1938)." *Colby Quarterly* 39 (December 2003): 314–44.

————. *Marsden Hartley: Race, Region, and Nation*. Durham, N.H: University of New Hampshire Press; Hanover, N.H.: University Press of New England, 2005.

————. "'On the Subject of Nativeness': Marsden Hartley and New England Regionalism." *Winterthur Portfolio 29* (Winter 1994): 227–45.

————. *Painting the Musical City: Jazz and Cultural Identity in American Art, 1900–1940*. Washington, D.C.: Smithsonian Institution Press, 1997.

Chauncey, George. *Gay New York: Gender, Urban Culture, and the Making of the Gay Male World, 1890–1940*. New York: Basic Books, 1994.

————. "Long-Haired Men and Short-Haired Women: Building a Gay World in the Heart of Bohemia." In *Greenwich Village: Culture and Counterculture*, edited by Rick Beard and Leslie Cohen Berlowitz. New Brunswick: Rutgers University Press, for the Museum of the City of New York, 1993.

Cheney, Anne. *Millay in Greenwich Village*. University, Ala.: University of Alabama Press, 1975.

Cohen, Allen, and Ronald L. Filippelli. *Times of Sorrow & Hope: Documenting Everyday Life in Pennsylvania During the Depression and World War II*. University Park: The Pennsylvania State University Press, 2003.

Connor, Celeste. *Democratic Visions: Art and Theory of the Stieglitz Circle, 1924–1934*. Berkeley: University of California Press, 2001.

Cooper, Emmanuel. *The Sexual Perspective: Homosexuality and Art in the Last 100 Years in the West*. London: Routledge and Kegan Paul, 1986.

Cooper, Helen A. "The Watercolors of Charles Duluth." *Antiques* 133 (January 1988): 258–65.

Corn, Wanda M. *The Great American Thing: Modern Art and National Identity, 1915–1935*. Berkeley: University of California Press, 1999.

————. *In the American Grain: The Billboard Poetics of Charles Demuth*. Poughkeepsie: Vassar College Art Gallery, 1991.

Cortissoz, Royal. "Another Show at the Modern Museum." *New York Herald Tribune*, December 15, 1929.

————. "Random Impressions in Current Exhibitions." *New York Times*, December 24, 1922.

Costello, Bonnie, ed., and Celeste Goodridge and Cristanne Miller, assoc. eds. *The Selected Letters of Marianne Moore*. New York: Alfred A. Knopf, 1997.

Crunden, Robert M. *American Salons: Encounters with European Modernism, 1885–1917*. New York: Oxford University Press, 1993.

————. *Body and Soul: The Making of American Modernism, Art, Music, and Letters in the Jazz Age, 1919–1926*. New York: Basic Books, 2000.

Daum, Fred J. "The Cork Industry as Lancaster Knows It." *Papers of the Lancaster County Historical Society* 54 (1950): 120–61.

Davidson, Abraham A. *Early American Modernist Painting, 1910–1935*. New York: Harper and Row, 1981.

Davies, Karen. "Charles Sheeler in Doylestown and the Image of Rural Architecture." *Arts Magazine* 59 (March 1985): 135–9.

de la Rie, E. Rene. "Fluorescence of Paint and Varnish Layers." *Studies in Conservation* 27, no.1 (February 1982): 1–7.

*Demuth Dialogue*, newsletter of the Demuth Foundation, Lancaster, Pennsylvania. 1982–Present.

Demuth Foundation. *Demuth on O'Keeffe on Demuth*. Lancaster, Pa.: Demuth Foundation, 1999.

Demuth, Henry C. *Demuth's 1770: Being a Brief History of the Demuth Tobacco Shop Which Was Founded at Lancaster in the Province of Pennsylvania in the Year of Our Lord 1770*. Lancaster: privately printed, 1925.

Dewey, John. "Americanism and Localism." *The Dial* 68 (June 1920): 684–8.

Dijkstra, Bram. *The Hieroglyphics of a New Speech: Cubism, Stieglitz, and the Early Poetry of William Carlos Williams*. Princeton: Princeton University Press, 1969.

_____, ed. *A Recognizable Image: William Carlos Williams on Art and Artists*. New York: New Directions, 1978.

Doezema, Marianne. *American Realism in the Industrial Age*. Cleveland: Cleveland Museum of Art, in cooperation with Indiana University Press, Bloomington, 1980.

Doss, Erika. *Benton, Pollock, and the Politics of Modernism: From Regionalism to Abstract Expressionism*. Chicago: University of Chicago Press.

_____. *Twentieth Century American Art*. New York: Oxford University Press, 2002.

Draper, Muriel. *Music at Midnight*. New York: Harper and Brothers, 1929.

_____. "Robert Locher: His Art and Craft." *Creative Art* 9 (July 1931): 52–6.

Early, William F. "Armstrong's Advertising and Marketing Services Department, 1911–1994." *Journal of the Lancaster County Historical Society* 98 (1996): 50–69.

Edmiston, Susan, and Linda D. Cirino. *Literary New York: A History and Guide*. Boston: Houghton Mifflin, 1976.

Eisler, Benita. *O'Keeffe and Stieglitz: An American Romance*. New York: Doubleday, 1991.

Fahlman, Betsy. "Arnold Rönnebeck and Alfred Stieglitz: Remembering the Hill." *History of Photography* 20 (Winter 1996): 304–11.

_____. "Charles Demuth's Paintings of Lancaster Architecture: New Discoveries and Observations." *Arts Magazine* 61 (March 1987): 24–9.

_____. "The Charles Demuth Retrospective at the Whitney Museum of American Art." *Arts Magazine* 62 (March 1988): 52–4.

_____. "The Great Draper Woman: Muriel Draper and the Art of the Salon." *Woman's Art Journal* 26 (Fall 2005/Winter 2006): 33–7.

_____. "Modern as Metal and Mirror: The Work of Robert Evans Locher." *Arts Magazine* 59, no. 8 (April 1985): 108–13.

_____. "*Nospmas M. Egiap Nospmas M.* by Charles Demuth." In *Masterworks of American Art from the Munson-Williams-Proctor Institute*, 126–7, 226. New York: Abrams, 1989.

_____. *Pennsylvania Modern: Charles Demuth of Lancaster*. Philadelphia, Pa: Philadelphia Museum of Art, 1983.

_____. "Works on Paper: Prints and Drawings by Arnold Rönnebeck." In *Arnold Rönnebeck*. New York: Conner-Rosenkranz, 1998.

Faison, S. Lane, Jr. "Fact and Art in Charles Demuth." *Magazine of Art* 43 (April 1950): 123–8.

Farnham, Emily. *Charles Demuth: Behind a Laughing Mask*. Norman: University of Oklahoma Press, 1971.

_____. "Charles Demuth: His Life, Psychology and Works." PhD diss., Ohio State University, 1959.

Ferber, Linda S., and Barbara Dayer Gallati. *Homer, Sargent and the American Watercolor Movement*. Brooklyn: Brooklyn Museum of Art, in association with Smithsonian Institution Press, Washington, D.C., 1998.

Feudtner, Chris. *Bittersweet: Diabetes, Insulin, and the Transformation of Illness*. Chapel Hill: University of North Carolina Press, 2003.

Fillin-Yeh, Susan. *Charles Sheeler: American Interiors*. New Haven: Yale University Art Gallery, 1987.

Fine, Ruth E., and Barbara Buhler Lynes, with Elizabeth Glasssman and Judith C. Walsh. *O'Keeffe on Paper*. Washington, D.C.: National Gallery of Art; Santa Fe: Georgia O'Keeffe Museum, 2000; distributed by Harry N. Abrams, New York.

Fletcher, Stevenson Whitcomb. *Pennsylvania Agriculture and County Life, 1840–1940*. Harrisburg: Pennsylvania Historical and Museum Commission, 1955.

Foshay, Ella M. *Reflections of Nature: Flowers in American Art*. New York: Knopf, in association with the Whitney Museum of American Art, 1984.

Frank, Robin Jaffee. *Charles Demuth: Poster Portraits 1923–1929*. New Haven: Yale University Art Gallery, 1994.

_____. "'Something Beyond Sex': Demuth's Drawings in the Hill Collection at Yale." *Yale University Art Gallery Bulletin* 2003: 74–93.

Friedman, Martin L. *The Precisionist View in American Art*. Minneapolis: Walker Art Institute, 1960.

Gallatin, A. E. *American Water-Colourists*. New York: E. P. Dutton, 1922.

_____. *Charles Demuth*. New York: William Edwin Rudge, 1927.

Gelb, Arthur, and Barbara Gelb. *O'Neill: Life with Monte Cristo*. New York: Applause, 2000.

Grafly, Dorothy. "The Whitney Museum's Biennial." *American Magazine of Art* 26 (January 1933): 5–12.

Green, Martin. *New York 1913: The Armory Show and the Patterson Strike Pageant*. New York: Charles Scribner's Sons, 1988.

Greenfield, Howard. *The Devil and Dr. Barnes: Portrait of an American Collection*. New York: Viking, 1987.

Greenough, Sarah et al. *Modern Art in America: Alfred Stieglitz and His New York Gallery*. Washington, D.C.: National Gallery of Art, 2000.

Hagen, Angela E. "Around the Galleries: Demuth Watercolors and Oils at 'An American Place.'" *Creative Art* 8 (June 1931): 441–3, 449.

Halter, Peter. "Dialogue of the Sister Arts: Number-Poems and Number-Paintings in America, 1920–1970." *English Studies* 63 (April 1982): 207–19.

_____. "'How Shall I be a Mirror to This Modernity?'. William Carlos Williams, Alfred Stieglitz and the Artists of the Stieglitz Circle." In *Papers from the Poetry Sessions of the European Association for American Studies Biennial Conference, Rome, 1984*, edited by Roland Hagenbüchle and Jaqueline S. Ollier, 72–101. Regensburg: Friedrich Pustet, 1989.

_____. *The Revolution in the Visual Arts and the Poetry of William Carlos Williams*. Cambridge: Cambridge University Press, 1994.

Harnsberger, R. Scott, and David L. Henderson. *Ten Precisionist Artists: Annotated Bibliographies*. Westport, Conn., Greenwood Press, 1992.

Harris, Ruth Green. "Demuth." *New York Times*, April 19, 1931.

Hartley, Marsden. "Farewell, Charles." In *The New Caravan*, edited by Alfred Kreymborg, Lewis Mumford, and Paul Rosenfeld. New York: W.W. Norton, 1936.

Haskell, Barbara. *The American Century: Art and Culture, 1900–1950*. New York: Whitney Museum of American Art in association with W. W. Norton, 1999.

_____. *Charles Demuth*. New York: Whitney Museum of American Art, in association with Harry N. Abrams, 1988.

Heller, Adele, and Lois Rudnick, eds. *1915, The Cultural Moment: The New Politics, the New Woman, the New Psychology, the New Art, and the New Theatre in America*. New Brunswick: Rutgers University Press, 1991.

Henderson, Alfred. "Frederick M. Allen, M.D., and the Psychiatric [sic] Institute at Morristown, N.J. (1920–1938)." *Academy of Medicine of New Jersey Bulletin* 16 (December 1970): 40–9.

Hollis Taggart Galleries. *From Hawthorne to Hofmann: Provincetown Vignettes, 1899–1945*. New York: Hollis Taggart Galleries, 2003.

Homer, William Innes. *Alfred Stieglitz and the American Avant-Garde*. Boston: New York Graphic Society, 1977.

Jackson, Kenneth T., ed. *The Encyclopedia of New York City*. New Haven: Yale University Press, 1995.

James, Henry Francis. *The Agricultural Industry of Southeastern Pennsylvania: A Study in Economic Geography*. Philadelphia: Geographical Society of Philadelphia, 1928.

Jewell, Edward Alden. "Art: Works by Five Artists Shown." *New York Times*, May 20, 1932.

_____. "Demuth's Retrospective Show." *New York Times*, April 14, 1931.

_____. "Modern Art Museum — Art 'Twixt Covers.'" *New York Times*, December 22, 1929.

Jones, Amelia. *Irrational Modernism: A Neurasthenic History of New York Dada*. Cambridge: Massachusetts Institute of Technology Press, 2004.

Kaiser, Charles. *The Gay Metropolis, 1940–1996*. New York: Houghton Mifflin, 1997.

Katlan, Alexander W. "Early Wood-Fiber Panels: Masonite, Hardboard, and Lower-Density Boards." *Journal of the American Institute for Conservation* 33, no. 3 (Fall/Winter 1994), 301–6.

Kellner, Bruce. *Carl Van Vechten and the Irreverent Decades*. Norman: University of Oklahoma Press, 1968.

_____, ed. *A Gertrude Stein Companion: Content with the Example*. New York: Greenwood Press, 1988.

_____. *The Harlem Renaissance: A Historical Dictionary for the Era*. Westport, Conn.: Greenwood Press, 1984.

_____. *Letters of Carl Van Vechten*. New Haven: Yale University Press, 1987.

_____. *Letters of Charles Demuth, American Artist, 1883–1935*. Philadelphia: Temple University Press, 2000.

_____, ed. *The Splendid Drunken Twenties: Selections from the Daybooks, 1922–1930, Carl Van Vechten*. Urbana: University of Illinois Press, 2003.

Kirkland, Winifred. "Americanization and Walt Whitman." *The Dial* 66 (May 31, 1919): 537–9.

Klein, H. M. J. *Lancaster County, Pennsylvania: A History*. 2 vols. New York: Lewis Historical Publishing Company, Inc., 1924.

Kornhauser, Elizabeth Mankin, ed. *Marsden Hartley*. Hartford: Wadsworth Atheneum Museum of Art, in association with Yale University Press, New Haven, 2003.

Kuhl, Nancy. *Intimate Circles: American Women in the Arts*. New Haven: Beinecke

Rare Book and Manuscript Library, Yale University, 2003.

Lancaster Board of Trade. *Resources and Industries of Lancaster, Pennsylvania.* Lancaster, Pa.: Lancaster Board of Trade, 1909.

Lancaster Newspapers Inc. *A Pictorial History of Lancaster, Pennsylvania in the Twentieth Century.* Marceline, Mo.: Heritage House Publishing, 1999.

Leavell, Linda. *Marianne Moore and the Visual Arts: Prismatic Color.* Baton Rouge: Louisiana State University Press, 1995.

Lestz, Gerald S. *Charles Demuth and Friends.* Lancaster, Pa.: John Baer's Sons, 2003.

_____. *Tobacco / Pro and Con: A New Look at an Old Subject.* Lancaster, Pa.: The Aurand Press, 1989.

Lévy, Sophie, ed. *A Transatlantic Avant-Garde: American Artists in Paris, 1918–1939.* Berkeley: University of California Press, in association with the Musée d'Art Américaine Giverny and the Terra Foundation for the Arts, 2003.

Litz, A. Walton, and Christopher MacGowan. *The Collected Poems of William Carlos Williams, Volume I, 1909–1939.* New York: New Directions, 1986.

Loose, John Ward Willson. *The Heritage of Lancaster.* Woodland Hills, Calif.: Windsor Publications, 1978.

_____. "A History of Sin and Vice: Lancaster — The Fallen Angel." *Journal of the Lancaster County Historical Society* 94 (1992): 105–16.

_____. *Lancaster County: The Red Rose of Pennsylvania.* Canoga Park, Calif.: CCA Publications, in cooperation with the Lancaster County Historical Society and the Lancaster Chamber of Commerce and Industry, 1994.

_____. "Lancaster's Northern Industrial District: The Railroad Cometh and Taketh."

*Journal of the Lancaster County Historical Society Journal* 101 (Spring 1999): 72–96.

Loughery, John. *The Other Side of Silence: Men's Lives and Gay Identities: A Twentieth-Century History.* New York: Henry Holt, 1998.

Lucic, Karen. "Charles Sheeler: American Interiors." *Arts Magazine* 61 (May 1987): 44–7.

_____. *Charles Sheeler and the Cult of the Machine.* Cambridge: Harvard University Press, 1991.

_____. *Charles Sheeler in Doylestown: American Modernism and the Pennsylvania Tradition.* Allentown, Pa.: Allentown Art Museum, 1997.

_____. "On the Threshold: Charles Sheeler's Early Photographs." *Prospects* 20 (1995): 227–55.

Lynes, Barbara Buhler, Lesley Poling-Kempes, and Frederick W. Turner. *Georgia O'Keeffe and New Mexico: A Sense of Place.* Princeton: Princeton University Press; Santa Fe: Georgia O'Keeffe Museum, 2004.

Lynes, Barbara Buhler, and Russell Bowman. *O'Keeffe's O'Keeffes: The Artist's Collection.* Milwaukee: Milwaukee Art Museum; Santa Fe: Georgia O'Keeffe Museum; New York: Thames and Hudson, 2001.

MacGowan, Christopher J. *William Carlos Williams's Early Poetry: The Visual Arts Background.* Ann Arbor, Mich.: UMI Research Press, Studies in Modern Literature, No. 35, 1984.

MacLeod, Glen. *Wallace Stevens and Modern Art: From the Armory Show to Abstract Expressionism.* New Haven: Yale University Press, 1993.

Mariani, Paul. *William Carlos Williams: A New World Naked.* New York: McGraw Hill, 1981.

Marling, Karal Ann. "*My Egypt*: The Irony of the American Dream." *Winterthur Portfolio* 15 (Spring 1980): 25–39.

_____. *Wall to Wall America: A Cultural History of Post-Office Murals in the Great Depression.* Minneapolis: University of Minnesota Press, 1982.

Marling, William. *William Carlos Williams and the Painters, 1909–1923.* Athens, Ohio: Ohio University Press, 1982.

Mazow, Leo G., with an essay by Michael R. Taylor. *John Covert Rediscovered.* University Park, Pa.: Palmer Museum of Art, 2003.

McBride, Henry. "Art News and Reviews — Important New Work on Watercolors: Remarkable Paintings by Charles Demuth." *The New York Herald,* December 17, 1922.

_____. "Attractions in the Galleries." *New York Sun*, May 21, 1932.

_____. "Charles Demuth, Artist." *Charles Demuth Memorial Exhibition,* New York: Whitney Museum of American Art, 1937.

_____. "Modern Art." *The Dial* 70 (February 1921): 234–6.

_____. "News and Reviews of Art — Attractive Winter Exhibitions in Many Galleries: Charles Demuth Displays His Beautiful Landscapes at Daniels." *The New York Herald*, December 5, 1920.

McGarry, Molly, and Fred Wasserman. *Becoming Visible: An Illustrated History of Lesbian and Gay Life in Twentieth-Century America.* New York: Penguin Studio, 1998.

Mehler, William A., Jr. *Let the Buyer Have Faith: The Story of Armstrong.* Lancaster, Pa.: Armstrong World Industries, 1987.

Mellby, Julie. "A Record of Charles Daniel and the Daniel Gallery." PhD diss., City University of New York, Hunter College, 1993.

Melosh, Barbara. *Engendering Culture: Manhood and Womanhood in New Deal Public Art and Theater.* Washington, D.C.: Smithsonian Institution Press, 1991.

Miller, Randall M., and William Pencak. *Pennsylvania: A History of the Commonwealth.* University Park: Pennsylvania State University Press; Harrisburg: Historical and Museum Commission, 2002.

Molesworth, Charles. *Marianne Moore: A Literary Life.* New York: Atheneum, 1990.

Miller, James E., Jr. *Complete Poetry and Selected Prose by Walt Whitman.* Boston: Houghton Mifflin, 1959.

Miller, Neil. *Out of the Past: Gay and Lesbian History from 1869 to the Present.* New York: Vintage Books, 1994.

Morrin, Peter et al. *The Advent of Modernism: Post-Impressionism and North American Art, 1900–1918.* Atlanta: High Museum of Art, 1986.

Naumann, Francis M., ed. *Beatrice Wood: A Centennial Tribute.* New York: American Craft Museum, 1997.

_____. "The Drawings of Beatrice Wood." *Arts Magazine* 57 (March 1983): 108–11.

_____, with Beth Venn. *Making Mischief: Dada Invades New York.* New York: Whitney Museum of American Art, 1996.

_____. *New York Dada, 1915–23.* New York: Harry N. Abrams, 1994.

*New York Times.* "The World of Art: Russian and American Paintings and a Group of Etchings," December 19, 1920.

Norton, Thomas E., ed. *Homage to Charles Demuth: Still Life Painter of Lancaster.* Ephrata, Pa.: Science Press, 1978.

Orvell, Miles. "The Artist Looks at the Machine: Whitman, Sheeler, and American Modernism." *Amerika Studien. American Studies* 41 (1996): 361–79.

Ozieblo, Barbara. *Susan Glaspell: A Critical Biography.* Chapel Hill: University of North Carolina Press, 2000.

Park, Marlene, and Gerald E. Markowitz. *Democratic Vistas: Post Offices and Public Art in the New Deal.* Philadelphia: Temple University Press, 1984.

Parsons, Frank A. *The Art of Home Furnishing and Decoration*. Lancaster, Pa.: Armstrong Cork Company, 1918.

Prentis, H. C. *Thomas Morton Armstrong (1836–1908): Pioneer in Cork*. New York: The Newcomen Society in North America, 1950.

Reed, Sue Welsh, and Carol Troyen. *Awash in Color: Homer, Sargent, and the Great American Watercolor*. Boston: Museum of Fine Arts and Bulfinch Press, 1993.

Rich, Daniel Catton. *The Flow of Art: Essays and Criticisms of Henry McBride*. New York: Atheneum, 1975.

Richwine, Keith Norton. "The Liberal Club: Bohemia and the Resurgence in Greenwich Village, 1912–1919." PhD diss., University of Pennsylvania, 1968.

Ritchie, Andrew Carnduff. *Charles Demuth*. New York: Museum of Modern Art, 1950.

Rosenfeld, Paul. "Art: Charles Demuth." *The Nation* 133 (October 7, 1931): 371–3.

Sadinsky, Rachael, and William G. Sackett. *Edward Fisk: American Modernist*. Lexington: University of Kentucky Art Museum, 1998.

Sarlós, Robert Károly. *Jig Cook and the Provincetown Players: Theatre in Ferment*. Amherst: University of Massachusetts Press, 1983.

Saslow, James M. *Pictures and Passions: A History of Homosexuality in the Visual Arts*. New York: Viking, 1999.

Sayre, Henry M. "American Vernacular: Objectivism, Precisionism, and the Aesthetics of the Machine." *Twentieth Century Literature* 335 (Fall 1989): 310–42.

———. *The Visual Text of William Carlos Williams*. Urbana: University of Illinois Press, 1983.

Schmidt, Peter. "Some Versions of Modernist Pastoral: Williams and the Precisionists." *Contemporary Literature* 21 (Summer 1980): 207–19.

———. *William Carlos Williams, The Arts, and Literary Tradition*. Baton Rouge: Louisiana State University Press, 1988.

Schmied, Wieland. "Precisionist View and American Scene: The 1920s." In *American Art in the 20th Century*, edited by Christos M. Joachimides and Norman Rosenthal, 47–59. Munich: Prestel, 1993.

Schnakenberg, Henry E. "Charles Demuth." *The Arts* 17 (May 1931): 581.

Scott, Wilford Wildes. "The Artistic Vanguard in Philadelphia, 1905–1920." PhD diss., University of Delaware, 1983.

Scott, William, and Peter Rutkoff. *New York Modern: The Arts and the City*. Baltimore: Johns Hopkins University Press, 2001.

Sill, Geoffrey M., and Roberta K. Tarbell, eds. *Walt Whitman and the Visual Arts*. New Brunswick: Rutgers University Press, 1992.

Simpson, Pamela H. *Cheap Quick and Easy: Imitative Architectural Materials, 1870–1930*. Knoxville: University of Tennessee Press, 1999.

Smith, Lindsay, ed. *I Shock Myself: The Autobiography of Beatrice Wood*. San Francisco: Chronicle Books, 1992.

Smith, Terry. *Making the Modern: Industry, Art, and Design in America*. Chicago: University of Chicago Press, 1993.

Stansell, Christine. *American Moderns: Bohemian New York and the Creation of a New Century*. New York: Henry Holt, 2000.

Stavitsky, Gail et al. *Precisionism in America, 1915–1941: Reordering Reality*. New York: Harry N. Abrams, in association with the Montclair Art Museum, 1994.

Stebbins, Theodore E., Jr. *American Master Drawings and Watercolors: A History of Works on Paper from Colonial Times to the Present*. New York: Harper and Row, 1976.

Stebbins, Theodore E., Jr., and Norman Keyes Jr. *Charles Sheeler: The Photographs*. Boston: Museum of Fine Arts, 1987.

Stebbins, Theodore E., Jr., Gilles Mora, and Karen E. Haas. *The Photographs of Charles Sheeler: American Modernist*. Boston: Bulfinch Press, 2002.

Steinman, Lisa M. *Made in America: Science, Technology, and American Modernist Poets*. New Haven: Yale University Press, 1987.

Stewart, Patrick Leonard, Jr. "Charles Sheeler, William Carlos Williams, and the Development of the Precisionist Aesthetic, 1917–1931." PhD diss., University of Delaware, 1981.

————. "Charles Sheeler, William Carlos Williams, and Precisionism: A Redefinition." *Arts Magazine* 58 (November 1983): 100–14.

Sussman, Elizabeth, with Barbara J. Bloemink and a contribution by Linda Nochlin. *Florine Stettheimer: Manhattan Fantastica*. New York: Whitney Museum of American Art, distributed by Harry N. Abrams, 1995.

Tarbell, Roberta K. "Whitman and the Visual Arts." In *A Historical Guide to Walt Whitman*, edited by David S. Reynolds, 153–204. New York: Oxford University Press, 2000.

Tashjian, Dickran. *Skyscraper Primitives: Dada and American Art, 1910–1925*. Middletown, Conn.: Wesleyan University Press, 1975.

————. *William Carlos Williams and the American Scene, 1920–1940*. New York: Whitney Museum of American Art, in association with the University of California Press, 1978.

Thirwall, John C., ed. *The Selected Letters of William Carlos Williams*. New York: McDowell, Obolensky, 1957.

Tichi, Cecelia. *Shifting Gears: Technology, Literature, Culture in Modernist America*. Chapel Hill: University of North Carolina Press, 1987.

The Tobacco Institute. *Pennsylvania and Tobacco: A Chapter in America's Industrial Growth*. Washington, D.C.: The Tobacco Institute, 1961.

Traylor, William R. *In Pursuit of Gotham: Culture and Commerce in New York*. New York: Oxford University Press, 1992.

Troyen, Carol, and Erica E. Hirschler. *Charles Sheeler: Paintings and Drawings*. Boston: Museum of Fine Arts, 1987.

Tsujimoto, Karen. *Images of America: Precisionist Painting and Modern Photography*. San Francisco: San Francisco Museum of Modern Art; Seattle: University of Washington Press, 1982.

Turner, Elizabeth Hutton. *Americans in Paris (1921–1931)*. Washington, D.C.: The Phillips Collection, 1996.

Tyler, Parker. *Florine Stettheimer: A Life in Art*. New York: Farrar, Straus and Company, 1963.

Van Vechten, Carl. "Ma-Draper." *Yale University Library Gazette* 37 (April 1963): 125–9.

————. "Pastiches et Pistaches: Charles Demuth and Florine Stettheimer." *The Reviewer* 2 (February 1922): 269–70.

Venn, Beth, and Adam D. Weinberg, eds. *Frames of Reference: Looking at American Art, 1900–1950, Works from the Whitney Museum of American Art*. New York: Whitney Museum of American Art, in association with University of California Press, Berkeley, 1999.

Walz, Jonathan Frederick. "The Riddle of the Sphinx or 'It Must Be Said': Charles Demuth's *My Egypt* Reconsidered." Master's thesis, University of Maryland, 2004.

Watson, Steven. *Prepare for Saints: Gertrude Stein, Virgil Thomson, and the Mainstreaming of American Modernism*. New York: Random House, 1998.

————. *Strange Bedfellows: The First American Avant-Garde*. New York: Abbeville Press, 1991.

Watson, Steven, and Catherine Morris, eds. *An Eye on the Modern Century: Selected Letters of Henry McBride*. New Haven: Yale University Press, 2000.

Wattenmaker, Richard J., and Anne Distel. *Great French Paintings from the Barnes Foundation: Impressionist, Post-Impressionist, and Early Modern*. New York: Alfred A. Knopf, in association with Lincoln University Press, 1993.

Weaver, Mike. *William Carlos Williams: The American Background*. Cambridge: Cambridge University Press, 1971.

Weber, Bruce. *The Heart of the Matter: The Still Lifes of Marsden Hartley*. New York: Berry-Hill Galleries, 2003.

Weber, Nicholas Fox. *Patron Saints: Five Rebels Who Opened America to a New Art*. New York: Alfred A. Knopf, 1992.

Weinberg, Jonathan. *Ambition and Love in Modern American Art*. New Haven: Yale University Press, 2001.

————. *Male Desire: The Homoerotic in American Art*. New York: Harry N. Abrams, 2004.

————. *Speaking for Vice: Homosexuality in the Art of Charles Demuth, Marsden Hartley, and the First American Avant-Garde*. New Haven: Yale University Press, 1993.

Wellman, Rita. "Charles Demuth: Artist." *Creative Art* 9 (December 1931): 483–4.

Wertheim, Arthur Frank. *The New York Little Renaissance: Iconoclasm, Modernism, and Nationalism in American Culture, 1908–1917*. New York: New York University Press, 1976.

Wetzsteon, Ross. *Republic of Dreams: Greenwich Village; The American Bohemia, 1910–1960*. New York: Simon & Schuster, 2002.

Whiting, Cécile. "Decorating with Stettheimer and the Boys." *American Art* 14 (Spring 2000): 24–49.

Whitney Museum of American Art. *Charles Demuth Memorial Exhibition*. New York: Whitney Museum of American Art, 1937.

Williams, William Carlos. *The Autobiography of William Carlos Williams*. New York: Random House, 1951.

————. *The Complete Poems of William Carlos Williams, 1906–1938*. Norfolk, Conn.: New Directions, 1938.

————. "Marianne Moore." *The Dial* 78 (May 1925): 393–401.

————. *Selected Essays of William Carlos Williams*. New York: Random House, 1954.

Woodbridge, Margaret. "Purveyor of Snuffs, Tobaccos and Cigars: A Tobacco Shop That is Older Than the United States." *United States Tobacco Review* (Summer 1978): 4–7.

Zabel, Barbara. *Assembling Art: The Machine and the American Avant-Garde*. Jackson: University Press of Mississippi, 2004.

————. "Stuart Davis's Appropriation of Advertising: The Tobacco Series, 1921–1924." *American Art* 5 (Fall 1991): 57–67.

## ARCHIVAL MATERIAL

Archives of American Art, Smithsonian Institution, Washington, D.C. Papers of Charles Demuth, Edward Fisk, Arnold Rönnebeck Family.

Barnes Foundation Archives, Merion, Pennsylvania. Charles Demuth, Albert Barnes correspondence.

Beinecke Rare Book and Manuscript Library, Yale University, New Haven, Connecticut, Yale Collection of American Literature, Papers of: Norman Douglas, Muriel Draper, Max Ewing, Mabel Dodge Luhan, Blanche Matthias, Howard Putnam Phelps, Arnold Rönnebeck, Gertrude Stein and Alice B. Toklas, Alfred Stieglitz, Carl Van Vechten, Richard Weyand Scrapbooks, and Edmund Wilson.

Demuth Foundation, Lancaster, Pennsylvania. Charles Demuth papers.

## List of Illustrations

Plate 1
Charles Demuth (1883–1935)
*My Egypt*, 1927
Oil and graphite on fiberboard,
35¾ x 30 inches
Whitney Museum of American Art,
New York; Purchase with funds from
Gertrude Vanderbilt Whitney
31.172

Plate 2
Charles Demuth (1883–1935)
*Buildings, Lancaster*, 1930
Oil and graphite on fiberboard,
24 x 20 inches
Whitney Museum of American Art,
New York; Gift of an anonymous donor
58.63

Plate 3
Charles Demuth (1883–1935)
*Chimney and Water Tower*, 1931
Oil and graphite on fiberboard,
29¼ x 23¼ inches
Amon Carter Museum, Fort Worth, Texas
1995.9

Plate 4
Charles Demuth (1883–1935)
*Buildings*, ca. 1930–31
Oil and graphite on fiberboard,
30 x 24 inches
Dallas Museum of Art, Dallas Art Association
Purchase Fund, Deaccession Funds/City of
Dallas (by exchange) in honor of Dr. Steven
A. Nash
1988.21

Plate 5
Charles Demuth (1883–1935)
*Buildings Abstraction, Lancaster*, 1931
Oil and graphite on fiberboard,
27⅞ x 23⅝ inches
Founders Society Purchase, General
Membership Fund
Photograph © 1990 The Detroit Institute
of Arts

Plate 6
Charles Demuth (1883–1935)
*And the Home of the Brave*, 1931
Oil and graphite on fiberboard, 30 x 24 inches
Alfred Stieglitz Collection, gift of Georgia
O'Keeffe, 1948.650
The Art Institute of Chicago. Photography
© The Art Institute of Chicago

Plate 7
Charles Demuth (1883–1935)
*After All*, 1933
Oil and graphite on fiberboard, 36 x 30 inches
Bequest of R. H. Norton, 53.43
Norton Museum of Art, West Palm
Beach, Florida

Fig. 1
Charles Demuth (1883–1935)
*Portrait of Augusta B. Demuth (the artist's
mother)*, 1906
Graphite on oil cloth
Yale University Art Gallery
Gift of William Kelly Simpson, BA 1947,
MA 1948, PhD 1954

Fig. 2
Demuth House, 118 East King Street,
Lancaster, Pennsylvania
Collection of the Demuth Museum,
Lancaster, Pennsylvania

Fig. 3
Watercolor of birds from Demuth's
childhood sketchbook
Collection of the Demuth Museum,
Lancaster, Pennsylvania

Fig. 4
Charles Sheeler (1883–1965)
*Doylestown House, Exterior View*, ca. 1917
Gelatin silver print
Photograph © The Lane Collection,
Photograph courtesy Museum of Fine
Arts, Boston

Fig. 5
Demuth Studio, ca. 1994
Collection of the Demuth Museum,
Lancaster, Pennsylvania

Fig. 6
Demuth as a young boy in the house on East
King Street
Collection of the Demuth Museum,
Lancaster, Pennsylvania

Fig. 7
Interior of Demuth house, before 1917
Richard Weyand Scrapbook (V: 312)
Yale Collection of American Literature,
Beinecke Rare Book and Manuscript Library,
Yale University

Fig. 8
Charles Demuth, ca. 1898
Collection of the Demuth Museum,
Lancaster, Pennsylvania

Fig. 9
Dining room, Demuth house, ca. 1934
Collection of the Demuth Museum,
Lancaster, Pennsylvania

Fig. 10
Charles Demuth, ca. 1905
Collection of the Demuth Foundation,
Lancaster, Pennsylvania

Fig. 11
Charles Demuth (1883–1935)
*Self-Portrait*, 1907
Oil on canvas
Collection of the Demuth Museum,
Lancaster, Pennsylvania

Fig. 12
Charles Demuth (1883–1935)
*Three Acrobats*, 1916
Watercolor on paper
Amon Carter Museum, Fort Worth, Texas
1983.127

Fig. 13
Charles Demuth (1883–1935)
*Cineraria*, 1923
Watercolor and graphite on paper
Amon Carter Museum, Fort Worth, Texas,
Purchase with funds provided by Nenetta
Burton Carter
1981.2

Fig. 14
Charles Demuth as a boy in the family
garden, ca. 1891
Collection of the Demuth Foundation,
Lancaster, Pennsylvania

Fig. 15
Charles Demuth in the family garden, 1928
Richard Weyand Scrapbook (V: 309)
Yale Collection of American Literature,
Beinecke Rare Book and Manuscript Library,
Yale University

Fig. 16
Charles Demuth (1883–1935)
*Bermuda: Stairway*, 1917
Watercolor with graphite underdrawing on
wove paper
BF 656 © Photograph Reproduced with the
Permission of The Barnes Foundation,™ All
Rights Reserved

Fig. 17
Arnold Rönnebeck (1885–1947)
*Charles Demuth*, Paris, 1913
Courtesy of the Arnold Rönnebeck family

Fig. 18
Arnold Rönnebeck (1885–1947)
*Charles Demuth*, Paris, 1913
Courtesy of the Arnold Rönnebeck family

Fig. 19
Arnold Rönnebeck (1885–1947)
*Charles Demuth*, 1913
Plaster bust (unlocated)
Courtesy of the Arnold Rönnebeck family

Fig. 20
Arnold Ronnebeck (1885–1947)
*Georgia O'Keeffe*, bronze, ca. 1924
Peter A. Juley and Son Collection,
Smithsonian American Art
Museum, J0119595

Fig. 21
Florine Stettheimer (1871–1944)
*Portrait of Alfred Stieglitz*, 1928
Oil on canvas
Fisk University Galleries,
Nashville, Tennessee

Fig. 22
Florine Stettheimer (1871–1944)
*Love Flight of a Pink Candy Heart*, 1930
Oil on canvas
Detroit Institute of Arts, 1995, Gift of Miss
Ettie Stettheimer

Fig. 23
Carl Van Vechten (1880–1964)
*Muriel Draper*, 1934
Carl Van Vechten Papers
Yale Collection of American Literature,
Beinecke Rare Book and Manuscript Library,
Yale University
Permission courtesy Carl Van Vechten Trust

Fig. 24
Florine Stettheimer (1871–1944)
*Cathedrals of Fifth Avenue*, 1931
Oil on canvas
The Metropolitan Museum of Art, Gift of Miss
Ettie Stettheimer, 1953. (53.24.3) Photograph
© 1995 The Metropolitan Museum of Art

Fig. 25
Carl Van Vechten (1880–1964)
*Robert Locher*, 1937
Carl Van Vechten Papers
Yale Collection of American Literature,
Beinecke Rare Book and Manuscript Library,
Yale University
Permission courtesy Carl Van Vechten Trust

Fig. 26
Beatrice Wood (1893–1998)
*Lit de Marcel*, 1917
Watercolor on paper
Francis M. Naumann, New York

Fig. 27
Edward Fisk (1886–1944)
*Helene Iungerich, Charles Demuth,
and Stuart Davis in Provincetown,
Massachusetts*, 1914
Photograph courtesy Milton Fisk

Fig. 28
Edward Fisk (1886–1944)
*Charles Demuth, Marsden Hartley, Louise
Bryant, and Eugene O'Neill on the beach in
Provincetown, Massachusetts*, 1916
Photograph courtesy Milton Fisk

Fig. 29
Charles Demuth (1883–1935)
*In the Province #7*, 1920
Tempera, watercolor, and graphite on
composition board
Amon Carter Museum, Fort Worth, Texas
1982.55

Fig. 30
Charles Demuth (1883–1935)
*Lancaster*, 1920
Tempera and pencil on paper
Philadelphia Museum of Art: The Louise and
Walter Arensberg Collection, 1950

Fig. 31
Charles Demuth (1883–1935)
*In the Province (Roofs)*, 1920
Gouache and pencil on paper
Photograph © 2006 Museum of Fine Arts,
Boston, Anonymous gift in memory of
Nathaniel Saltonstall

Fig. 32
Charles Demuth (1883–1935)
*From the Garden of the Château*, 1921
(reworked 1925)
Oil on canvas
Fine Arts Museums of San Francisco,
Museum purchase, Roscoe and Margaret
Oakes Income Fund, Ednah Root, and
the Walter H. and Phyllis J. Shorenstein
Foundation Fund, 1990.4

Fig. 33
Alfred Stieglitz (1864–1946)
*Charles Demuth*, 1915
Platinum print
Alfred Stieglitz Collection, Image © 2006
Board of Trustees, National Gallery of Art,
Washington, D.C.
1949.3.354

Fig. 34
Dr. Albert Coombs Barnes
Temple University Libraries, Urban Archives,
Philadelphia, Pennsylvania

Fig. 35
Julius T. Bloch (1888–1966)
*Charles Demuth*, ca. 1921
Red fabricated chalk on off-white wove paper
Philadelphia Museum of Art: Gift of the
Executors of the Estate of Julius Bloch, 1967

Fig. 36
Man Ray (1890–1976)
*Hands of Charles Demuth*, 1921
Gelatin silver print
George Eastman House, Rochester, New York
© 2007 The Man Ray Trust/Artist Rights
Society (ARS), NY/ADAGP, Paris

Fig. 37
Charles Demuth (1883–1935)
*Rue de Singe qui Pêche*, 1921
Tempera on academy board
Daniel J. Terra Collection, 1999.44
Terra Foundation of American Art,
Chicago, Illinois
Photo credit: Terra Foundation for American
Art, Chicago / Art Resource, NY

Fig. 38
Charles Demuth (1883–1935)
*Bermuda: Houses Seen Through Trees*, 1918
Watercolor with graphite underdrawing on
wove paper
BF 647 © Photograph Reproduced with the
Permission of The Barnes Foundation,™ All
Rights Reserved

Fig. 39
Alfred Stieglitz (1864–1946)
*Charles Demuth*, 1923
Gelatin silver print
Amon Carter Museum, Fort Worth, Texas,
Gift of Doris Bry. Copyright courtesy of the
Georgia O'Keeffe Foundation
P1998.75

Fig. 40
Alfred Stieglitz (1864–1946)
*Charles Demuth*, 1923
Palladium print
Alfred Stieglitz Collection, Image © 2006
Board of Trustees, National Gallery of Art,
Washington, D.C.
1949.3.583

Fig. 41
Charles Demuth (1883–1935)
*Eggplants and Pears*, 1925
Opaque and transparent watercolor over
graphite on paper
Photograph © 2006 Museum of Fine Arts,
Boston, Bequest of John T. Spaulding

Fig. 42
Charles Demuth (1883–1935)
*Calla Lilies (Bert Savoy)*, 1927
Oil on composition board
Alfred Stieglitz Collection
Fisk University Galleries,
Nashville, Tennessee

Fig. 43
Peggy Bacon (1895–1987)
*Charles Demuth*, ca. 1935
Crayon on paper
National Portrait Gallery, Smithsonian
Institution, Washington, D.C.
73.3

Fig. 44
Charles Demuth (1883–1935)
*The Figure 5 in Gold*, 1928
Oil on cardboard
The Metropolitan Museum of Art, Alfred
Stieglitz Collection, 1949 (49.59.1)
Photograph © 1996 The Metropolitan
Museum of Art

Fig. 45
Dorothy Norman (1905–1997)
*Charles Demuth*, 1932
Gelatin silver print
National Portrait Gallery, Smithsonian
Institution, Washington, D.C.
© 2000 Center for Creative Photography, The
University of Arizona Foundation

Fig. 46
Undated view of Lancaster showing the spire
of Trinity Lutheran Church at left, along with
the smokestacks and water tower prevalent
in Demuth's late architectural works,
Richard Weyand Scrapbook (V: 317)
Yale Collection of American Literature,
Beinecke Rare Book and Manuscript Library,
Yale University

Fig. 47
Charles Demuth (1883–1935)
*Piano Mover's Holiday*, 1919
Tempera on composition board
BF 339 © Photograph Reproduced with the
Permission of The Barnes Foundation,™All
Rights Reserved

Fig. 48
Charles Demuth (1883–1935)
*End of the Parade, Coatesville, Pa.*, 1920
Tempera and pencil on board
Collection of Ed Shein

Fig. 49
Charles Demuth (1883–1935)
*Lancaster*, 1921
Tempera on board
Albright-Knox Art Gallery, Buffalo, New York,
Room of Contemporary Art Fund

Fig. 50
Charles Demuth (1883–1935)
*Aucassin and Nicolette*, 1921
Oil on canvas
Columbus Museum of Art, Ohio: Gift of
Ferdinand Howald
1931.123

Fig. 51
Lew Engle
Armstrong's water tower and smokestack,
ca. 1986
Private Collection

Fig. 52
Charles Demuth (1883–1935)
*Masts*, 1919
Tempera on composition board
BF 343 © Photograph Reproduced with the
Permission of The Barnes Foundation,™ All
Rights Reserved

Fig. 53
Armstrong Floor Plant, Lancaster,
Pennsylvania, 1908–09
*History of the Floor Plant 1908–1980*
(Lancaster, Pennsylvania: Armstrong, 1980)
page 6

Fig. 54
Undated image showing tanks for boiling
linseed oil, Armstrong factory complex,
Lancaster, Pennsylvania
Photograph courtesy of Hagley Museum and
Library, Wilmington, Delaware
83.250.27

Fig. 55
Linoleum being cured by festoon hanging in
stoves, Armstrong factory complex, Lancaster,
Pennsylvania, 1909
*History of the Floor Plant 1908–1980*
(Lancaster, Pennsylvania: Armstrong, 1980)
page 8

Fig. 56
Armstrong factory complex, 1986
Private Collection

Fig. 57
Charles Demuth (1883–1935)
*Machinery*, 1920
Tempera and oil on cardboard
The Metropolitan Museum of Art, Alfred
Stieglitz Collection, 1949 (49.59.2)
Photograph © 1991 The Metropolitan
Museum of Art

Fig. 58
Armstrong Cork Company, Lancaster,
Pennsylvania, May 21, 1927; the spire of
Trinity Lutheran Church can be seen in the
upper right
Photograph courtesy of Hagley Museum and
Library, Wilmington, Delaware
70.200.2431

Fig. 59
Undated image of the Demuth tobacco shop
Photograph courtesy of the Demuth
Foundation, Lancaster, Pennsylvania

Fig. 60
Young Charles in the family tobacco store,
early 1890s
Photograph courtesy of the Demuth
Foundation, Lancaster, Pennsylvania

Fig. 61
Undated image of Ferdinand Demuth inside
the Demuth tobacco shop
Photograph courtesy of the Demuth
Foundation, Lancaster, Pennsylvania

Fig. 62
Sheldon Dick (1906–1950)
*Tobacco Hanging in a Barn, Churchtown
Vicinity, Lancaster County*, 1938
Farm and Security Administration, Office of
War Information and Collection, Prints and
Photographs Division, Library of Congress,
Washington, D.C. (LC-USF34-040246-D)

Fig. 63
Sheldon Dick (1906–1950)
*Barn, Lancaster County or Vicinity*, May 1938
Farm and Security Administration, Office of
War Information and Collection, Prints and
Photographs Division, Library of Congress,
Washington, D.C. (LC-USF33-020075-M4)

Fig. 64
Arthur Rothstein (1915–1985)
*Dutch Barn, Lancaster County*,
December 1941
Farm and Security Administration, Office of
War Information and Collection, Prints and
Photographs Division, Library of Congress,
Washington, D.C. (LC-USF34-024505-D)

Fig. 65
Sheldon Dick (1906–1950)
*Lancaster County, Pennsylvania, Rural Scene*,
May 1938
Farm and Security Administration, Office of
War Information and Collection, Prints and
Photographs Division, Library of Congress,
Washington, D.C. (LC-USF33-020068-M4)

Fig. 66
Postcard from Georgia O'Keeffe to Charles
Demuth, postmarked July 14, 1931
Private Collection

Fig. 67
Carl Van Vechten (1880–1964)
*Charles Demuth and Georgia O'Keeffe*, 1932
Carl Van Vechten Papers
Yale Collection of American Literature,
Beinecke Rare Book and Manuscript Library,
Yale University
Permission courtesy Carl Van Vechten Trust

Fig. 68
Charles Demuth (1883–1935)
*After Sir Christopher Wren*, 1920
Watercolor, gouache and pencil on board
The Metropolitan Museum of Art, Bequest
of Scofield Thayer, 1982 (1984.433.156)
Photograph © 1992 The Metropolitan
Museum of Art

Fig. 69
A set of carving tools from Demuth's era
Collection of the Demuth Museum,
Lancaster, Pennsylvania

Fig. 70
Demuth's pencil stubs with hand-chiseled
finger grips
Collection of the Demuth Museum,
Lancaster, Pennsylvania

Fig. 71
Demuth's paint box with various brushes and
tubes of oil color
Collection of the Demuth Museum,
Lancaster, Pennsylvania

Fig. 72
Demuth's easel
Collection of the Demuth Museum,
Lancaster, Pennsylvania

Fig. 73
Illustration of man lifting a Beaver Board
panel from a stack; from the brochure,
*Beaver Board and its Uses*, 1920, p. 5
(Trade Cat. B386 1920, Hagley Library,
Winterthur, Delaware)

Fig. 74
Beaver Board logo on reverse of
manufactured panel that was cut down and
used as a painting support

Fig. 75
Photomicrograph detail (6x) of *In the
Province #7* showing recessed graphite lines
of spire, wood fibers caught up in paint, and
paint layer raised in relief

Fig. 76
Photomicrograph detail (6x) of *In the
Province #7* showing Demuth's use of pooled
pigment and his blotting technique in
watercolor in background surrounding trees

Fig. 77
Photomicrograph detail (6x) of *In the
Province #7* revealing use of watercolor for
naturalistic rendering of trees

Fig. 78
Photomicrograph detail (6x) of *In the
Province #7* showing use of pooled technique
in application of transparent blue watercolor
wash in background

Fig. 79
Photomicrograph detail (6x) of *In the
Province #7* showing Demuth's application
of finishing touches in opaque tempera for
rooftop of building behind trees

Fig. 80
Photomicrograph detail (6x) of *In the Province #7* showing Demuth's use of hatched brushwork in application of tempera for red chimney (note how red strokes feather across the vertical line)

Fig. 81
Charles Demuth (1883–1935)
Study for *And the Home of the Brave*, ca. 1931
Graphite on paper
Judith and Arthur Marks

Fig. 82
Charles Demuth (1883–1935)
Study for *Buildings, Lancaster*, ca. 1930
Graphite on paper
Judith and Arthur Marks

Fig. 83
Marsden Hartley (1877–1943)
Preparatory sketch with color notes for *Whale's Jaw Rock, Dogtown*, ca. 1931–34

Fig. 84
Georgia O'Keeffe (1887–1986)
*Untitled (New York Street with Moon)*, 1925
Graphite on paper
The Georgia O'Keeffe Museum
CR: 482

Fig. 85
Charles Demuth (1883–1935)
Study for *Chimney and Water Tower*, ca. 1931
Graphite on paper
Amon Carter Museum, Fort Worth, Texas
1995.19

Fig. 86
Charles Demuth (1883–1935)
Study for *My Egypt*, ca. 1927
Graphite on paper
Tacoma Art Museum, Museum purchase.
Photograph by Richard Nicol.

Fig. 87
Charles Demuth (1883–1935)
Study for *And the Home of the Brave*, ca. 1931
Graphite on paper
Jay E. Cantor

Fig. 88
Charles Demuth (1883–1935)
Study for *And the Home of the Brave*, ca. 1931
Graphite on paper
Professor Joseph Masheck

Fig. 89
Charles Demuth (1883–1935)
Study for *And the Home of the Brave*, ca. 1931
Pencil on paper
Professor Joseph Masheck

Fig. 90
Charles Demuth (1883–1935)
Study for *After All*, ca. 1933
(sketch #14 from sketchbook)
Graphite on paper
Yale University Art Gallery, New Haven, Connecticut, Gift of Dr. and Mrs. William R. Hill in memory of Richard Weyand

Fig. 91
Charles Demuth (1883–1935)
Study for *After All*, ca. 1933
(sketch #15 from sketchbook)
Graphite on paper
Yale University Art Gallery, New Haven, Connecticut, Gift of Dr. and Mrs. William R. Hill in memory of Richard Weyand

Fig. 92
Charles Demuth (1883–1935)
Sketch of a water tower (upside down) sketch #18 from Charles Demuth's Sketchbook, ca. 1931
Graphite on paper
Yale University Art Gallery, New Haven, Connecticut, Gift of Dr. and Mrs. William R. Hill in memory of Richard Weyand

Fig. 93
Charles Demuth (1883–1935)
Study for *After All*, ca. 1933
(sketch #16 from sketchbook)
Graphite on paper
Yale University Art Gallery, New Haven, Connecticut, Gift of Dr. and Mrs. William R. Hill in memory of Richard Weyand

Fig. 94
Raking-light detail of *Chimney and Water Tower*; this is the only painting from the industrial oil series the artist executed on the smooth side of the Masonite panel, making it closer in appearance to a traditional oil on panel painting

Fig. 95
Cover and interior spread of brochure
*Masonite Home* (1934); the broad applications
of Masonite were highlighted at the 1934
Chicago World's Fair, held the year following
the completion of *After All*, Demuth's
last painting
Collection of Rick Stewart

Fig. 96 a and b
Details of the reverse of Georgia O'Keeffe's
*Untitled (Skunk Cabbage)*, ca. 1927, and
*Calla Lily in Tall Glass, No. II*, 1923; both
works are oil on Masonite. Like Demuth,
O'Keeffe primed the reverses of her panels,
which appear similar to those used by
Demuth for his industrial oils. O'Keeffe
also tested her colors on the reverse of
*Untitled (Skunk Cabbage)*. The Georgia
O'Keeffe Museum.

Fig. 97
Reverse of *Buildings* showing blue primer

Fig. 98
Detail of primed reverse of *Chimney
and Water Tower* showing Demuth's
dove signature

Fig. 99
Raking-light detail of *Buildings* showing
Demuth's use of incised working lines

Fig. 100
Photomicrograph detail (6x) of *Chimney and
Water Tower* showing drawing in graphite
through wet paint along curving bottom edge
of stovepipe

Fig. 101
Photomicrograph detail (6x) of *Chimney and
Water Tower* showing drawing in graphite
over dry paint to create brick façade

Fig. 102
Raking-light detail of *Buildings* showing
texture of Masonite support

Fig. 103
Photomicrograph detail (6x) showing
pentimento in *Chimney and Water Tower*
where Demuth covered over earlier recessed
graphite working line with zigzag brushwork

Fig. 104
X-radiograph of *Chimney and Water Tower*
showing pentimento in the elimination of
tipi-like structure in the lower left

Fig. 105
X-radiograph detail of *Buildings* showing
Demuth shifted the tower to the right, as
seen in the repositioning of the legs

Fig. 106
Detail of *After All* showing incisions in
railings of fire escapes

Fig. 107
Photomicrograph detail (6x) of *Chimney and
Water Tower* showing signature "C.D. '31" in
black crayon

Fig. 108
Raking-light detail of *Buildings* showing the
swirling brushstrokes in the chimney pipe
and smoke

Fig. 109
Detail of *Buildings* showing nuances in
shades of red and attesting to Demuth's skill
as a colorist

Fig. 110
Ultraviolet-light detail of *Buildings* showing
that Demuth repainted the billowing smoke
and much of the sky

Fig. 111
Ultraviolet-light photograph of *Buildings
Abstraction, Lancaster* revealing that
Demuth changed the color of the background
surrounding the steam (middle right) and
repainted the background (lower right)

Fig. 112
Ultraviolet-light photograph of *Chimney and
Water Tower* showing fluorescent drips near
base of chimney

Fig. 113
*Chimney and Water Tower* in its original
silver leaf frame

## Exhibition Checklist

All works by Charles Demuth (1883–1935)
unless otherwise indicated

*My Egypt*, 1927
Oil and graphite on fiberboard
34 ¾ x 30 in.
Whitney Museum of American Art, New York
Purchase with funds from Gertrude Vanderbilt Whitney
31.172

*Buildings, Lancaster*, 1930
Oil and graphite on fiberboard
24 x 20 in.
Whitney Museum of American Art, New York
Gift of an anonymous donor
58.63

*Buildings*, ca. 1930–31
Oil and graphite on fiberboard
30 x 24 in.
Dallas Museum of Art, Dallas Art Association Purchase Fund, Deaccession
Funds/City of Dallas (by exchange) in honor of Dr. Steven A. Nash
1988.21

*Chimney and Water Tower*, 1931
Oil and graphite on fiberboard
29 ¼ x 23 ¼ in.
Amon Carter Museum, Fort Worth, Texas
1995.9

*And the Home of the Brave*, 1931
Oil and graphite on fiberboard
30 x 24 in.
The Art Institute of Chicago, Alfred Stieglitz Collection, gift of Georgia O'Keeffe
1948.650

*After All*, 1933
Oil and graphite on fiberboard
36 x 30 in.
Norton Museum of Art, West Palm Beach, Florida
Bequest of R. H. Norton
53.43

## DRAWINGS

Study for *My Egypt*, ca. 1927
Graphite on paper
8½ x 6½ in.
Tacoma Art Museum, Tacoma, Washington

Study for *Chimney and Water Tower*, c. 1931
Graphite on paper
8¼ x 6⁷⁄₁₆ in.
Amon Carter Museum, Fort Worth, Texas
1995.18

Study for *Chimney and Water Tower*, c. 1931
Graphite on paper
8¼ x 6⁷⁄₁₆ in.
Amon Carter Museum, Fort Worth, Texas
1995.19

Study for *And the Home of the Brave*, c. 1931
Graphite on paper
8¼ x 6⁷⁄₁₆ in.
Professor Joseph Masheck

Study for *And the Home of the Brave*, c. 1931
Graphite on paper
8¼ x 6½ in.
Professor Joseph Masheck

Study for *And the Home of the Brave*, c. 1931
Graphite on paper
10¹⁵⁄₁₆ x 8⁹⁄₁₆ in.
Jay E. Cantor

Study for *Buildings, Lancaster*, ca. 1930–31
(two-sided drawing; verso: Study for *And the
Home of the Brave*)
Graphite on paper
8¼ x 6½ in.
Judith and Arthur Marks

Sketchbook, ca. 1921–35
28 sketches in graphite and watercolor
10⅝ x 8¼ in.
Yale University Art Gallery
Gift of Dr. and Mrs. William R. Hill in
memory of Richard Weyand
1995.51.3a-bb

## RELATED WORKS BY DEMUTH

*Three Acrobats*, 1916
Watercolor and graphite on paper
12¹⁵⁄₁₆ x 7⅞ in.
Amon Carter Museum, Fort Worth, Texas
1983.127

*In the Province #7*, 1920
Tempera, watercolor, and graphite on
composition board
19⅞ x 15⅞ in.
Amon Carter Museum, Fort Worth, Texas
1982.55

*Cineraria*, 1923
Watercolor and graphite on paper
9¹⁵⁄₁₆ x 13¹⁵⁄₁₆ in.
Amon Carter Museum, Fort Worth, Texas
Purchase with funds provided by Nenetta
Burton Carter
1981.2

## PHOTOGRAPHS

Alfred Stieglitz (1864–1946)
*Charles Demuth*, 1923
Gelatin silver print
9½ x 7⅝ in.
Amon Carter Museum, Fort Worth, Texas,
Gift of Doris Bry
Copyright Courtesy of the Georgia
O'Keeffe Foundation
P1998.75

**EXHIBITION VENUES**

Amon Carter Museum
*Fort Worth, Texas*
*August 18–October 14, 2007*

Norton Museum of Art
*West Palm Beach, Florida*
*November 10, 2007–*
*January 20, 2008*

Whitney Museum
of American Art
*New York*
*February 23–April 27, 2008*

*Chimneys and Towers:*
*Charles Demuth's Late Paintings*
*of Lancaster* is organized by the
Amon Carter Museum, Fort Worth,
Texas. The exhibition and the
accompanying publication have been
made possible in part by grants from
The Henry Luce Foundation and The
National Endowment for the Arts.

**FOR THE**
**AMON CARTER MUSEUM**

Will Gillham
*Director of Publications*

Timothy Gambell
*Graphic Designer*

Miriam Hermann
*Publications Assistant*

Mary Jane Crook
*Editor*

Steven Watson
*Manager of*
*Photographic Services*

Jonathan Frembling
*Library and*
*Archives Reference*
*Services Coordinator*

Bill Maize
*Production Manager*

The Amon Carter Museum was
established through the generosity
of Amon G. Carter (1879–1955) to
house his collection of paintings and
sculpture by Frederic Remington
and Charles M. Russell; to collect,
preserve, and exhibit the finest
examples of American art; and to
serve an educational role through
exhibitions, publications, and
programs devoted to the study of
American art.

This publication was produced in
conjunction with the Anne Burnett
Tandy Distinguished Lectures on
American Art.

**BOARD OF TRUSTEES**

Ruth Carter Stevenson
*President*

Robert M. Bass
Bradford R. Breuer
Michael Conforti
Walker C. Friedman
John P. Hickey Jr.
Karen Johnson Hixon
Mark L. Johnson
Carter Johnson Martin
Richard W. Moncrief
Stephen P. Smiley
Benjamin F. Stapleton
Nenetta Carter Tatum
William E. Tucker
Alice L. Walton

Ron Tyler
*Director*

Learning Centre. Canolfan Dysgu
Coleg Y Cymoedd Campus Nantgarw Campus
Ysgol Y Coleg, Parc Nantgarw

**LIBRARY OF CONGRESS CATALOGING-IN-PUBLICATION DATA**

Fahlman, Betsy.

    Chimneys and towers : Charles Demuth's late paintings of Lancaster /

    by Betsy Fahlman. Technical essay Across the final surface / by Claire Barry.

        p. cm.

    Includes bibliographical references.

    ISBN 978-0-88360-102-0 (alk. paper)

    1. Demuth, Charles, 1883-1935 — Criticism and interpretation. 2. Architecture

    in art. 3. Precisionism — Pennsylvania — Lancaster. 4. Painting — Expertising.

    I. Barry, Claire M. Across the final surface. II. Amon Carter Museum of

    Western Art. III. Title.

    ND237.D36F28 2007

    759.13 — dc22

        2007016801

**COPYRIGHT © 2007 AMON CARTER MUSEUM**

3501 Camp Bowie Boulevard

Fort Worth, Texas 76107

www.cartermuseum.org

All rights reserved.

Distributed by the University of Pennsylvania Press

3905 Spruce Street

Philadelphia, Pennsylvania 19104-4112

www.upenn.edu/pennpress

ISBN-10: 0-8122-2012-9

ISBN-13: 978-0-8122-2012-4